BARRINGTON BARBER

DRAWING CLASS

BARRINGTON BARBER

DRAWING CLASS

LEARN TO DRAW IN JUST 12 LESSONS

ARCTURUS

ARCTURUS

This edition published in 2009 by Arcturus Publishing Limited
26/27 Bickels Yard, 151–153 Bermondsey Street,
London SE1 3HA

Editor: Ella Fern

ISBN: 978-1-84837-238-2
AD000062EN

Printed in Singapore

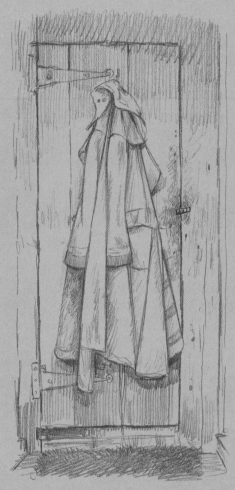

■ CONTENTS

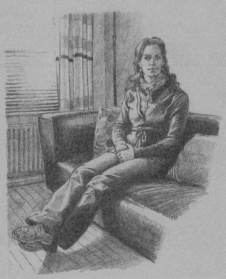

INTRODUCTION

Learning to draw is not difficult – everybody learns to walk, talk, read and write at an early age, and discovering how to draw is easier than any of those processes! Drawing is merely making marks on paper which represent some visual experience. All it takes to draw effectively is the desire to do it, a little persistence, the ability to observe and a willingness to take time to correct any mistakes. This last point is very important as mistakes are not in themselves bad – they are opportunities for improvement, as long as you always put them right so that you will know what to do the next time.

Many of the exercises in this book incorporate the time-honoured methods practised by art students and professional artists. If these are followed diligently, they should bring about marked progress in your drawing skills. With consistent practice and regular repetition of the exercises, you should be able to draw competently and from there you will see your skills burgeon. Don't be put off by difficulties along the way, because they can be overcome with determination and a lot of practice and this means you are actively learning, even if it may seem a bit of a struggle at times. The main thing is to practise regularly and keep correcting your mistakes as you see them. Try not to become impatient with yourself, as the time you spend altering your drawings to improve them is time well spent.

Work with other students as often as you can, because this also helps your progress. Drawing may seem like a private exercise, but in fact it's a public one, because your drawings are for others to see and appreciate. Show your work to other people and listen to what they say; don't just accept or reject their praise or criticism, but check up on your work to see if they have seen something you haven't. If other people's views aren't very complimentary, don't take offence. Neither praise nor criticism matters except in so far as it helps you to see your work more objectively. Although at first a more experienced artist's

views are of great value, eventually you have to become your own toughest critic, assessing exactly how a drawing has succeeded and how it has not worked.

Talk to professional artists about their work if you get the chance. Go to art shows and galleries to see what the 'competition' is like, be it from the old masters or your contemporaries. All this experience will help you to move your work in the right direction. Although working through this book will help you along your path to drawing well, it is up to you to notice your weaknesses and strengths, trying to correct the former and building on the latter.

Steady, hard work can accomplish more than talent by itself, so don't give up when you are feeling discouraged; drawing is a marvellously satisfying activity, even if you never get your work into the Royal Academy or the Tate Modern. Enjoy yourself!

Barrington Barber

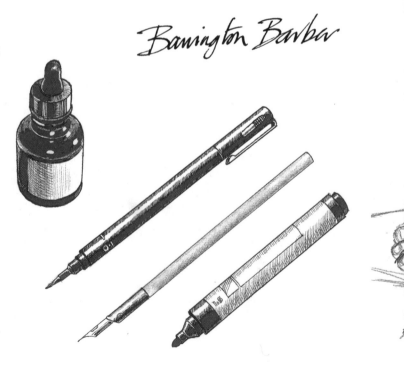

EQUIPMENT

When you first start to draw the most obvious tools to use are pencils, since you will have used these since you were a child and will feel very comfortable with them. Later on, when you are feeling more confident and preparing to take your drawing skills further, you will want to try a variety of mediums to see the different marks they make, enjoying the way you can expand your range of techniques. You will find drawing implements described on pages 124–53, with exercises to try them out on.

For your surfaces, you will need medium-weight cartridge paper, which you can buy in sheets or in a sketchbook. The latter will be most versatile, because you can take it around with you as well as using it at home. The sizes you will find convenient for travelling with are A5, A4 and A3 – anything larger is unwieldy.

A drawing board to use at home can be bought ready-made from an art supplies shop, but it's easy enough to make one cheaply by sawing it from a piece of MDF or thick plywood; an A2 size is most useful. Sand the edges to smooth them out and, if you wish, paint the board with either primer or a white emulsion to protect the surface against wear and tear. To attach your cartridge paper to the board, traditional clips or drawing pins can be used, but I prefer masking tape, which is light, easy to adjust and doesn't seem to damage the paper if it is used carefully.

Whether you draw sitting down or standing up, you will need to have your paper surface at a reasonably steep angle. If you want to draw standing up, which is usually the most accurate way to draw from life, you will need an easel to support your drawing board unless

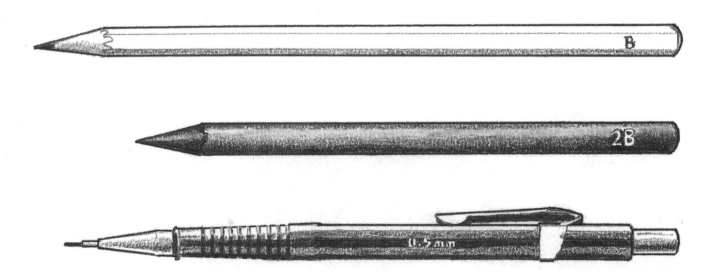

you are working with a small sketchbook. You can buy small folding easels or larger radial easels – I prefer the latter. If you like to draw sitting down and haven't got an easel, you can support an A2 drawing board on your knees and lean it on the edge of a table or the back of another chair.

No matter whether you are using an easel or more informal support, your sight line should be such that the part of the drawing you are working on is directly facing your gaze. If you are looking at the surface from an angle oblique to the paper, you will draw slight distortions without realizing it until you step back and see the drawing more objectively. Keep the grip on the pencil, or whatever implement you are using, fairly light and relaxed – you don't need to hold it in a vice-like grip. Also try different ways of drawing with the pencil, both in the normal pen grip and also in the brush grip, especially when you are drawing standing up – the more vertical your surface, the easier it is to use the brush grip.

Keep relaxing your shoulders, arm and wrist – a smooth, easy action is more conducive to good drawing. If you realize your movement is becoming anxious and constricted, stand back from the easel a little and work with sweeping strokes until you feel your action loosening again. As a beginner it's all too easy to become tense, perhaps through worrying that you are about to spoil a drawing that has been going well so far, but remember you are doing this for pleasure! The exercises in this book should help you to enjoy the learning process and concentrate on your progress rather than your mistakes.

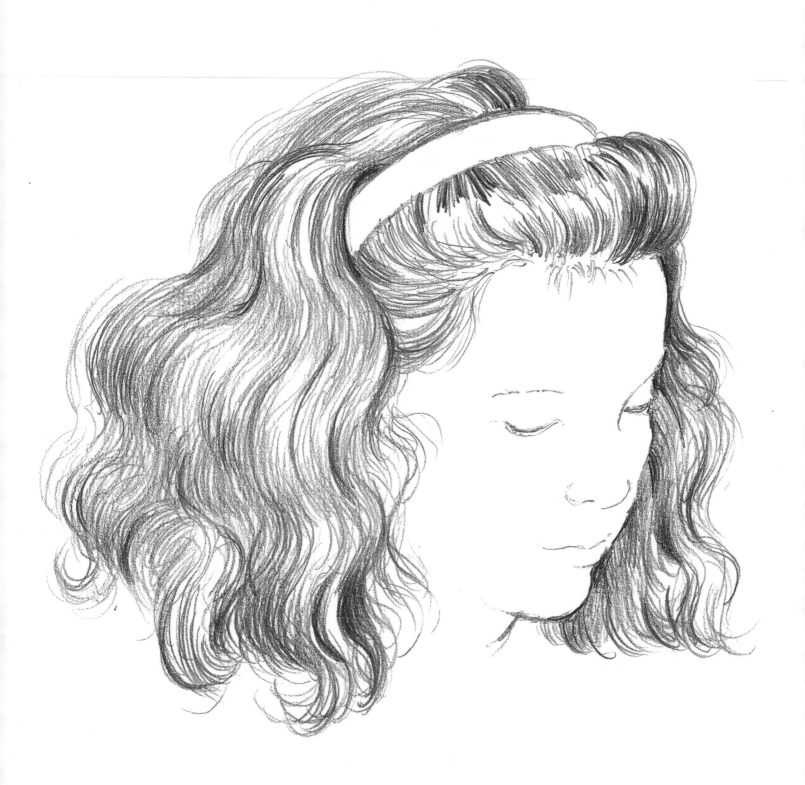

◼ LESSON I

BASIC EXERCISES IN LINE, SHAPE AND TEXTURE

This lesson is primarily designed for people who haven't done very much drawing, but even if you are already quite practised you may find that carrying out the exercises shown here is a good way to loosen yourself up for what follows. The main point of them is to work on the basic skills necessary to draw anything with some degree of verisimilitude. The practice of making marks, which after all is what drawing consists of, never loses its usefulness however accomplished you become.

So included in this section are exercises in drawing lines, tones, textures, and then simple shapes. All of the latter need a certain amount of control of the pencil, and practising this is never time wasted. You will also find lessons in simple perspective to introduce you to the practicalities of drawing shapes that appear to have some dimension.

These are followed by drawing the outlines of objects you have in front of you in order to familiarize yourself with working from life. This is where the real skill of an artist is honed, and it is something that you will never stop practising if you want to draw well. Finally, you will find exercises that give you some practice in adding texture to the objects that you draw in order to make them look more realistic.

■ MARK MAKING

These exercises are mainly for the benefit of complete beginners in drawing, but even if you are reasonably competent they will still be of great benefit. It is practising every day that produces manual dexterity, which is essentially what the artist needs. The more often you follow exercises such as these the more your hand and eye learn to work together, making your drawing more skilful.

Don't ignore the aesthetic quality of making marks; try to make your group of exercises look good on the paper.

Exercise I

Start by making a scribbly line in all directions. Limit it to an area and try to produce a satisfying texture.

Next try short, staccato marks that fill the space. Notice how none of them overlap and the spaces in between remain similar.

When you are drawing these more controlled uniform lines, make them all the same length and the same distance apart, keeping them as straight as possible. Repeat these three exercises.

Now take a line for a walk, but don't cross over it anywhere. This may seem rather obsessive, but it is a step on the way to teaching your hand to draw recognizable forms.

Next try a variety of straight lines, again trying to get them straight and the same distance apart, fitting into an imagined rectangle. First do diagonals from lower left to upper right, then horizontals, then diagonals from upper left to lower right. Next, try the two diagonals across each other to form a net, then the horizontals and verticals in the same fashion.

To practise more circular forms, make spirals. Work from outside to inside, clockwise and anti-clockwise, then tighter with the lines closer together; next work from the centre outwards, anti-clockwise then clockwise.

Now zig-zag your pencil up and down.

Use the same action, but incorporate some loops.

Try to produce a dark mass with lines going up and down.

Next, lay another mass of lines horizontally over this dark mass.

Finally, add third and fourth layers, both at diagonals.

Exercise 2

The next exploration in mark making is to draw a mass of zigzags in a continuous line crisscrossing over itself.

Now make softer, curvy lines overlapping themselves.

And now cloud-like shapes, going round and round in a continual line overlapping itself.

Next come circles, but not large – lots of them lined up both horizontally and vertically.

Inside each circle, put a nicely drawn spot.

Next make a network of vertical and horizontal lines, drawn very carefully.

Spread a mass of dots over an area as evenly as possible. Remember that this is training for the eye as well as the hand, so the evenness of the dots is important.

Draw several rows of small squares in lines as evenly as possible, as square as possible and lined up both vertically and horizontally.

This exercise is a bit harder to draw evenly, but try it anyway. Make rows of triangles fitting together so that the space between them is as even as possible and they are lined up horizontally and vertically.

Draw rows of spirals joined together as if they were the waves on the sea. Under them draw rows of waves, again as even as you can get them.

For the rest of the exercises on this page, the emphasis is on lightness of touch and control of the direction.

The first one is a vague circular shape of closely drawn lines, light in pressure to create a shaded area of tone.

Using the same technique, draw horizontal lines.

Next, make them vertically.

Then draw them diagonally, slanting to the left.

Again working diagonally, start dark with some pressure, gradually lightening the touch until it fades away.

Now make a series of similar shaded areas, starting from a curved drawn line so that one edge is defined.

Shade away from a zigzag edge.

Then shade away from an S-curved edge.

Now draw a circle and shade inside and outside of opposite edges.

Finally, do the same again only with two circles, one within the other.

■ BASIC SHAPES

So far, the exercises you have done with your pencil have been a bit like doodling. The next phase is a rather more intellectual one, where you have to envisage a form in your mind before trying to draw it.

Exercise 1

First, without too much thought, draw a circle as perfectly as you can. Now close your eyes and see in your mind's eye a perfect circle. It is extraordinary how we can do this yet draw something much less than perfect.

For your second attempt, draw one very lightly with a compass and then go over it in freehand, teaching yourself the way the shape should look. With practice of this kind it won't be long before your freehand circles have improved.

Now try an equilateral triangle – that is, a triangle that has all three sides equal in length. Not quite so easy as it looks, is it? But there is also a mechanical device to help you here: describe a circle with a compass, then draw the triangle within it, all angles touching the circle.

Next, a square. You will know that all the sides of a square are equal in length, and the corners are all right angles, but it can take a bit of time to get that right in the drawing. The mechanical device here is to measure the sides.

Because you are not used to seeing it so much, it is not so easy to draw a square balanced up on one corner, like a diamond shape. You will find it harder to get the sides equal.

Now we move on to slightly more complex shapes. The point of this is to get your eye, brain and hand acting together, so that gradually the practice of drawing becomes easier.

First, draw a five-pointed star without lifting your pencil from the paper. This is also easier drawn inside a circle with all the angles touching it, but try it with and without.

Secondly, try a six-pointed star, which is merely two equilateral triangles superimposed on one another.

Thirdly, draw a star of eight points, which is one square superimposed on another square.

Now try an egg-shape. This is narrower at one end than the other; draw it with the broader end at the base.

The crescent is another shape much harder than it looks at first glance, but the secret is to realize that the curve is a part of a circle. Try it freehand and then with a compass-drawn circle to help.

Exercise 2

In this exercise we start to look at ways of making things appear three-dimensional, in a conventional way – that is, they are only approximations of perspective, which is the way we tend to see shapes in space.

Draw a square, then another the same size but slightly above and to one side of the first. Join the corners with straight lines to link them up, giving a result like a transparent cube.

The next figure is similar, but put in only three of the joining lines so that the cube looks solid rather than transparent.

Now another way of drawing a cube; draw a flattened parallelogram, like a diamond on its side, and then project straight vertical lines down from the corners of this shape to another diamond shape below.

This time draw only three of the joining lines and two edges of the lower diamond, so that the cube looks solid again.

Next, draw a cylinder. First draw an ellipse – a flattened circle – then project two parallel lines vertically downwards to meet a similar ellipse.

Try again, only this time leave out the upper edge of the lower ellipse to make the cylinder look more solid.

Reverse the process so that the upper ellipse has only one edge; the cylinder now appears to be seen from below.

Now move on to cones, which are just two converging straight lines with an ellipse at the wider end.

Try this without part of the ellipse and then with the cone balanced on its point.

Exercise 3

You won't have found any of those exercises difficult after a bit of practice. The next stage is to practise making areas of tone on spheres, cubes, cylinders and cones.

First draw a circle as accurately as you can. Now, with very light strokes, put an area of tone over the left-hand half of the circle. Increase the intensity in a crescent shape around the lower left-hand side of the circle, leaving a slight area closest to the edge to act as the reflected light that you usually get

around the darker side of the sphere. Put in the cast shadow on the area that would be the ground, spilling out to the left and fading as it gets further from the sphere.

Now have a go at a cube, covering the left-hand side with a darkish tone. When this is dark enough, cover the other vertical side evenly all over with a much lighter tone. All that is needed then is a cast shadow as before, but fitting the squarer shape of the figure.

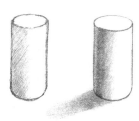

A cylinder is similar to a sphere, but the shading is only on the vertical surface. Again make a column of darker tone just away from the left-hand edge.

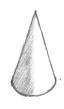
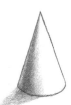

With a cone you have to allow for the narrowing shape, which is reflected in the cast shadow.

■ SIMPLE DRAWINGS

Let's look now at some patterns that have their origin in nature. These are all doodles again, but more formal; they are representative of what you might see growing in the countryside or in your garden.

Exercise 1

For the first shape, make a small circle with five small lines coming out from it, then draw petal shapes around the outside of the lines. The result looks like a flower.

The next one is similar in design, but the petals are more pointed and there are six of them this time.

Draw a small circle then put elongated petals around it, one at the top, one opposite at the bottom and one either side to form a cross. Fill in with four diagonal petals. In the spaces between, draw partially visible petals, followed by an outer set.

To draw a Tudor rose, start again with a circle, then put in five sets of small lines radiating from it. Around this, draw a five-petalled rose shape with overlapping edges, then put a small leaf shape projecting from the centre of each petal. Then draw in the last set of petal shapes in between each leaf.

The last flower shape is a bit like a chrysanthemum, with multiple long, thin, pointed petals radiating from a central point.

Next we go on to plant-like shapes with a central stalk. These drawings will help you to get a feel for the way in which natural growth proceeds. The first is just a straight stalk with a leaf shape on the end and additional stalks growing out of the central one, each bearing a leaf. Make the middle leaves larger and the bottom leaves smaller.

In the next drawing there is again a straight stalk, but the branches are all curling. Keep the twigs at the top and bottom simple and allow the middle layers to be more complex. Notice how some curl one way and some the other. Play around and experiment.

Here the stalk is drawn more substantially, thickest at the base and tapering to a point at the top. Draw the lower branches also with a bit of thickness and allow small, straight twigs to branch off in all directions. Try to maintain the same growth pattern all over the plant.

The last drawing is a similar growth pattern, but this time all the branches and twigs are curly. Start with the central trunk and add the thicker branches first before putting in the smaller ones. Have fun and be inventive.

Exercise 2

Now we move on to the human head, hand and foot. Like the plant forms, these are diagrammatic drawings, but they give you a good idea of the shape and proportion of the human head and extremities.

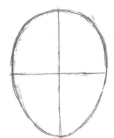

Start by drawing an oval like an egg perched on its smaller end, then divide it halfway both vertically and horizontally.

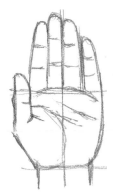

The hand is a simple block shape, with the palm almost square and the fingers about the same length as the palm. Draw a central line and this will be where the fingers divide two and two. They tend to taper a little towards the top, and the middle finger is usually the longest, with the forefinger or third finger coming next, then the little finger.

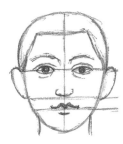

When the head is upright and facing you directly the eyes are halfway down. On the average face, the end of the nose is halfway between the eyes and the bottom of the chin. The mouth is about one-third nearer the nose than the bottom of the chin. There is about one eye length between the eyes, and also between the eye and the outer side of the head.

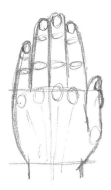

The thumb is usually a little shorter than the little finger, but appears much more so because it starts lower down the hand. Check with your own hand, noticing the knuckles on the back and the padded fleshy parts on the palm.

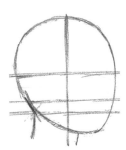

From the side, the head is as wide as long. Divide as before, placing the ear behind the halfway vertical.

The foot is simpler, especially when seen from the side. Notice how the toes curve and how they tend to be progressively shorter from the big toe to the little one. Some people have the second toe longer than the big toe, but this is variable.

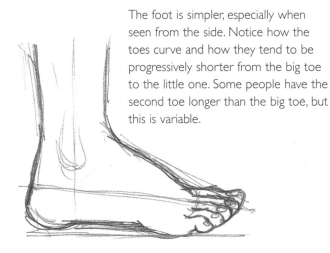

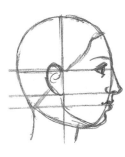

Project the nose, mouth and chin beyond the oval. The length of the ear is from about the eyebrow down to the bottom of the nose. Notice the shape of the eye seen from the side.

17

▢ SIMPLE PERSPECTIVE

In order to draw in a way that gives an effect of three dimensions you will need to learn a little about perspective, which is a way to make depth and space look more convincing. In life, perspective gives us an ability to assess the placing of objects and people in relation to one another, and you will need to mirror this in your drawings to make them realistic.

Exercise 1

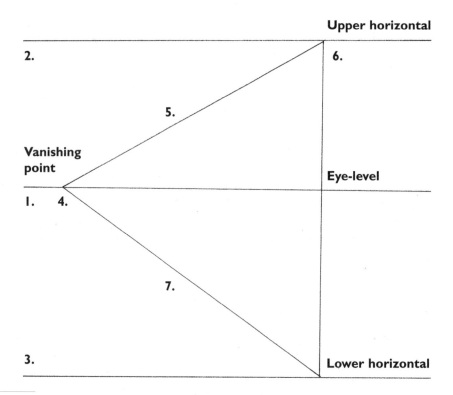

First, construct three horizontal lines that are parallel to each other across the page. The central one should be slightly nearer the top line than the bottom line. This central line **(1)** represents your eye-level, which will always be the line of the horizon. The others are the upper horizontal **(2)** and the lower horizontal **(3)**.

Now, to the right of the centre of your space, draw a vertical line from the upper horizontal to the lower horizontal **(6)**. Fix a point on the eye-level line and join the two ends of the vertical line to this point, which is called the vanishing point **(4)**. These two lines are the upper perspective line **(5)** and the lower perspective line **(7)**. You now have a triangle connecting the three horizontals and the vertical.

8.

9.

Next draw two vertical lines parallel to the original vertical, one to the right **(9)** and one to the left **(8)**, which will cut across the two lines going to the vanishing point.

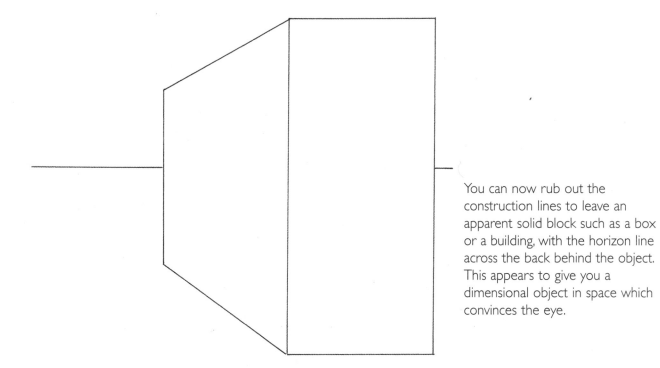

You can now rub out the construction lines to leave an apparent solid block such as a box or a building, with the horizon line across the back behind the object. This appears to give you a dimensional object in space which convinces the eye.

Exercise 2

The next drawing is going to give an impression of an interior space, such as a room with a cupboard or worktop inside it. All this is done with ruler, pencil and eraser, with the minimum of effort.

Draw a horizontal line across the page which will represent the eye-level or horizon (1). Fix a vanishing point on it towards the left of the centre (1A). Now draw two perspective lines, upper (2) and lower (3). On the lowest end of the lower perspective line construct a square (4, 6, 8, 9) making sure that the top and bottom edges are parallel to the horizon line. Then join the two corners of the top edge to the vanishing point (1A). These two perspective lines are 5 and 7.

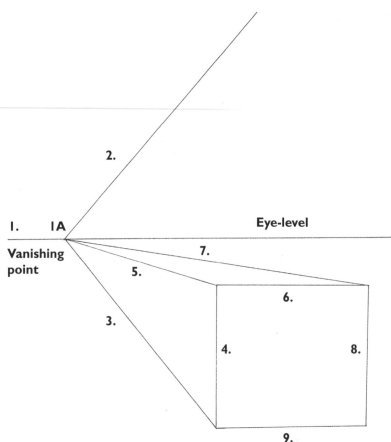

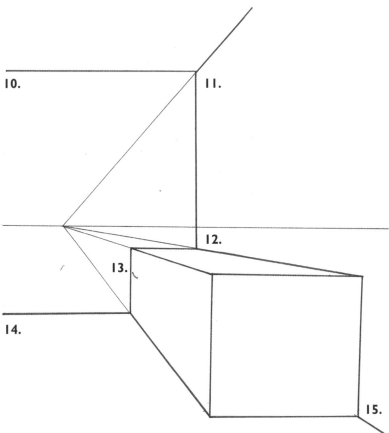

The next step is to draw a vertical line (13) and a horizontal line (12) further down the perspective lines to indicate the top and side edge of a cupboard shape. Then, to complete the illusion of an interior, draw a horizontal line (14) to indicate the lower edge of a wall where it meets the floor, a vertical line (11) to indicate the corner where two walls meet, and from where this line meets the upper perspective line, another horizontal (10), which represents the wall meeting the ceiling.

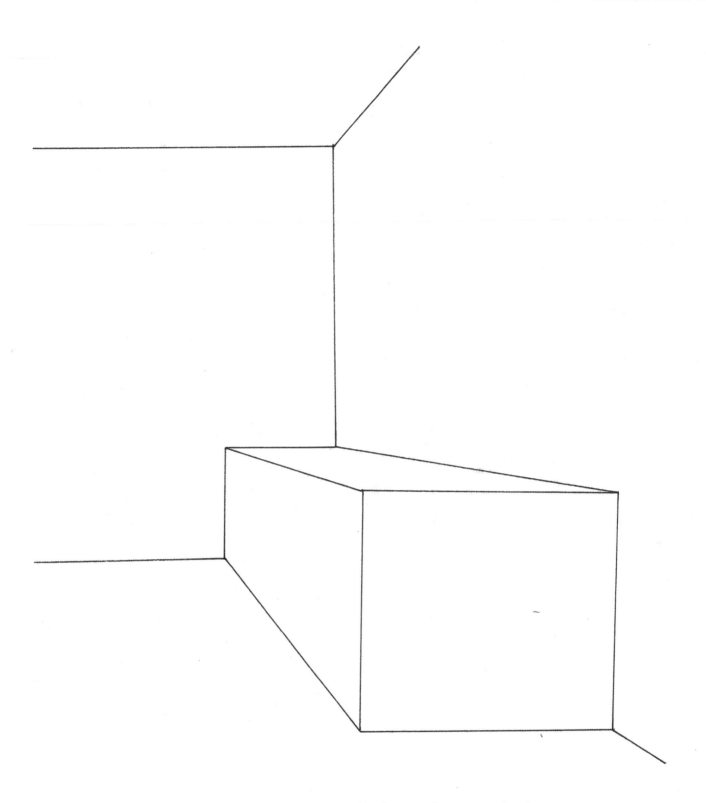

Finally, erase the construction lines,
leaving an apparent interior space
with a cupboard in it.

OBJECTS AND SHADING

The exercises over the following pages should be fun, so try to feel at ease as you do them. Don't grip the pencil too tightly, keep your shoulders relaxed and don't hunch up or get too close to your work. Draw what interests you and don't worry about mistakes – just correct them when you see them. To do this next set of exercises you will need to have some simple household objects in front of you. I have chosen some items from my own house – yours don't have to be exactly the same, but it will help you to follow my drawings as well as having the actual object in front of you.

Before you start, look very carefully at each object to familiarize yourself with its shape. I have used glass objects for the first exercises, because you can see through them to understand how the shape works.

Exercise I

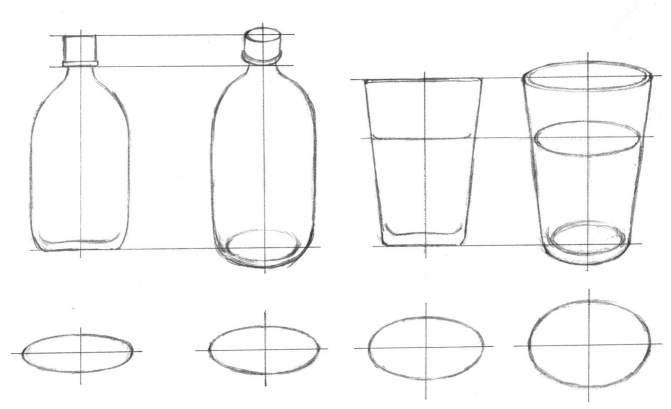

My first object is a bottle, seen directly from the side. As it was exactly symmetrical, I put in a central line first. Then I drew an outline of its shape including the screw top, making sure that both sides were symmetrical.

From a higher eye-level, I could see the bottle's rounded shape. To show this I needed to draw the elliptical shapes that circles make when seen from an oblique angle. Again I carefully constructed the shape either side of a central vertical line.

The ellipses shown below the bottles demonstrate how they become flattened to a greater or lesser degree depending upon the eye-level from which a rounded object is seen. Although they become deeper across the vertical axis the further they are below your eye-level, the horizontal axis remains the same width. Don't be put off by the difficulty of drawing them, because even professional artists don't find them so easy; with practice, you will be able to draw them well.

The next object is a glass tumbler with some water in it – slightly easier to draw than the bottle because it has straight sides. Draw the outline first at eye-level and then seen from slightly above. In the latter drawing there are three ellipses: the top edge of the glass, the surface of the water and the bottom of the glass.

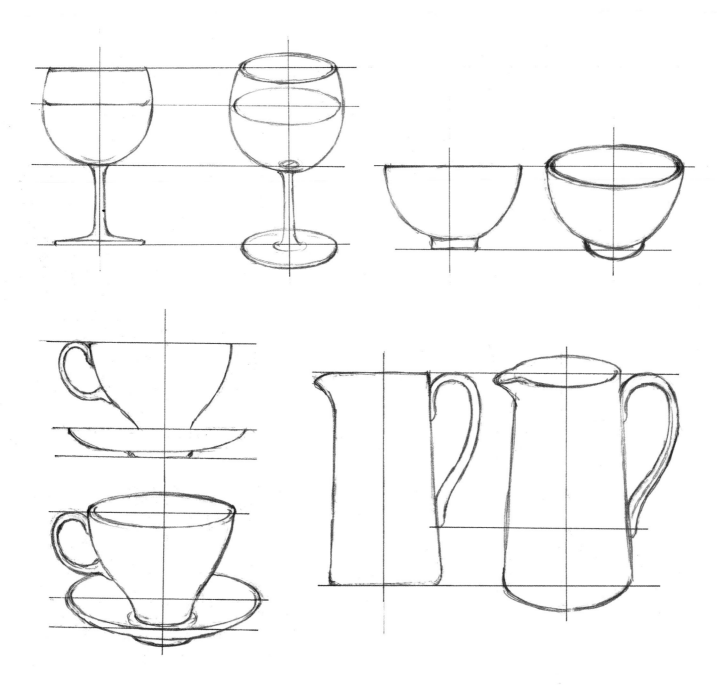

The third object, a wine glass with some liquid in it, is a bit harder. Here you will see that there are three ellipses of varying width, but the object is still symmetrical from side to side. Go carefully and enjoy discovering the exact shape.

Next, some opaque subjects, starting with a bowl. The side view drawing is easy enough; make the curve as accurate as you can, and then tackle the view from just above. This time you aren't able to see through the sides, so you have only one edge of the lower ellipse to draw.

The cup and saucer is more complex, but with a bit of steady care and attention you will soon get the shape right. Drawing it from above is a little harder and because you can't see through the porcelain it might be trickier to get the lower ellipses right first time.

The jug should be a bit easier after the cup and saucer, and it is placed here on purpose so that the effort you make on the more complex drawing pays off on the easier one. As before, draw the exact side view first before you depict it more naturally, seen from slightly above.

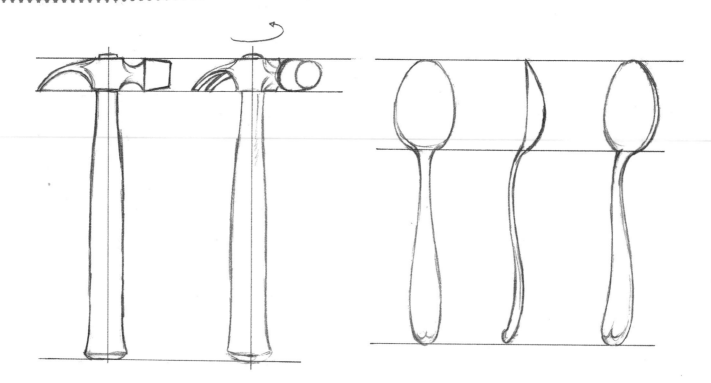

Exercise 2

Now you're ready to move on to a series of objects which are of varying difficulty. The drawing of the hammer is quite easy from the exact side view but is a bit trickier from a more oblique view.

There are two ways to draw the spoon, from the exact front and from the exact side, before you try a more natural view.

The pot is not too difficult if you have completed all the other objects so far, and the box is very simple – but beware of the third version, a slightly more complex view where the perspective can easily go wrong.

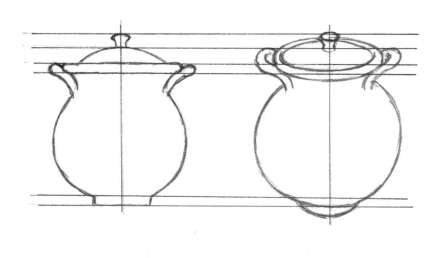

The saucepan and the teapot are of varying difficulty, but by now you are getting used to the problems of drawing like this. This sequence of objects is merely to give you practice in drawing, doing as many as you can in the time you have available.

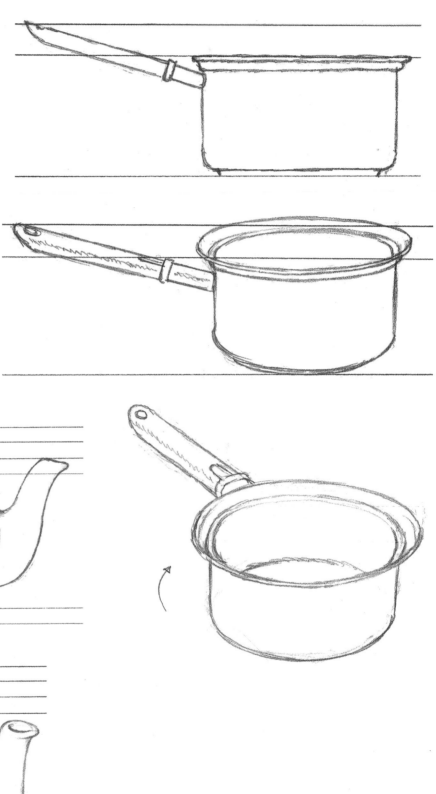

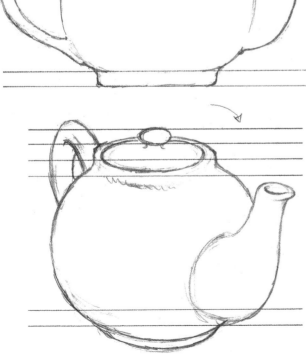

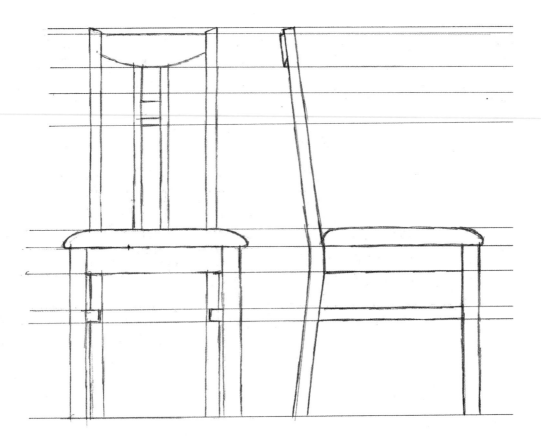

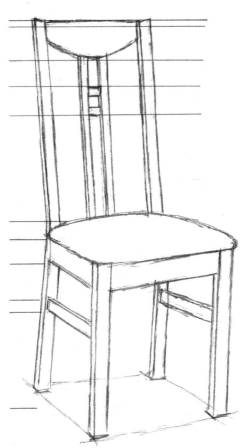

The chair is more complex than it looks at first glance. Follow the same course of drawing it from the exact side and front before trying to draw it in perspective. Understanding the construction of the chair is useful when you are trying to draw it.

Exercise 3

All these objects are simple enough in outline. However, to make them look more three-dimensional and substantial, the use of shading of some sort is needed.

First make line drawings of the objects as accurately as possible. On the book, shading to show the curve of the spine and fine lines giving an effect of the packed pages is almost all there is to do, with the addition of a small cast shadow to anchor it to a surface.

The pot needs quite heavy tone in the interior space to give some idea of the inner hollow. Then add a graduated tone around the cylinder and a small cast shadow to complete the picture.

The apple needs to be shaded in a vertical direction between the upper surface and the bottom, concentrating on the left-hand side to indicate the direction of the light. Also add a cast shadow and some shading where the stalk comes out of its hollow.

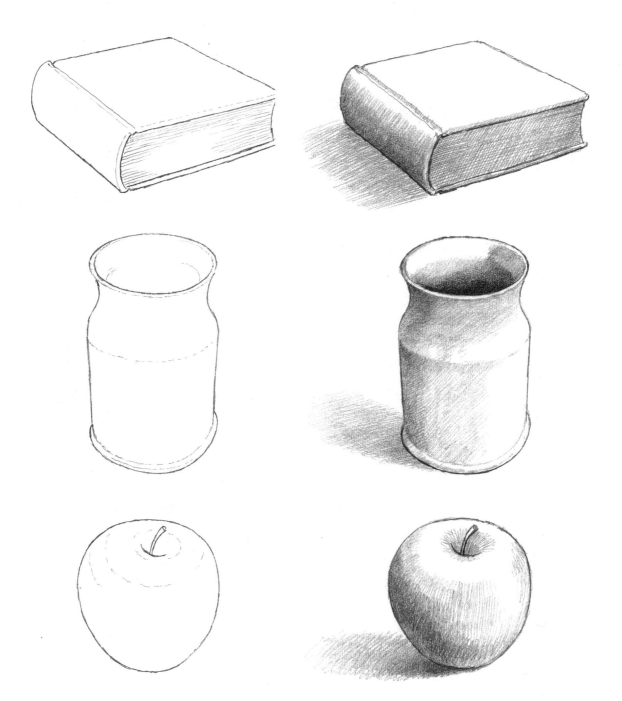

■ TEXTURES AND MATERIALITY

Here we look at developing a feel for different types of materials and transferring their textural qualities on to paper. As in the first exercises on pages 12–13, take care over the appearance of your drawings as a group.

Grass

The first of these drawings of texture shows an impression of an area of grass-like tufts – that is to say, very conventional patterns that resemble grass, not drawings taken directly from life. When you have tried the stylized version, you could go and look at a real lawn and try to draw that from life.

Wood

Now try doing this wooden plank, with its knots and wavy lines of growth. The floorboards in your house might be a good example of this kind of wood pattern.

Beach

Next, a drawing that resembles a pebbled beach, with countless stones of various sizes. Again, after drawing a conventional version like this, you could try working with a real area of pebbles or stones.

Mesh

This carefully drawn mesh looks a bit like a piece of hessian or other loosely woven cloth. Make sure that the lines don't get too heavy or the cloth-like effect will be destroyed.

Fur

This resembles fur, such as on a rug or the back of a cat. The short, wavy lines go in several directions, but follow a sort of pattern.

Rock

This drawing shows the surface of what might be a piece of grained and fissured rock. Again, after trying out this example, have a look at the real thing which will show you how comparatively stylized this pattern is.

Clouds

This smoky texture is produced by using a soft pencil, then a paper stump to smudge the dark areas. After that, a little rubbing of some of the darker parts gives a cloudy look.

Leaves

All that is needed to give the effect of thick, hedge-like leaves is a large number of small leaves drawn adjacent to and overlapping each other. Try to maintain a certain amount of variety in the angles of the leaves to make them more convincing.

Water

This watery texture is achieved by keeping all the marks you make horizontal and joined together to create the effect of ripples. Smudge a little of the drawing to create greyer tones, but leave some untouched areas to look like reflected light.

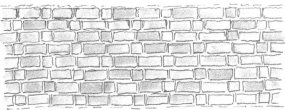

Brick

This brickwork effect is not difficult but is a bit painstaking. The trick is to keep the horizontals as level as possible but draw the edges rather wobbly, which gives the rather worn look of older bricks. Smudge some tone on some of the bricks, varying it rather than making it even.

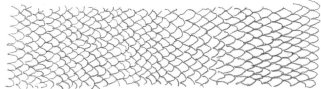

Snakeskin

Drawing snakeskin or fish scales is just a matter of drawing many overlapping scale shapes without being too precise or you will lose the movable look of natural scales. Again, it requires a rather painstaking effort, but apart from that it is easy.

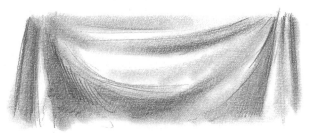

Drapery

This drapery is done by drawing descending curves to emulate cloth, and then using a paper stump to smudge and soften the edges of the tone. The only sharp lines should be at the sides where the cloth appears to be gathered up.

■ PRACTISING TEXTURE

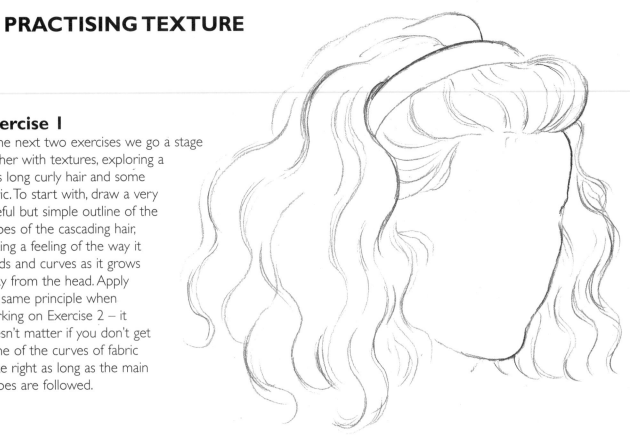

Exercise 1

In the next two exercises we go a stage further with textures, exploring a girl's long curly hair and some fabric. To start with, draw a very careful but simple outline of the shapes of the cascading hair, getting a feeling of the way it winds and curves as it grows away from the head. Apply the same principle when working on Exercise 2 – it doesn't matter if you don't get some of the curves of fabric quite right as long as the main shapes are followed.

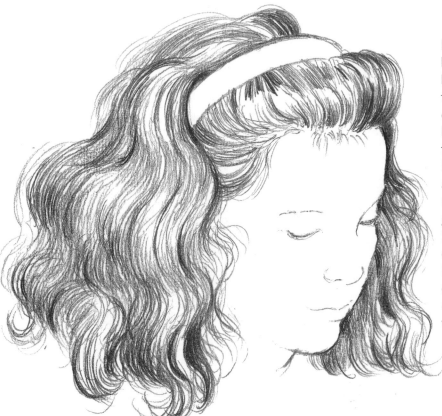

Having got the main shapes of the hair and the fabric you can now build up a texture of lines and tone to produce a convincing impression of the way they look. The hair can be worked in with strokes following the main shapes of the curves of the hair, in some cases drawn heavier and darker and elsewhere drawn much lighter and fainter. This gradually produces the look of hair in waves. Notice how often at the edges of the mass of hair the tone looks darker, and how there is a contrast between the dark under curve and the lighter upper curve where the larger waves curl round.

Exercise 2

With the fabric, first notice the main folds and carefully draw them in as accurately as you can. The texture here is much simpler to draw than hair, just needing either darker or lighter tones to indicate the folds. As this particular piece of fabric is an old sweater, it can be drawn softly and slightly rough in texture to indicate the look of wool.

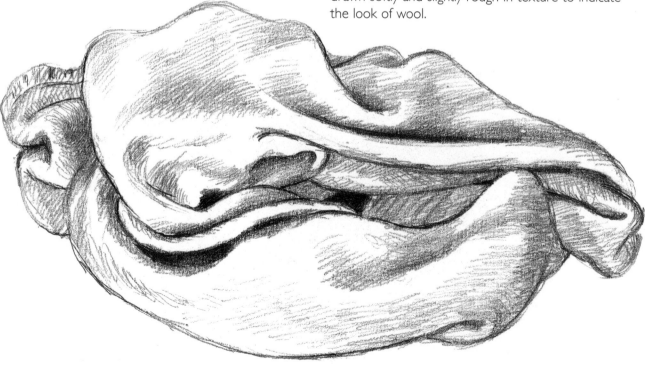

Now for two more kinds of texture and materiality – a basket and a plant. As before, draw in the main shapes of the objects first, being careful to get some idea of how the woven strands in the basket weave in and out of each other, and the delicacy of the outline of the leaves.

Exercise 3

In the case of the basket, the difficulty is to achieve the effect of the interweaving strands without drawing every one exactly. Try to obtain a general impression with the lined-up marks so that weaving looks uniform enough without looking too cleancut. The texture of basketwork is not very precise, and you can exploit this fact to give a

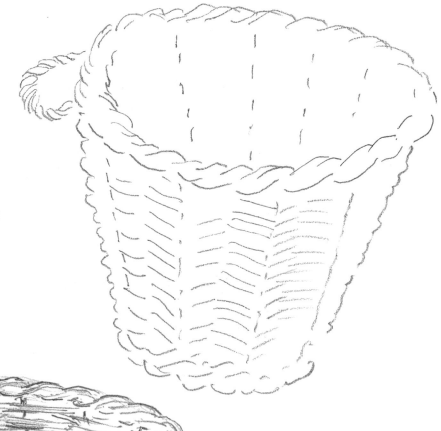

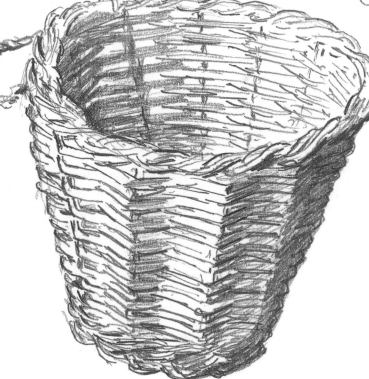

good impression rather than try to draw every strand exactly. Make sure that the shaded parts are strong enough to convince the eye of the depth of the space inside and around the object. Try not to overdraw on the lighter areas so that the contrast between the two parts will work better for you.

Exercise 4

With the plant, again the trick is to not overdraw the darker areas. One or two of the leaves at the back and bottom of the plant will be in deep shade, but most of them will be relatively light in tone. Try not to make your marks too heavy, because this sort of material has a rather delicate nature. Again it doesn't matter too much if some of your leaves are not exactly in the right place, as long as they look fairly

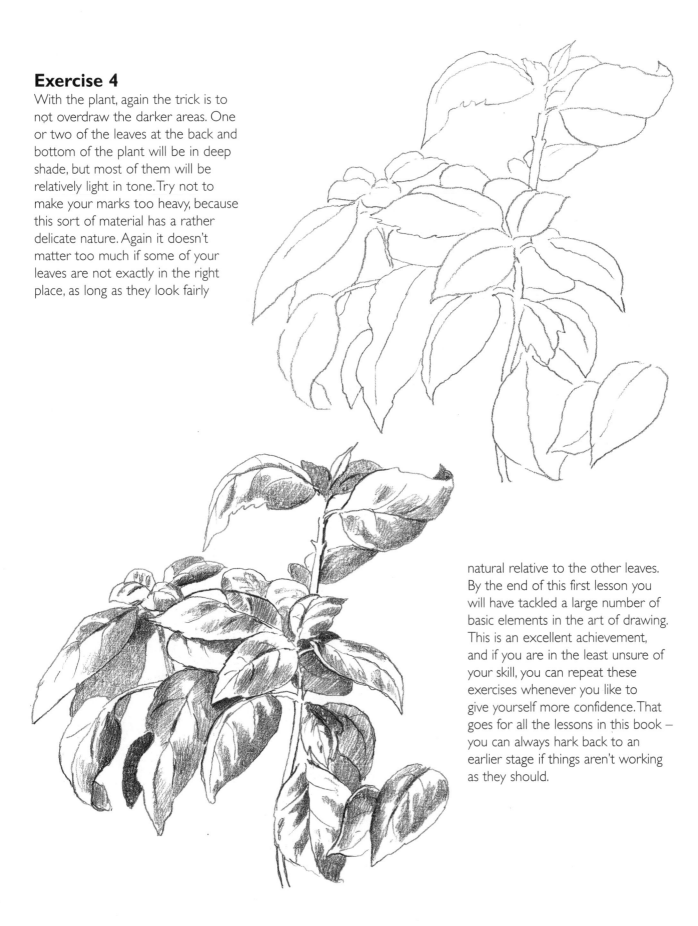

natural relative to the other leaves. By the end of this first lesson you will have tackled a large number of basic elements in the art of drawing. This is an excellent achievement, and if you are in the least unsure of your skill, you can repeat these exercises whenever you like to give yourself more confidence. That goes for all the lessons in this book – you can always hark back to an earlier stage if things aren't working as they should.

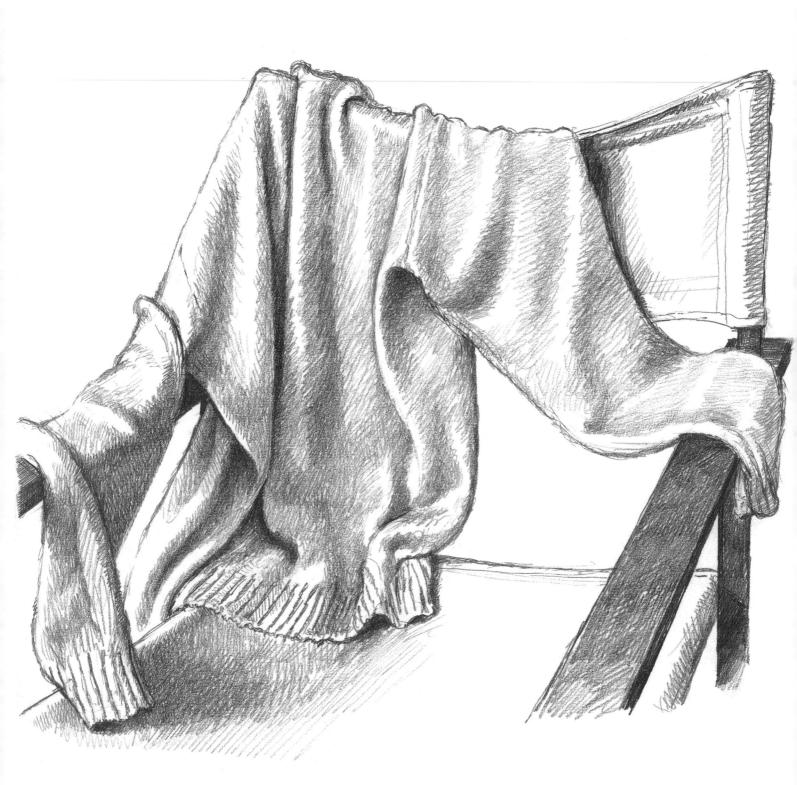

■ LESSON 2

FORM AND TONE

This series of exercises is all about trying to make the shape of the objects you draw look more realistic by establishing their form in more detail. In order to do this you will also have to keep working on your drawing of outline shapes and build further on what you have already begun to learn about tone.

So, starting off with carefully drawn shapes, you need to follow this up with adding tone and shading to the forms to give a feeling of solidity. This needs quite a lot of practice, so there are many variations in the objects I have given you to draw. You will also begin to see how the methods that you use in one drawing can easily be adapted for other things that at first glance seem very different. The more you can practise these methods the better you will become at drawing.

One thing you will come to realize is that there is no such thing as a difficult or easy drawing; they all have the same degree of difficulty, although some may take longer because there is more complexity in the shape. Drawing only becomes easier with increased skill, and then of course you draw more extensively so the challenges also increase. One of the great things about art is that you never come to the point where you know it all – there is always further to go.

■ **DEVELOPING FORM AND TONE**

To start our investigations into developing form, we look at two objects, a thermos flask and a tumbler, made of metal and glass respectively. Whereas the flask needs a building up of tone to show its rounded form and the darker parts of the metal, the glass tumbler needs only minimal shading, because it is transparent.

First just draw the outline shapes of the objects and in the vacuum flask mark where the edges of the brightest and darkest areas of tone are to be. In the glass tumbler just put in the edge shapes of the moulded glass and the surface of the water.

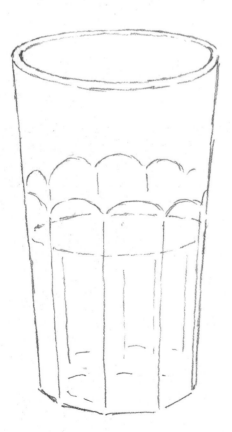

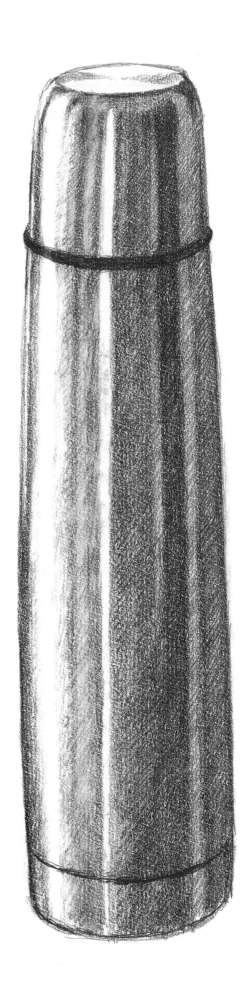

Having done this, put in all the darkest tones on the flask as smoothly as you can. Gradually fill up all the other areas where the tones are less intense, making sure that you leave the brightest bits totally white, clean paper. When you have covered all the areas of tone, study the whole drawing to see if you need to strengthen any of the darkest parts.

With the glass tumbler the trick is not to do too much shading. Put in the very darkest parts first, noticing that there are not very many of them. Then add the medium and lightest tones, underdoing the tone rather than overdoing it. When you think you've finished give it a careful look to see if any tones really need to be strengthened, and then stop before you overwork it.

At first you might not be very successful in your efforts but as you continue to practise you will soon develop the necessary skill to make your work look more convincing.

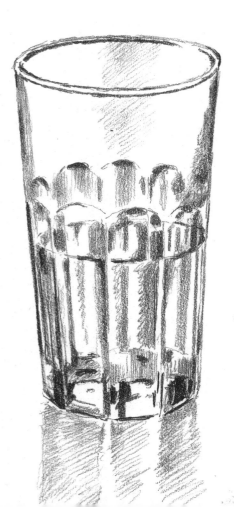

■ A STILL LIFE WITH LINE AND TONE

To set up a simple still-life arrangement, take some ordinary everyday objects that are not too complex in shape. My particular choice has been a tray with a teapot, a jug, a sugar bowl and a cup and saucer and spoon. This has the benefit of being both immediately to hand and familiar. I have put these items on a small tray to limit the area to be drawn. This means that they all overlap each other from my viewpoint, which forces a composition on the picture that I don't have to choose.

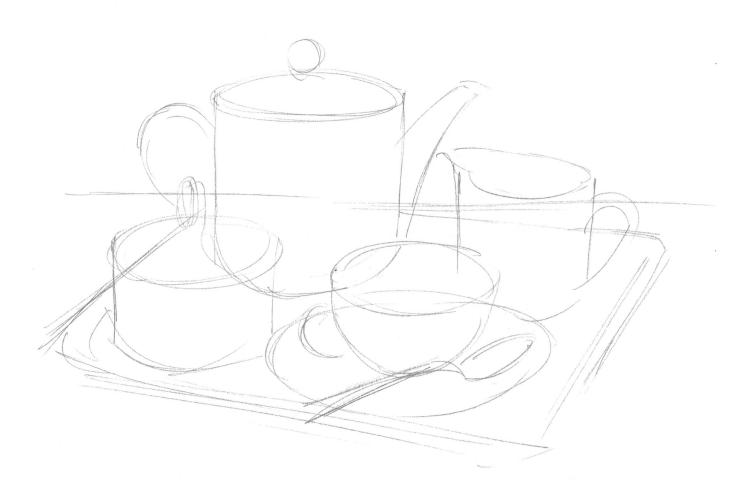

Step 1

So now I have my still life in front of me, and I need to assess the whole picture in a simple way that helps me to start the drawing. With very light strokes I indicate the main shapes of the group of objects very loosely, altering and erasing any marks that don't look like the group of shapes I can see. At this stage the main point of the exercise is to get a very simple idea of all the shapes together and their relative sizes and forms.

Step 2

Having arrived at a satisfactory set of forms, I now need to define them more accurately. This means carefully drawing an outline of each object, showing how they overlap each other and how each shape is formed, this time very decisively. I am then left with a complete outline picture of the whole still life. Any obvious mistakes can be carefully redrawn – it is easier to correct the mistake first and then erase the bits that are not correct.

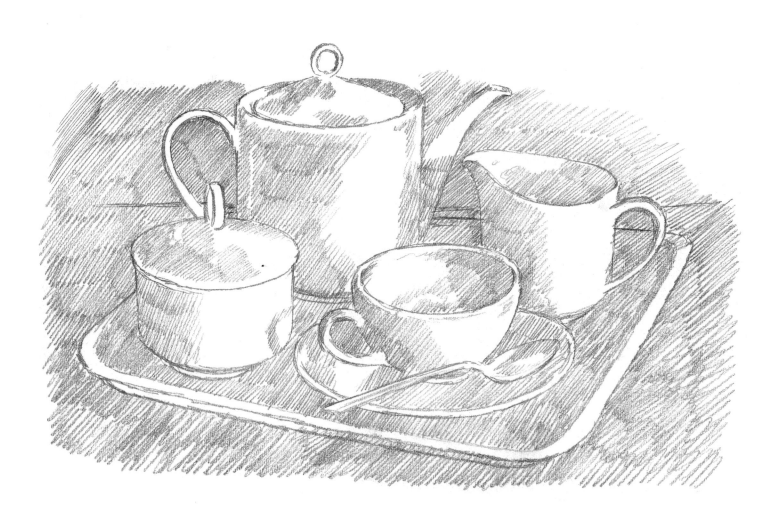

Step 3

Now the essence of the picture is complete, I can turn to the tonal values that will help me show the three-dimensional qualities of the forms. At this stage I put only one depth of tone all over, except for areas of white paper to act as highlights. When this is finished the whole picture has taken on a more solid look.

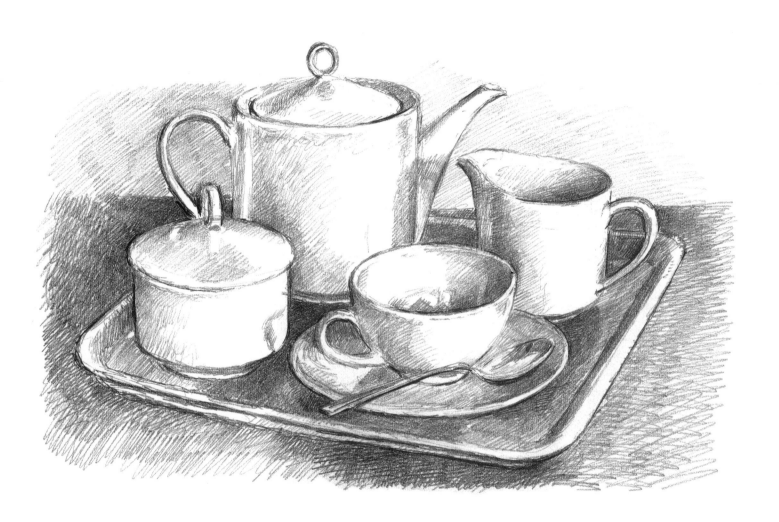

Step 4

The final stage of the drawing is an exercise in seeing which areas are much darker than all the others and which less dark. I find the best way to deal with this is to do the very darkest areas first and then gradually add any tone required to the less dark places. As you can see, quite large areas have a fairly dark tone, especially the table-top and the surface of the tray. When I am satisfied that the tones in the drawing match the tones that I can see on the objects, I know that my shading exercise has finished. If any areas are a little too dark I can gently drag an eraser across the tone to lighten it.

This exercise may take you some time to complete, and if you find that it is becoming a chore you should stop and continue some time later – it doesn't matter if it takes longer than one session.

DRAWING YOUR OWN HAND

This exercise starts with the simple task of drawing around the outline of your own hand. Just place your hand flat on the paper and then carefully draw all around the shape, making sure that the pencil point does not get too far away from, or too much under, the edge of your hand.

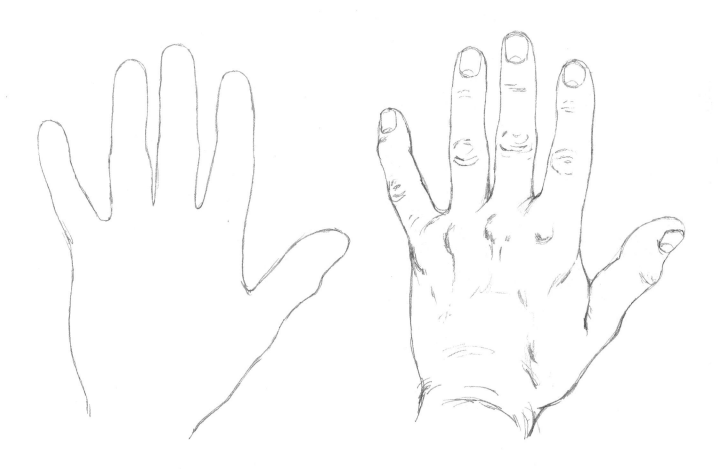

Lift your hand carefully off the paper, keeping it flat and in the same position as before, then draw in all the wrinkles, bumps and hollows that you can see in the simplest way possible, and of course the fingernails too. You will have a fairly good representation of your own hand, matching it for size and shape. Now have a go at drawing it in the same position but without tracing around the edge of it. Does the second drawing look as good as the first one?

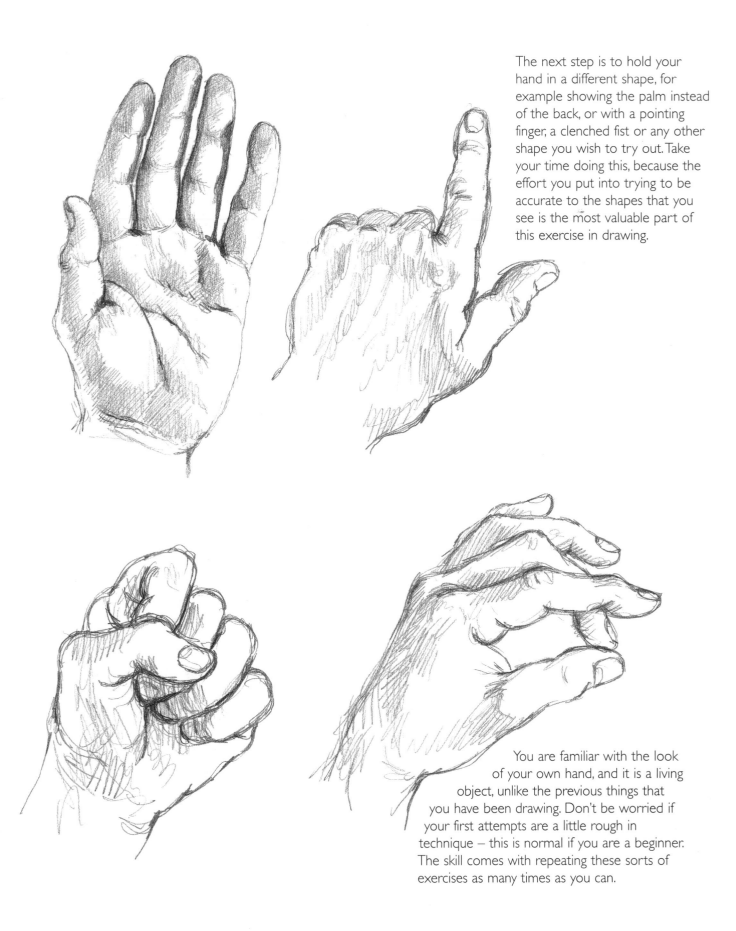

The next step is to hold your hand in a different shape, for example showing the palm instead of the back, or with a pointing finger, a clenched fist or any other shape you wish to try out. Take your time doing this, because the effort you put into trying to be accurate to the shapes that you see is the most valuable part of this exercise in drawing.

You are familiar with the look of your own hand, and it is a living object, unlike the previous things that you have been drawing. Don't be worried if your first attempts are a little rough in technique – this is normal if you are a beginner. The skill comes with repeating these sorts of exercises as many times as you can.

■ DRAWING A HEAD AND FACE

This exercise is one for which you will need a model. If someone you know will sit for you for an hour you can draw their face, but if this is difficult, simply position yourself in front of a good-sized mirror and draw your own.

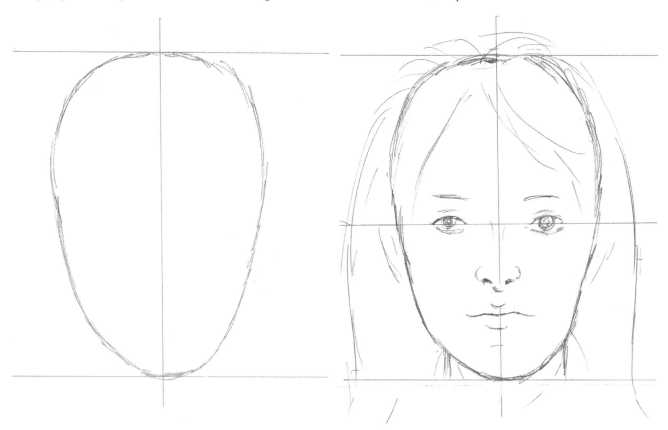

Step 1

To start with you need to draw a straight-on, full-face view, so that you can understand the proportions of the human head. Make a mark at the top of the page to indicate where the top of the head is going to be, and another where the point of the chin will go. Don't make the distance between these two points bigger than the size of the head, although it doesn't matter if it is a bit smaller. Now draw a line straight down to join the top mark to the bottom. This indicates the centre of the head vertically. All the shapes you are going to draw should be evenly balanced either side of this line.

Looking carefully at the shape of the head in front of you, whether your own or your model's, have a go at drawing the oval shape of the whole head – and I mean the whole head, not just the face. You'd be surprised how many beginners draw the head as though there is nothing much above the hairline.

Step 2

Draw a horizontal line halfway down the head to show the level of the eyes. Mark in the position and shape of the eyes on this line. The distance between them is the same as the length of the eye from corner to corner.

Then mark in the end of the nose, about halfway between the eyes and the point of the chin. Draw just the nostrils and the bottom edge of the nose. Next draw the line of the mouth, which is slightly nearer the nose than the chin – it is usually positioned at one-fifth of the whole head length from the bottom of the chin. Draw the shape between the lips, then, more lightly, put in the shape of the upper lip below the nose and the fold under the lower one, not the edge of the lip colour.

Mark in the hair, the position of the ears, if they can be seen, and the eyebrows. The tops of the ears and the eyebrows are at about the same level. So now you have the basic head with its features put in.

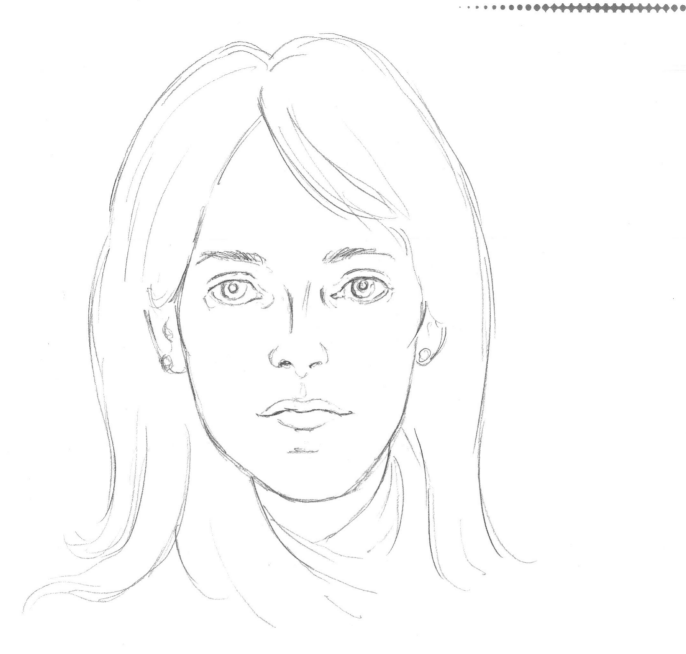

Step 3

The next stage is to draw all the features and the hair, correcting any mistakes as you go. Look at the thickness of the eyebrows and note that the shape of the inner corner of the eye is different to that of the outer. If the eyes are looking straight at you, the iris is slightly hidden by the upper eyelid and usually touches the lower one. You can't see a great deal of the ears from this angle, but try to get the shape as accurately as you can.

The most important areas of the nose are the under part and the shape of the nostrils. There are usually marks that you can draw lightly to indicate the area where the nose is closest to the eyes and there may be a strong shadow showing the bonier part of the nose – but mark it in only lightly, or it will look like a beak.

The mouth is a bit easier, but remember that the strongest marks should be reserved for the line where the lips meet; if you make the edges of the lip colour too strong it will have the effect of flattening the lips. There is usually a strong fold under the lower lip which can be more defining of the mouth than the edge of the colour.

The outline of the jaw and cheekbones is important to show the characteristics of the face in front of you. If you make the jaw too large or small it will look clumsy or weak respectively, so take your time to get this right.

The hair is also important, especially where it defines the shape of the skull underneath. If it's too big your model will look like an alien, while if it's too small the head will appear to lack enough space for brains.

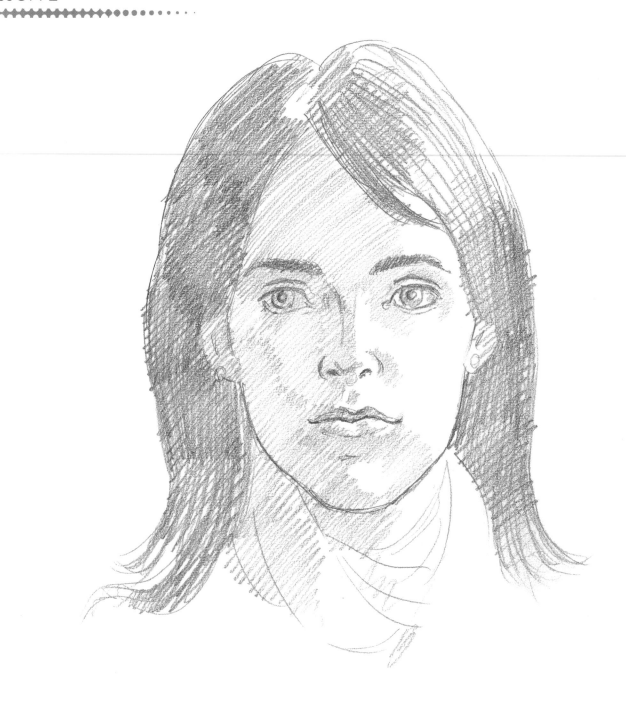

Step 4

Now you can start to mark in the shading on the face and hair, putting it all in at the same strength. There will usually be light coming from one side, and in my example the left side of the face is in some shadow and the right side is in more light. This stage is where the

projecting features such as the nose, eyebrows and mouth start to show their form.

Shade the hair in the same way, but take the marks in the direction that the hair grows. If the hair is dark, put another layer of tone everywhere except where the light shines strongly on it.

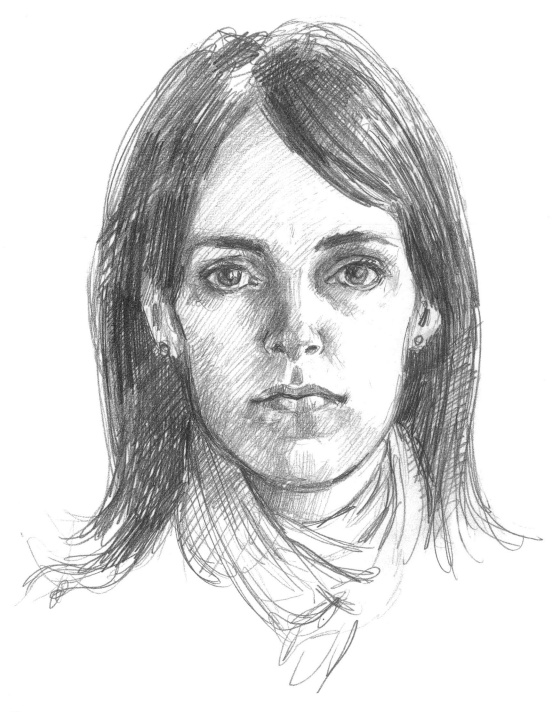

Step 5

In the last stage, draw in the very darkest tones and the variety of tones over the whole head. You may have to darken the hair quite a bit, but remember that only the deepest shadows should be black.

Mark in the edges of the eyelids carefully. The edge of the upper lid is much darker than the lower, partly because it is facing downwards and partly because the eyelashes cast a shadow. The pupil of the eye is dark, but usually you can see a bright speck which reflects the light in the room, which gives the eye its sparkle. Note the shadow around the eye near to the nose.

The shading around the nose and the mouth should be done very carefully – if you make it too dark the result will look a bit cartoonish. Try to let the tones melt into each other so that there are no sudden changes. The shading on the sides of the jawline are often darker than on the point of the jaw because the light is reflected back up under the chin. Keep stopping to look at the whole picture to see if you are getting the balance of tone right. Don't be afraid of erasing over and over again to get the right effect – the result may end up a bit messy, but you will have learnt a valuable lesson about form in a drawing.

■ A STILL LIFE OF FRUIT

First collect a few pieces of fruit that appeal to you and arrange them on a surface so that some of them are behind others. I've chosen a bunch of grapes, which I've placed further back than the rest of the fruit, and three tomatoes, an apple and a nectarine.

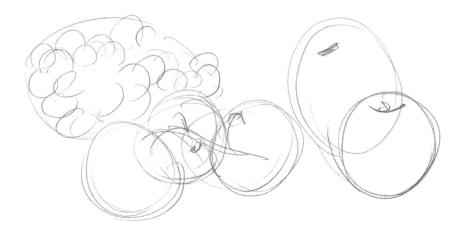

Start off by making a very loose sketch to get some idea as to how the arrangement looks. This drawing is not precise and is really to give you a basis on which to start drawing more definitely.

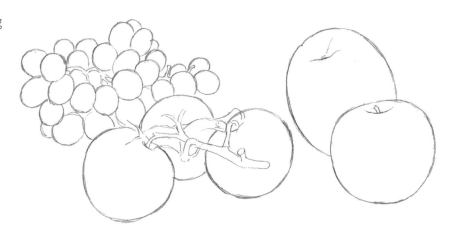

In the next stage, draw the shapes of each piece of fruit quite concisely, making sure that each is as accurate as possible. This is the time to do any correcting and erasing, with the hope that it won't then be necessary in any later stages.

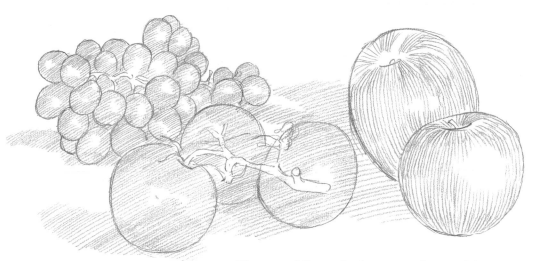

Then carefully put in the areas of tone, all in a uniformly light tone. With the larger pieces of fruit, draw the tonal area with your pencil strokes following the form of the fruit.

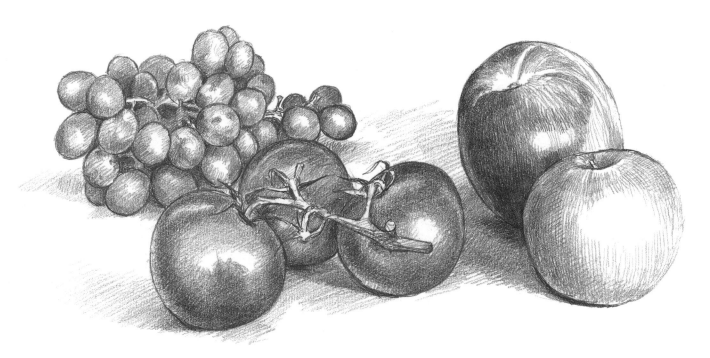

Now all that is needed is to work over all the tonal areas until the darkest to lightest values make sense. One way to see how correct your tonal values are is to half-close your eyes when you look at the still life, which will help you to see tone rather than colour. If you have taken the tone over the highlighted areas by mistake, you can bring those back by using an eraser to re-establish them.

A STILL LIFE OF PLANTS

A plant still life can be either formal or informal – for example, a vase of flowers usually gives a more formal effect than plants in a flowerbed or window box. The one shown here is a large box of various herbs.

Start as usual with a very loose sketch of the main shapes of the plants, getting some idea of the way that they grow and fall.

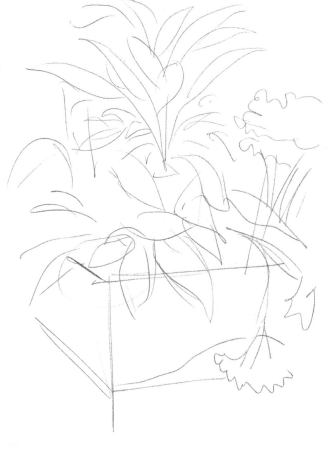

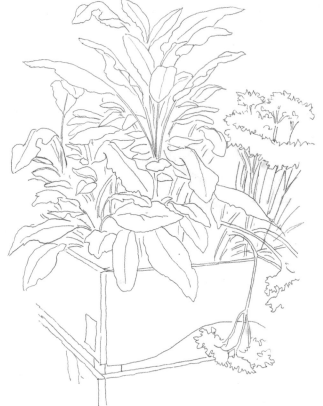

Next comes a line drawing to put in all the leaves and stalks so that the plants are differentiated. At this stage you should make any necessary corrections – although the shapes may be changing all the time if you are working outside in the slightest breeze.

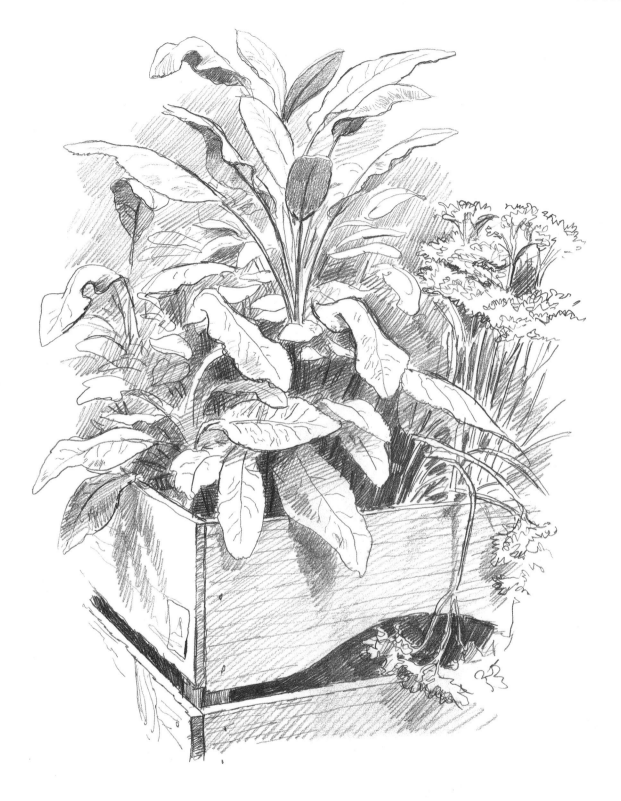

Putting in shading will give some depth to the plants.
The darkest shadows go in first, then gradually build up
the different tonal areas until the result looks fairly
realistic. There is no need to draw the smaller leaves
exactly – just put them in with an expressive scribble.
The contrast between the box and the leaves helps to
make the leaves look softer and more fragile.

SHOWING MATERIALITY

As you get more proficient, you will find that the marks you make when you draw any object give an effect of the material that it is made of. On these pages there are two examples to help you realize this. The first is an exercise often given to art students to test their ability to observe shape and texture, and that is to take a piece of paper, crumple it up, and then put it down and draw it as accurately as you can. The second exercise is to draw a piece of woollen, cotton or silk clothing, showing its texture clearly. When you have finished you will have reached the end of the second lesson, and you will have managed to draw many very different objects and discovered how they can be done.

Exercise 1

Start by drawing the crumpled paper in outline so that you have got the whole shape down. Keep the line light and as smooth as you can. When you think your drawing is close enough to the shape in front of you, make any corrections you need to.

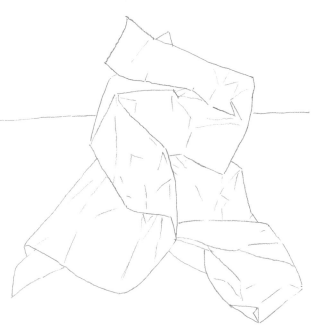

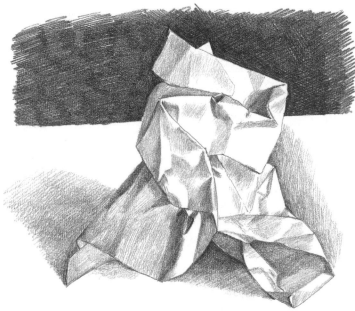

Now carefully put in as much of the tonal areas as you can – it is a bit difficult with white paper, because some of the tones are so similar. When all the tones on the paper are done, put in the background tones. As you can see on my example, the wall behind is quite dark, but the paper is resting on a white surface. The dark wall helps to throw the mass of paper forward in space a little, and gives contrast to the rest of the tonal areas.

Exercise 2

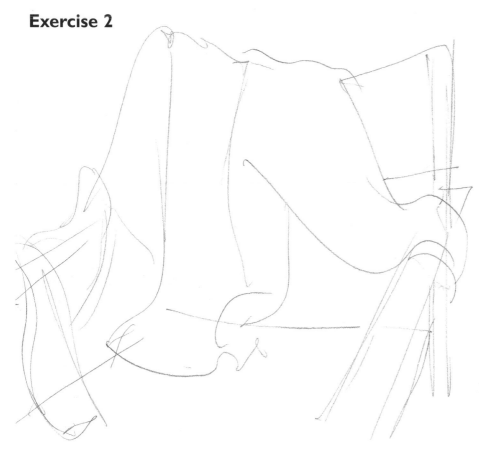

Step 1

For the piece of clothing, try this knitted cotton sweater draped across the back of a wood and canvas chair. First draw a rough sketch to make sure you have got the mass and bulk of the subject right.

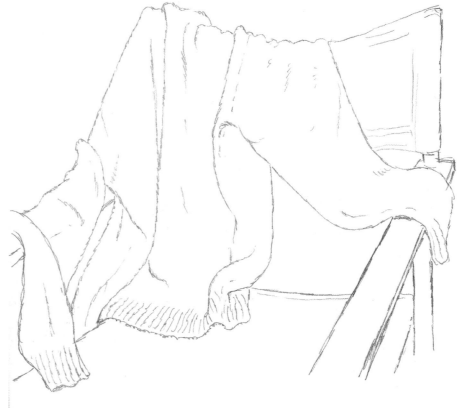

Step 2

Now make a careful outline drawing, allowing the lines to suggest the soft edges of the material as well as the shape of it. Make sure that the hard, smooth lines of the chair contrast with the texture of the sweater's outline.

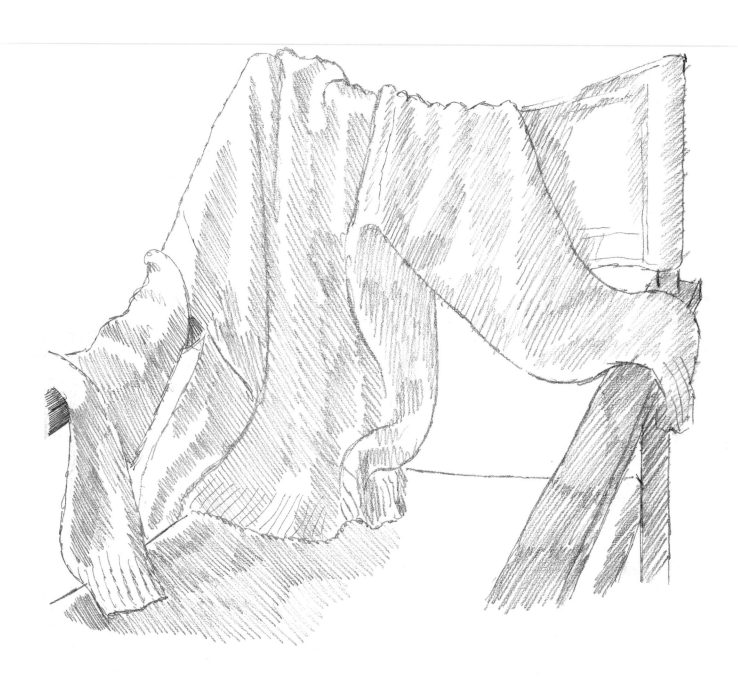

Step 3

Next make a careful all-over rendering of the main tone, not differentiating between dark and light tones at this stage.

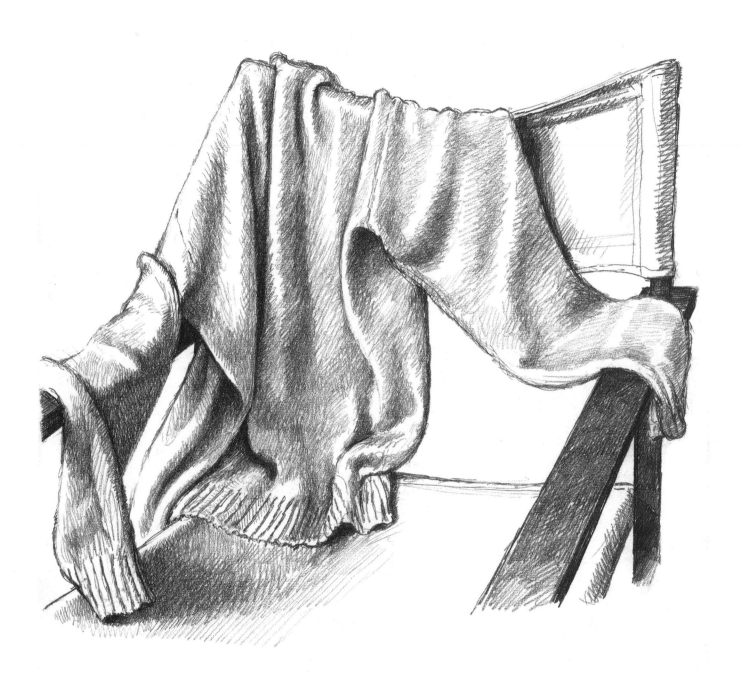

Step 4

Lastly, build up the tonal values to give an effect of the texture and soft drape of the garment, taking care to make the chair look harder and sharper-edged than the cloth.

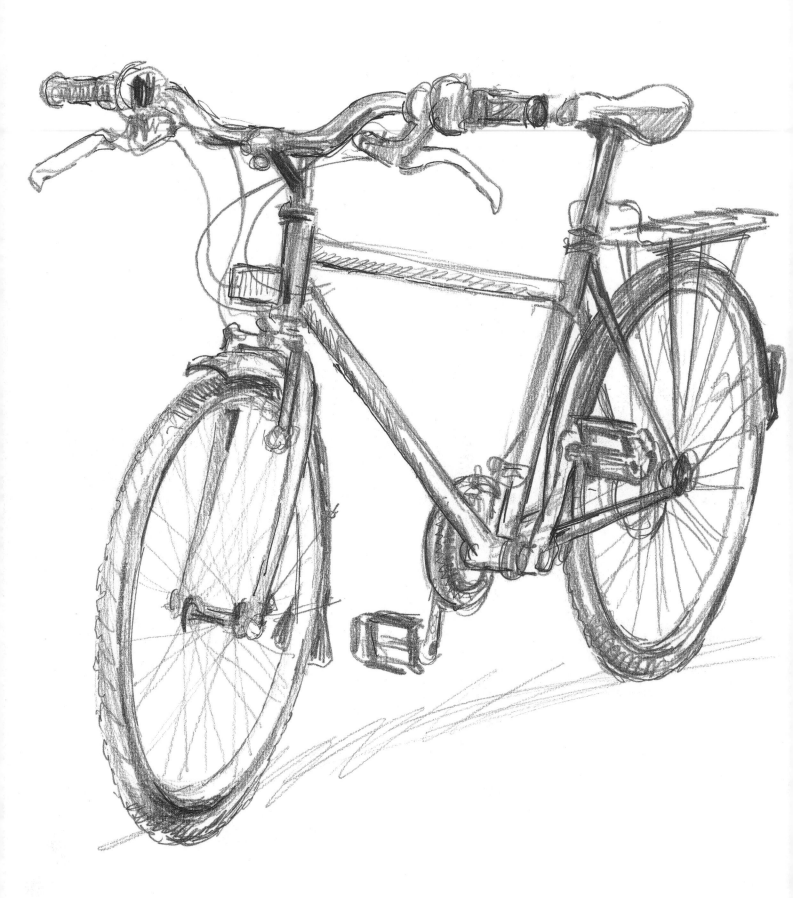

■ LESSON 3

CHOOSING YOUR SUBJECTS

In this lesson you will be looking at subjects and developing your drawings with more attention to detail. The natural world, the human form and manmade objects offer an endless source of material, and most of us don't need to look far to find a subject to draw within these areas.

Starting with the world of plants, you will practise drawing the subtle and fragile shapes of leaves and flowers with much careful observation. That is indeed the most important thing here, because without it you will only be drawing the conventional images of the world that are fixed in your mind. There is nothing wrong with drawing from your imagination in itself, but it will not add much to your drawing skills. These have to be informed by all the new things that you start to see when you are studying forms in some depth.

Next you will draw the human figure, at first economically and then in some detail. You will also try methods of looking at manmade objects in different ways to allow your drawing skills to develop more extensively. As an artist, you will learn to see the world in ways that people lacking strong visual interests don't tend to develop.

All these exercises are similar to those traditionally undertaken by art students, and if you follow them through there's no doubt your drawing will improve. But remember, the more you practise the better you will get; most professional artists don't let a day go by without some form of practice.

■ DRAWING LEAVES AND FLOWERS

This exercise is designed to set you on the right path to drawing plants and flowers close up. Start with the simplest forms that you feel comfortable with, but don't hesitate to draw something more complex if the subject holds greater interest for you, since that is more important than anything else.

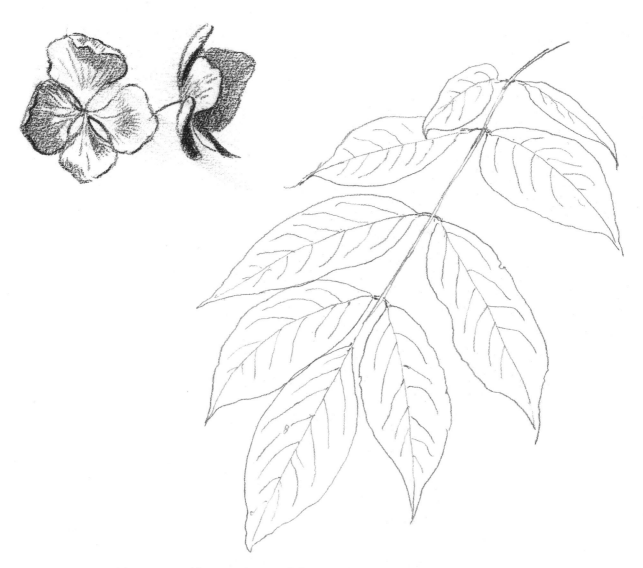

I have started here with a small four-petalled blossom using a soft conté pencil, which leaves a rather chalky line. I've drawn in the parts in shadow, but kept it all fairly simple.

The next subject I drew was this stalk with leaves. I didn't try to show texture, satisfying myself with the shapes of the leaves and their arrangement on the stalk, with the main veins drawn in as well. Try this, looking only at the outline shape of your plant, but drawing every detail of the edges.

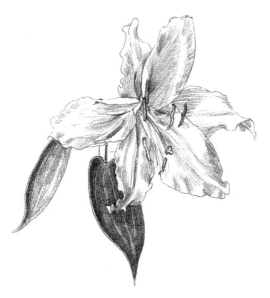

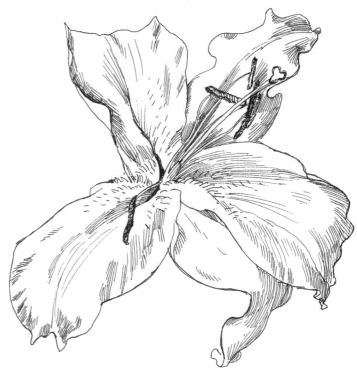

My next drawings are more complex. At first I just drew the strong, well-defined shapes of some unopened lilies, using a conté pencil to get a soft edge without any details of texture.

Next I moved on to an opened blossom, with all its complexity of texture and construction. This required much more attention to the details of tone and textural values, so that the form can be seen clearly. In your own drawing, take this quite slowly because it does require good observation of every detail.

Now have a go at a simple drawing of a more complex leaf and a drawing in ink of another lily blossom. This will help to increase your technical strengths by giving you more practice with slightly different mediums.

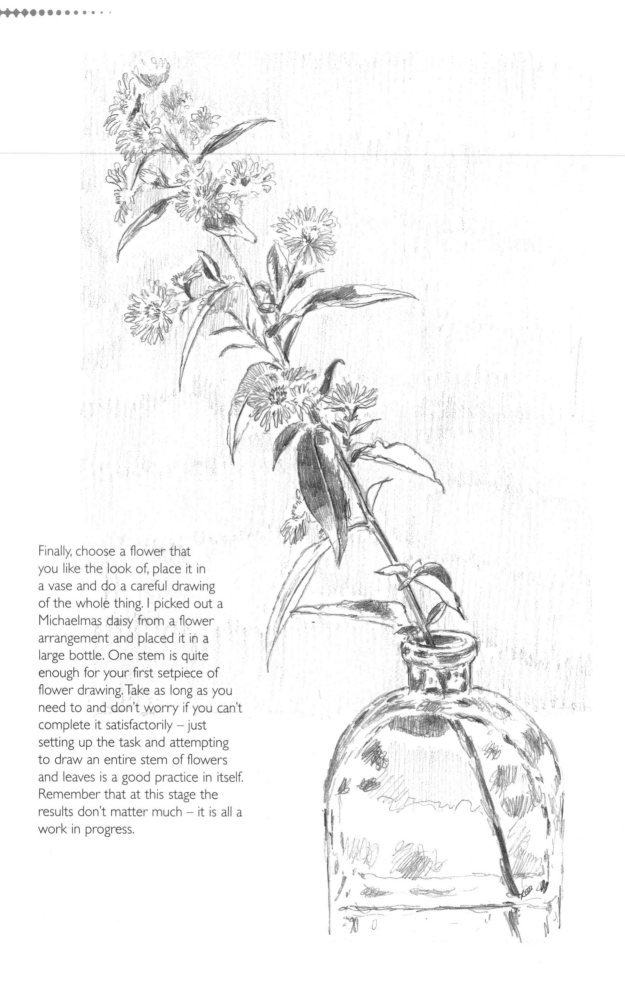

Finally, choose a flower that you like the look of, place it in a vase and do a careful drawing of the whole thing. I picked out a Michaelmas daisy from a flower arrangement and placed it in a large bottle. One stem is quite enough for your first setpiece of flower drawing. Take as long as you need to and don't worry if you can't complete it satisfactorily – just setting up the task and attempting to draw an entire stem of flowers and leaves is a good practice in itself. Remember that at this stage the results don't matter much – it is all a work in progress.

DRAWING TREES

Continuing from the previous exercise, we stay with the natural world but tackle a larger subject in the form of trees. This will require you to go outdoors to draw unless you have good views of whole trees from your window. Don't try to bite off more than you can chew at this stage – just choose trees that you can see easily in one glance.

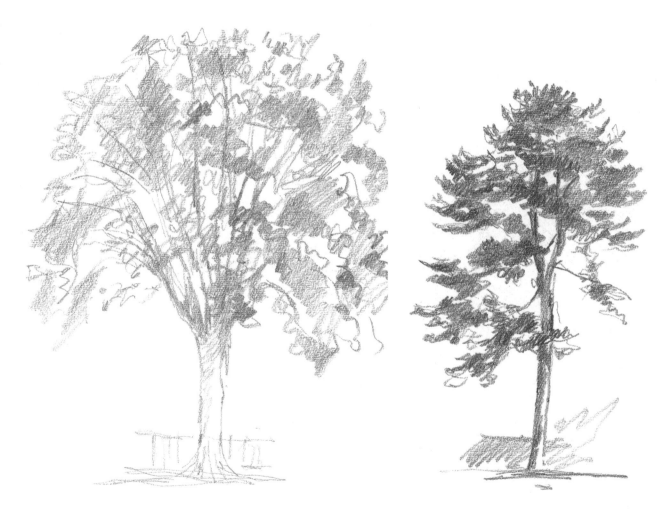

I started with a fairly loose rendition of a tree, drawing the trunk and branches first and then marking in the main bulk of the vegetation with broad, scribbly strokes, using a very soft pencil (6B). Notice that there is no detail at all in this drawing – I was content to show just the main shape.

My next drawing is a bit sharper in tone, mainly because it is a pine tree seen against the sunlight, which almost reduces the tree to a silhouette. The shape of this tree was very distinct and quite simple, so it did not tax my powers of concentration too much. What did seem to be important was the upcurving shape of the branches and the rather sharp edge of the shapes.

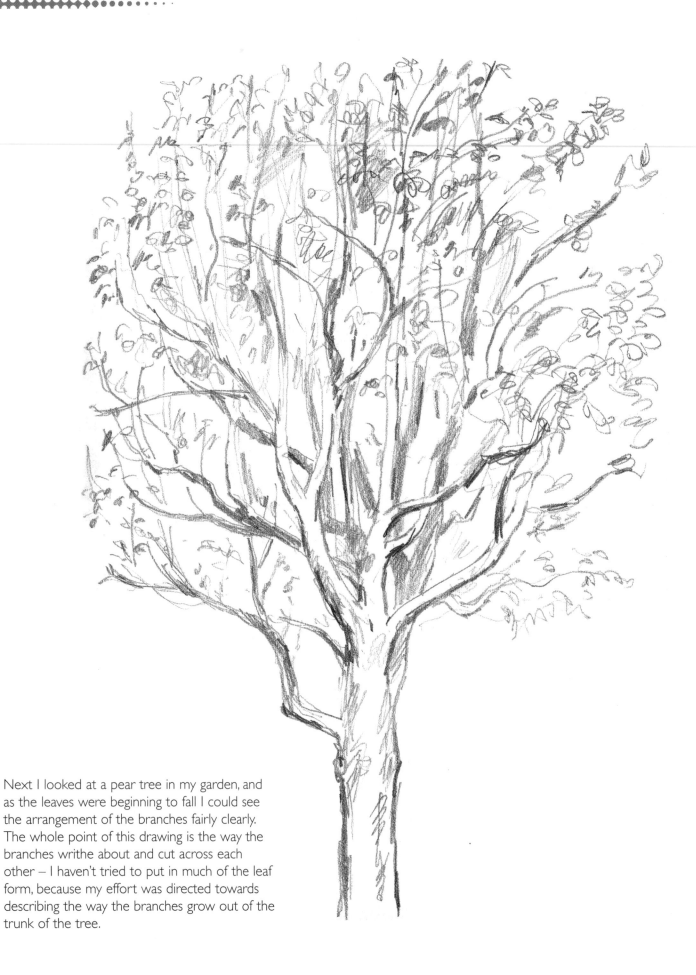

Next I looked at a pear tree in my garden, and as the leaves were beginning to fall I could see the arrangement of the branches fairly clearly. The whole point of this drawing is the way the branches writhe about and cut across each other – I haven't tried to put in much of the leaf form, because my effort was directed towards describing the way the branches grow out of the trunk of the tree.

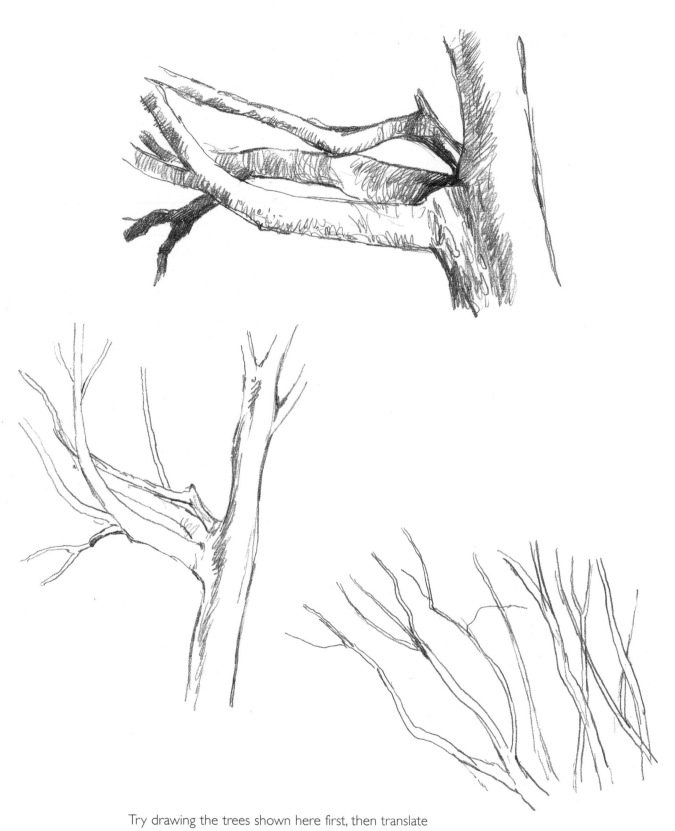

Try drawing the trees shown here first, then translate what you have learnt to real life and also have a go at close-ups of branches from different trees, describing how they look growing out of the trunk and standing out against the sky.

■ DRAWING A HUMAN FIGURE

Figure drawing is not so easy as drawing plants, not least because it requires the co-operation of your friends or relatives. Most people don't like to sit still for too long, so you may have to stop drawing sooner than you would wish because your model has got tired of posing. The idea here is to draw a whole figure including the face and clothes, so make sure your model is comfortable before you start and allow them some breaks to move around and stretch cramped muscles.

Step 1

First make a simple sketch of the position of the figure on the chair. I was sitting quite close to my subject, so the legs disappear at the lower edge of the picture. Notice how in this initial drawing the main shape of the movement through the body and the arrangement of the arms and head are already shown, albeit briefly.

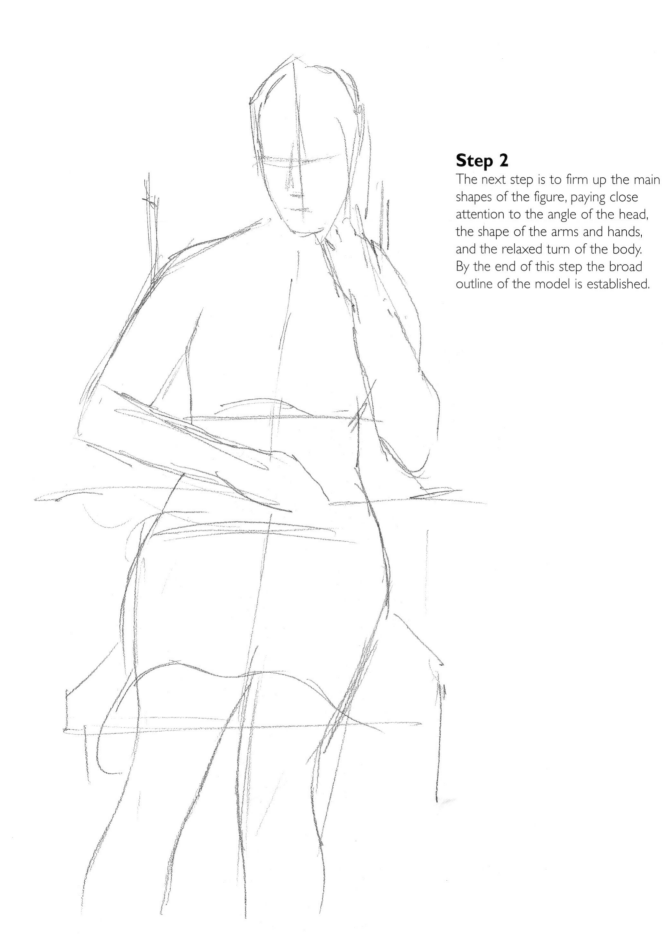

Step 2

The next step is to firm up the main shapes of the figure, paying close attention to the angle of the head, the shape of the arms and hands, and the relaxed turn of the body. By the end of this step the broad outline of the model is established.

Step 3

Now it's time to look at the details of each part of the figure, making careful note of the shape of the head and the hair, and the way the features are arranged. Next, the way that the clothes drape around the body needs to be seen clearly, but don't put in every detail of the clothing at this stage – just the main folds that define the form underneath. Put in the hands and the parts of the chair that can be seen; in this case I could see the model's legs so I defined the main shape of these as well.

Step 4

Firm up the shapes of the body and head, so that your model starts to become recognizable. Remember that this is always a work in progress, and you don't have to end up with a highly finished piece of work. Alter or erase anything that you think is not looking like the shapes you can see, and don't worry if the drawing becomes very messy; this just means that you are beginning to observe more sharply, and the effort to correct your drawing is never wasted.

Notice that on my finished drawing the marks are very exploratory – the edge of the body is drawn with a variety of lines, not sharply defined. This allows for the fact that you can see around the edges of a three-dimensional form and so there is never really one sharp line. I have not put in much texture or shading, just enough to show the form in a simple fashion. It is still a drawing in progress, and if I could get my model to sit again in exactly the same position with the same clothes on, I could continue drawing for another period of time.

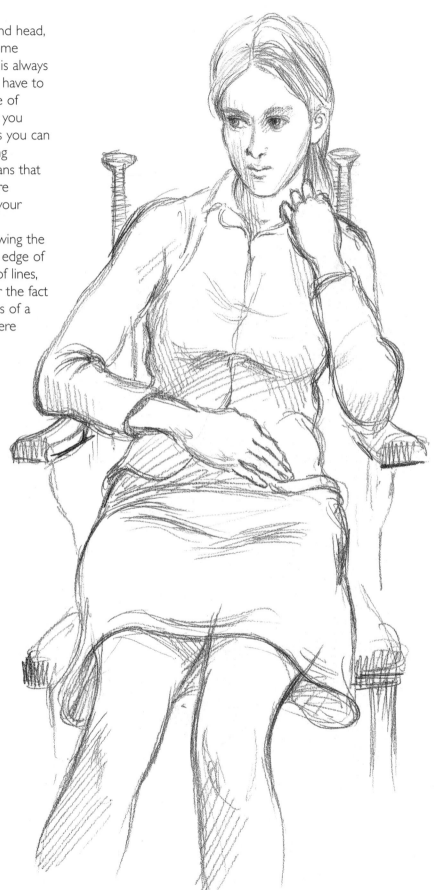

■ DRAWING FACIAL FEATURES

Having had a go at drawing the human figure, your next exercise is to look at it in some detail to familiarize yourself with its constituent parts. At this stage we will draw the face, normally our first point of recognition when we see people, taking it in stages.

Eyes

The most significant part of the face that we recognize are the eyes, so we will start there. You can begin by drawing only one eye, but it's probably a good idea to draw both together so that the relationship of the two eyes to each other is observed.

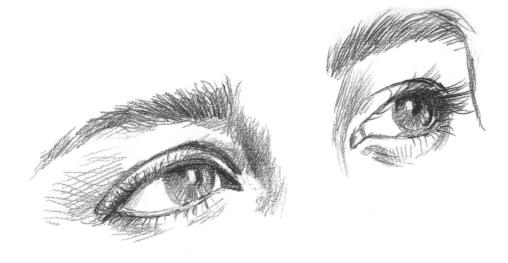

My first drawing is of the eyes of a young woman who is looking to one side. Notice how the inner shape of the corner of the eye is different to that of the outer corner and how the eyes are set slightly around the curve of the head. Draw the eyebrows as well so that the space between the eyes can be judged more easily. This girl's eyes are looking up towards the light, so they are not open wide – the iris (the coloured part of the eye) is covered slightly by the upper lid and is touching, if not slightly under, the lower lid, something that is often not observed by beginners.

Now try drawing one eye, taking note of every detail of its shape and construction. I have drawn a diagram of the eye as well to emphasize its form. Note that the inner corner has the tear duct hollow, while the outer corner is simpler. The thickness of the eyelid can be seen on both the upper and lower lid, and they curve over the eyeball; the iris and the pupil curve too. The pupil will of course enlarge or diminish according to how much light is shining on the eye.

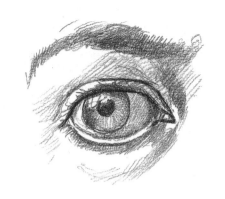
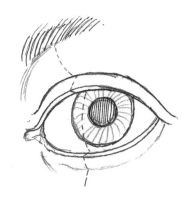

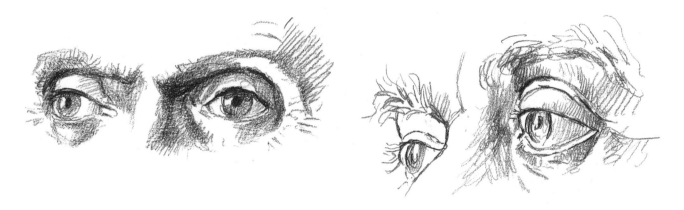

Now go back to drawing a pair of eyes, only this time try someone of a different age. I have shown the eyes of two older men, so the shape and texture of the skin around the eyes are a bit different. Notice the wrinkles and pouches around the eyes, and the difference in the eyebrows. While all eyes are a bit different, the main form is always the same; younger eyes are just a bit simpler in form, without all the marks of time.

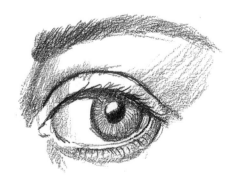

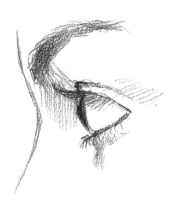

Finally, single eyes again, one of which is seen from the side view where the shape of the eyeball is more easily seen.

Mouths

Mouths are the next most recognizable part of the human face,
except in the case of someone with a really dramatic nose. Draw
mouths both shut and slightly open to understand the formation
of the lips; the lower lip is often thicker than the upper one, but
this is not invariably the case.

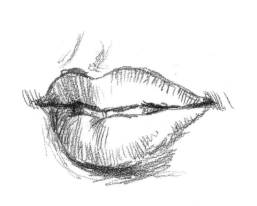

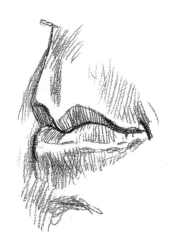

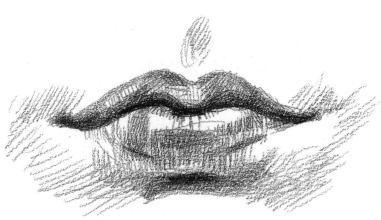

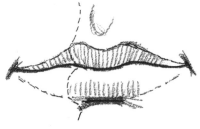

The typical Cupid's bow shape of the upper lip is often more
sharply defined than the lower lip. When you draw the mouth,
don't draw the colour of the lips, just their form, otherwise it
will look as though all your people have strong lipstick on. The
diagram on the left shows how the curves of the lip work as an
overall shape.

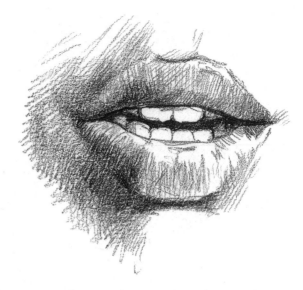

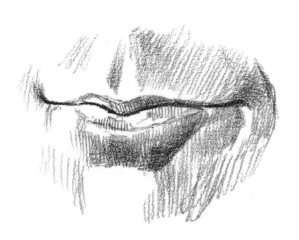

This is more obvious when you draw the mouth open.

The strongest line on the mouth is where the lips part, not their outer edge.

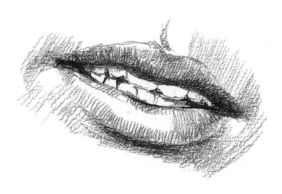

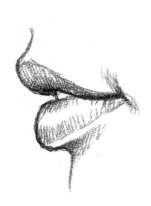

When the mouth is slightly open you will be able to see some teeth. Leave plenty of untouched paper here or they will look very grubby.

Don't forget to draw the mouth from the side as well, and notice whether the lower lip protrudes less or more than the upper lip.

Noses

There is a lot of variation in noses, and they often form a very characterful part of the face. They are not at all hard to draw in profile, but quite tricky full-face.

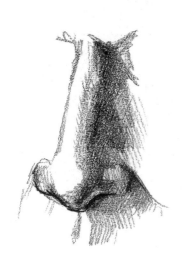
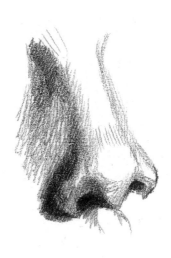
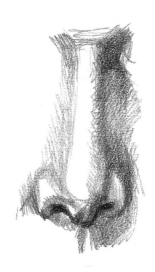

It's easiest to describe the shape from the front when there is a strong light coming from one side to cast a shadow.

If the light is more even, be careful not to overemphasize the tonal values on the nose unless it is a very strong one.

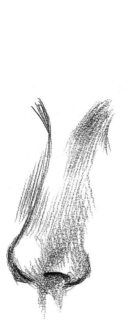
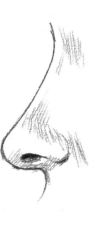
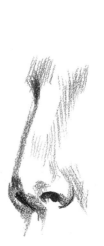
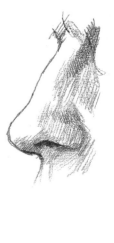

Most noses come in three or four types: the snub or retroussé nose, the straight nose, the strong, curved nose or the broken nose. The straight nose is probably the most difficult to draw because of the lack of bumps or indentations. Most beginners tend to make their subject's nose too long or too short, so observe it carefully in relation to the rest of the face.

Ears

Ears are often neglected in a portrait because long hair is partially hiding them or because we rarely look at them. Indeed, most of us would be hard put to recognize the ears of even our nearest and dearest.

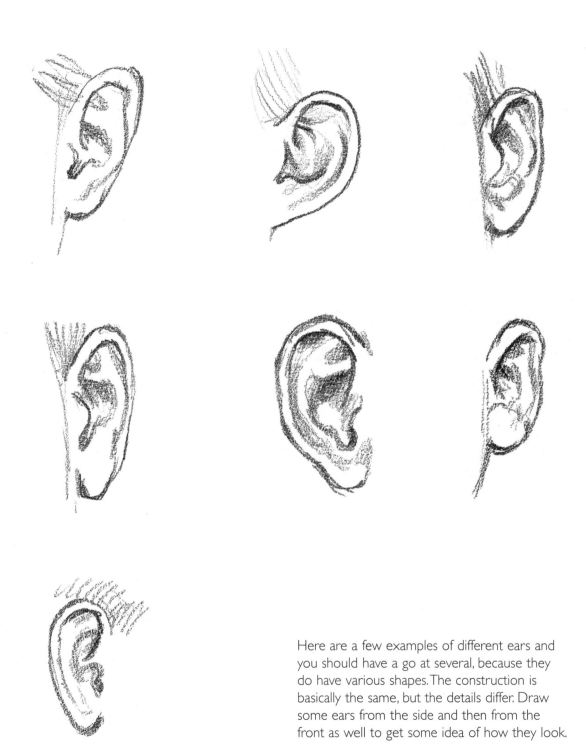

Here are a few examples of different ears and you should have a go at several, because they do have various shapes. The construction is basically the same, but the details differ. Draw some ears from the side and then from the front as well to get some idea of how they look.

Hair

There is a lot of interesting variation in hair, particularly if it is long. The main overall difference is between curly and straight hair, the former being the most difficult to draw correctly. Notice how the hair forms in lumps and hanks – you don't have to draw every strand.

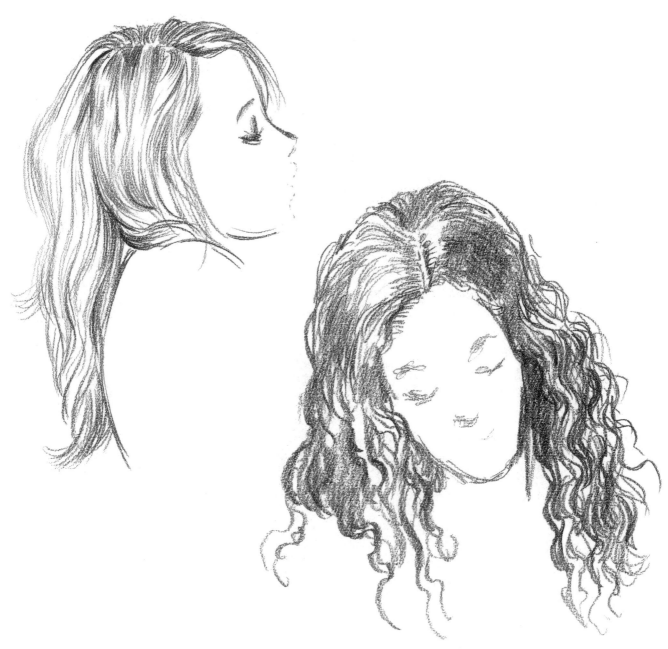

Obviously, hair seen from the front of the head has less volume than when it is seen from the side or back. It's difficult not to respond immediately to the colour of the hair, but it will look more convincing if you try to concentrate on the form as much as you can.

Profile

Now you've seen how varied the human face can appear, finish this exercise by drawing a simple profile view, putting in only the outline of the top of the head, the forehead, the nose, the lips and the chin, with just the main shape of the eyes, eyebrows and hair.

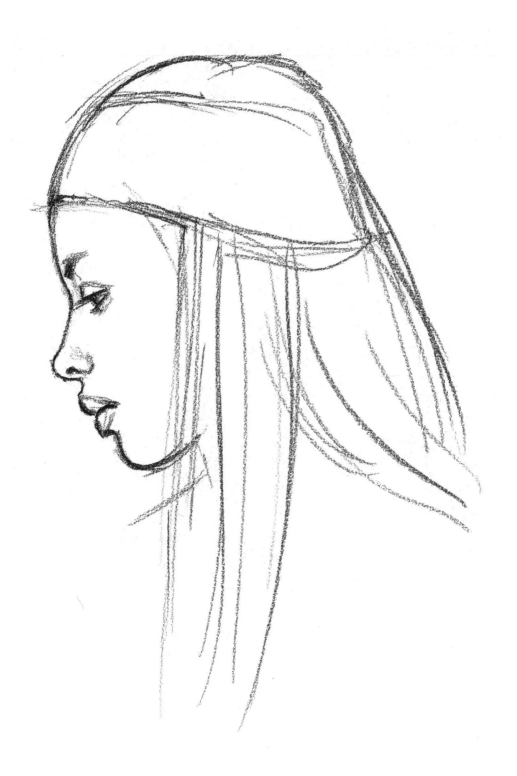

◼ DRAWING LARGER OBJECTS

You have practised drawing small objects such as cups and cutlery to give you the idea of showing man-made forms – now it's time to tackle larger objects that are often functional and complex. Of course the largest objects made by man are architectural or major works of engineering, but for this stage we will look at items such as vehicles and furniture.

Exercise 1

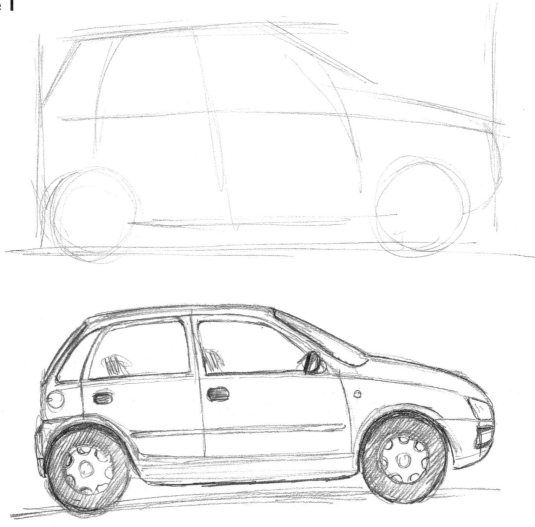

Start with a car – either your own or one that is close enough for you to draw it easily. First do a fairly simple drawing of the car from the side, the most recognizable view of a car shape.

Lightly block out a roughly rectangular shape that encompasses the length and height of the vehicle and mark in the position of the wheels, the line of the windows, and the slope of the bonnet and back. Then carefully draw in all the main parts of the machine, including the door handles, wing mirrors, wheel hubs, lights and even an indication of the headrests of the seats inside where they are visible through the windows. The main focus here is not artistic beauty but literal precision in the placing of all the parts of the vehicle and their proportions, more like a technical drawing.

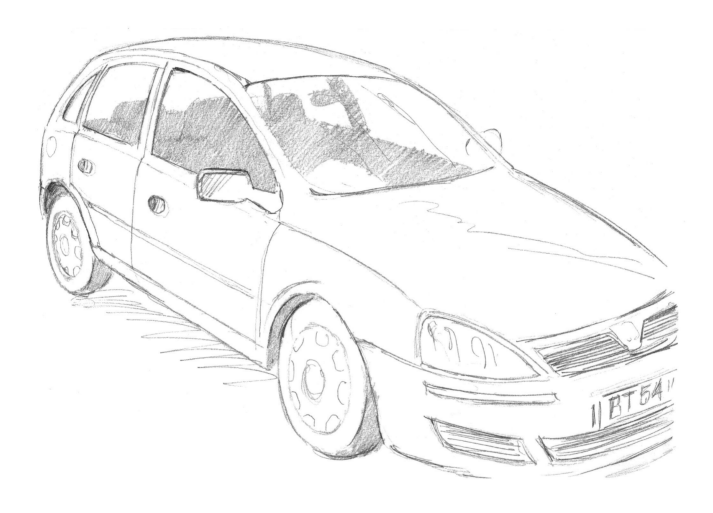

Now take up a new position where you can see the car from three-quarters front and side view. This is a lot harder to draw and you may have to refer back to your profile view to check that you are placing things correctly. The hardest part will be getting the proportion right, since the parts nearer to you will appear much larger than the parts further back.

Exercise 2

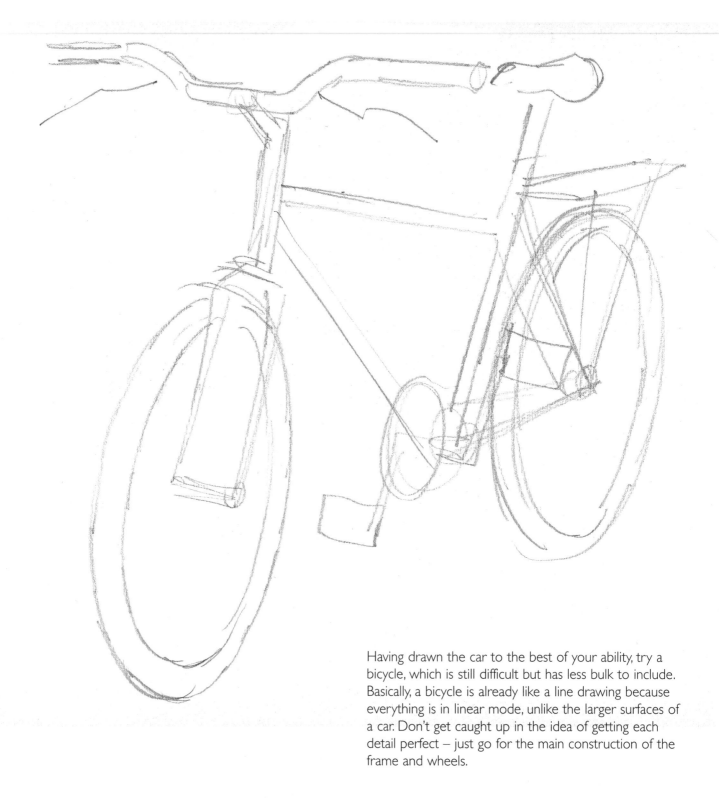

Having drawn the car to the best of your ability, try a bicycle, which is still difficult but has less bulk to include. Basically, a bicycle is already like a line drawing because everything is in linear mode, unlike the larger surfaces of a car. Don't get caught up in the idea of getting each detail perfect – just go for the main construction of the frame and wheels.

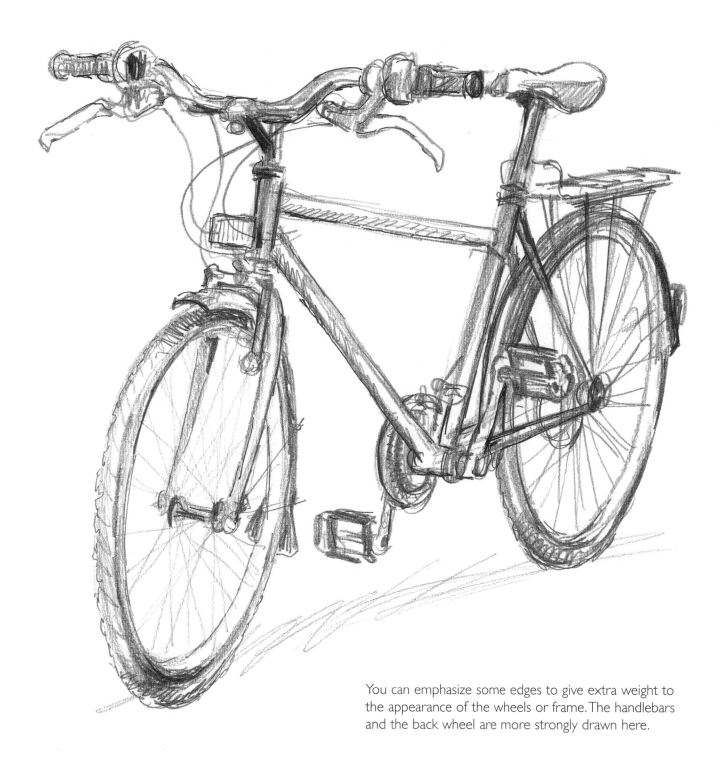

You can emphasize some edges to give extra weight to the appearance of the wheels or frame. The handlebars and the back wheel are more strongly drawn here.

DRAWING NEGATIVE SHAPES

So far, when you have drawn a subject you have no doubt been concentrating on trying to reproduce its shapes without giving any thought to what happens between them. In other words, you have been drawing only its positive shapes. However, those shapes between, known as negative shapes, are equally important in your work.

To learn how to handle these, first have a go at drawing a chair as I have done here, constructing its form so that it's clear where the back and the ends of the arms and legs form a complete cuboid shape, with the legs convincingly on the floor and the armrests both of similar length. Like the car on page 76, this is very much like a technical drawing.

Now look at it in a different way. Staying in the same position relative to the chair, fill in all the spaces between the legs, rungs, arms and back so that you end up with a chair shape that is like a negative photograph. It's not easy at first, but if you observe all these shapes very carefully you will achieve a drawing that starts to look like a chair. This exercise is very valuable to you as an artist because it makes you look at everything when you draw a subject, including all the apparent spaces around it, which are just as much of what you see as the solid objects that make up the scene. It is also much easier to measure size and proportion when you include all the bits you don't usually draw. When you carry out this exercise you are practising seeing like an artist, not just your handling of your medium.

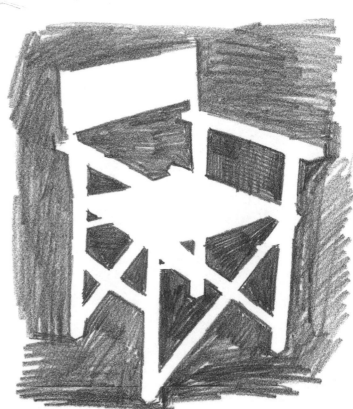

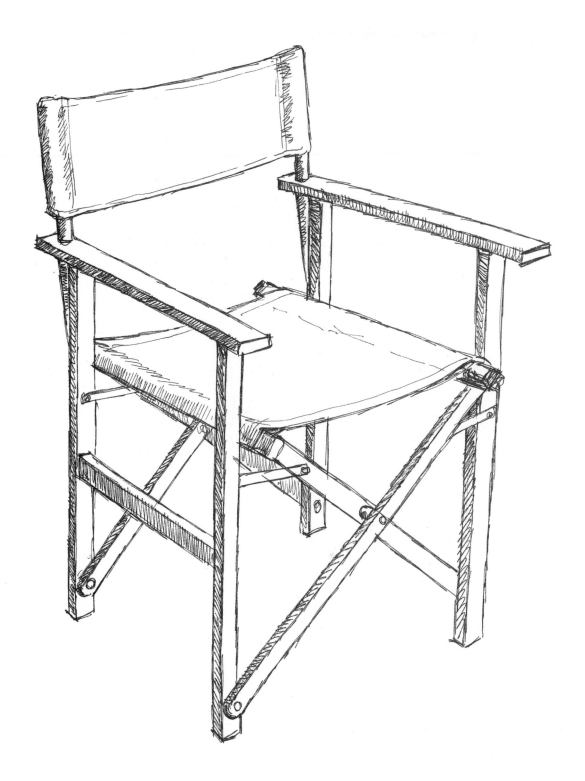

Finally do a straight observational drawing in either pencil or pen, getting everything in the right place and in the correct proportion. Try to be as accurate as you can, without actually measuring.

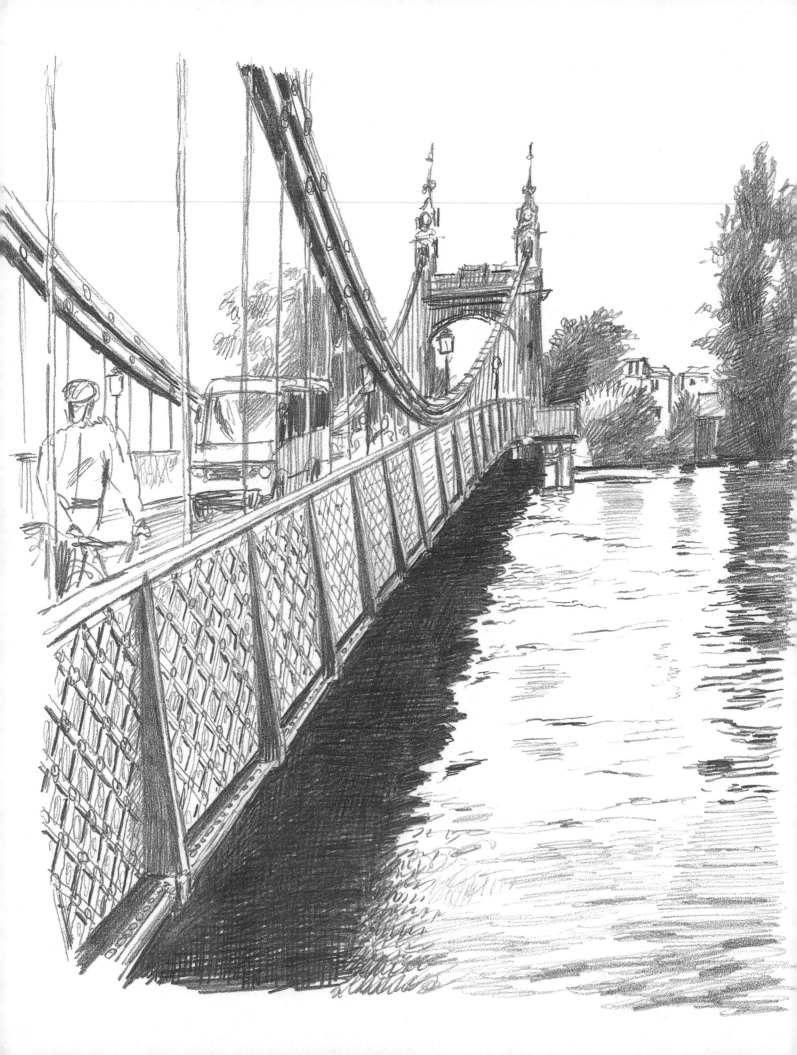

■ LESSON 4

THE OUTSIDE WORLD

In this lesson the emphasis is on going out of your house
to explore the surrounding landscape as a subject. While
drawing landscapes is not much different in essence
from drawing anything else, the sheer scale of the view is
sometimes a bit daunting, so you will need to find ways of
tackling that.

The lesson is quite short in comparison to some of the
others, but it will take you longer to work through because of
the nature of the subject matter, and you will be returning to
landscapes later on. This is also the lesson where you first
begin to place objects in the larger scheme of things and start
to understand how a whole scene can be handled.

One thing that you may find difficult is that when you are
drawing in public places, someone will almost certainly want
to see what you are doing. In the main I find that people are
quite polite about this, but if you find the attention
unnerving, remember that it's of no consequence what
anyone thinks of your work except you and your teacher. In
fact you have become your own teacher with the help of this
book, so steel yourself to disregard any uncomplimentary
remarks – what matters is that you keep drawing.

■ WATER AND PLANTS: PRACTICE

Finding a path into drawing a whole landscape is made so much easier by looking closely at its fundamental parts and realizing that a pebble, a rock and a mountain are effectively the same forms on a different scale, just as a leaf and stalk on a houseplant are a miniature version of a tree and a puddle is a tiny lake.

Make an easy start by dropping a little water on to a flat, plain surface that won't absorb the moisture – I used my kitchen worktop. What you will then have is a very small pool of water that reflects the light. Draw carefully around the outline shape, then put in any tone that you can see, shading it with your pencil. It will probably be quite simple, as you can see that my puddle was. There were a few tiny outer splashes of water as well, which I put in – adding any extra details like this will help you to get the feel of water and its properties.

Now return to drawing plants again to get a clearer idea of how they work visually. I have drawn just two bunches of leaves that were growing in my road – I could have drawn much more from what was there, but this was quite good enough to get my hand in for drawing vegetation. You will have to decide how much you need to draw in order to feel confident.

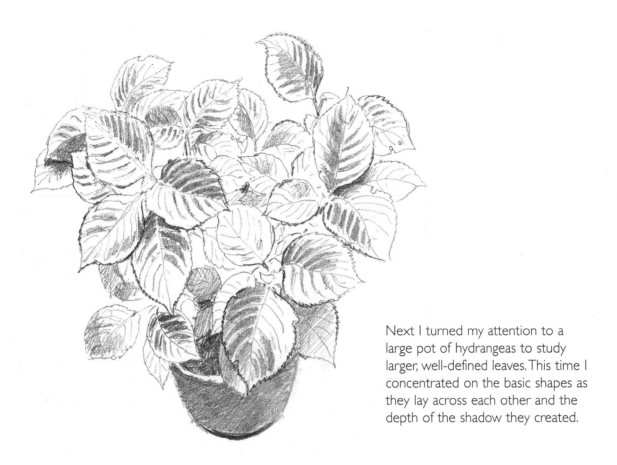

Next I turned my attention to a large pot of hydrangeas to study larger, well-defined leaves. This time I concentrated on the basic shapes as they lay across each other and the depth of the shadow they created.

The fig tree provides a good example of massed leaf forms that give a general idea of how vegetation can look as part of a larger landscape.

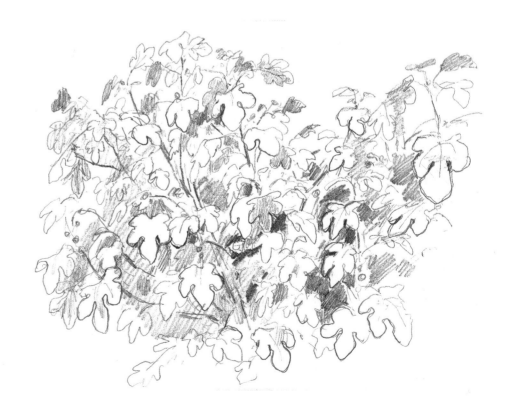

85

■ AN EXPANSE OF WATER

This exercise will require your total concentration and all of the drawing skills you have acquired so far. My drawing is of a small English river, in Sussex. I haven't included much landscape around it, so the only real problem is drawing the water – but this is quite a problem, partly because it is moving, as opposed to the flat surface of a lake on a windless day. I picked a very calm day so that the movement was reduced to a minimum, but even so your task is not an easy one.

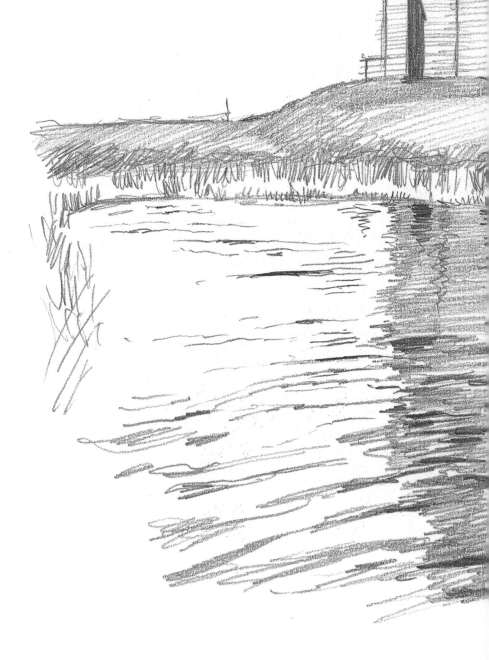

Notice how the reflections of the bank and the building upon it are making a darker tone across the surface of the water, but everything is broken up by the ripples, which reflect the light and shade in various ways. The darker tones of the larger ripples help to define the surface so don't hesitate to put in as many of these as you can see, but show the difference between the brighter part of the water and the darker part.

Don't be afraid to put in the very darkest tones, because one of the properties of water is to reflect the lights and darks in quite strong contrasts. It will require some judgement on your part to get the right balance of the tonal values – that is, the difference between the tones from the darkest to the lightest. Take a bit of time calculating these differences – it is never wasted.

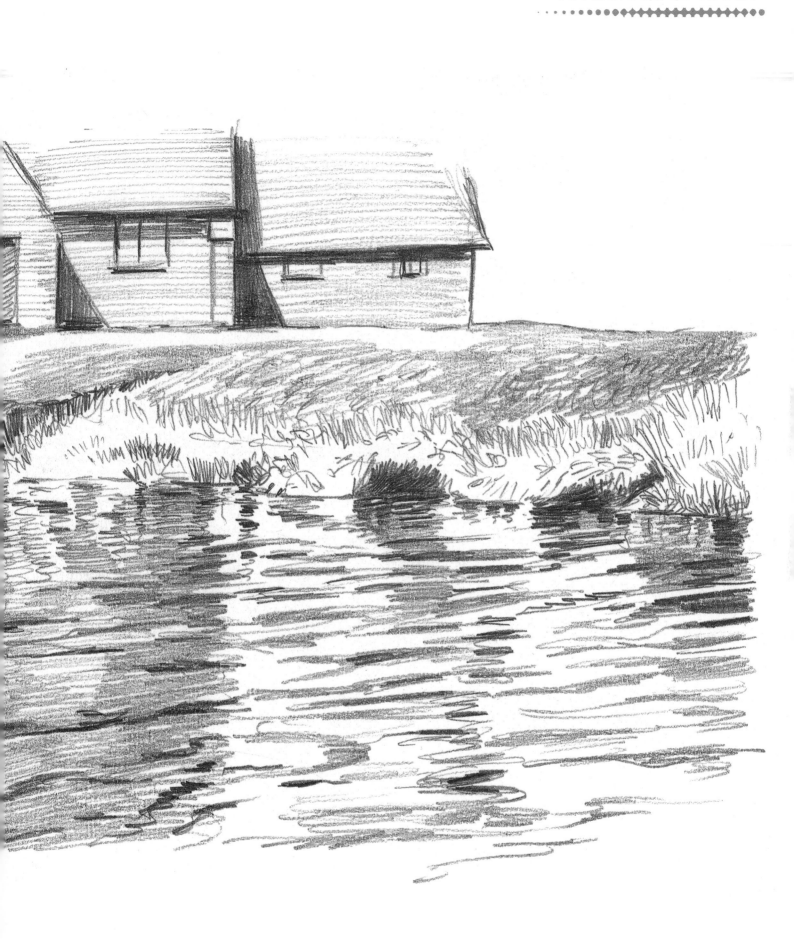

■ A SCENE CLOSE TO HOME

Now I want you to tackle a landscape drawing that can be done close to where you live. Pick a nice day when you won't have to be struggling with the wind or trying to protect your drawing from the rain – the idea is to make things as easy as possible for yourself on your first attempt to draw a real landscape.

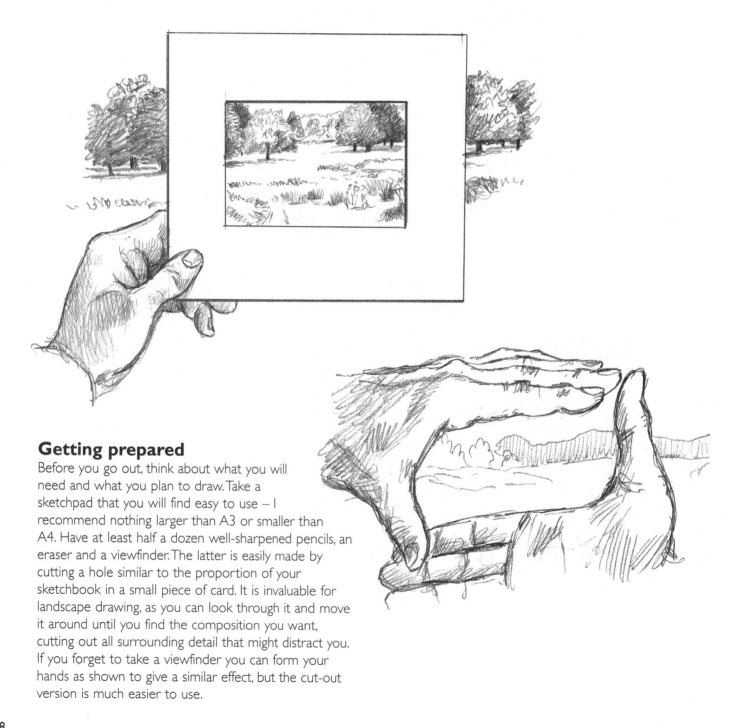

Getting prepared

Before you go out, think about what you will need and what you plan to draw. Take a sketchpad that you will find easy to use – I recommend nothing larger than A3 or smaller than A4. Have at least half a dozen well-sharpened pencils, an eraser and a viewfinder. The latter is easily made by cutting a hole similar to the proportion of your sketchbook in a small piece of card. It is invaluable for landscape drawing, as you can look through it and move it around until you find the composition you want, cutting out all surrounding detail that might distract you. If you forget to take a viewfinder you can form your hands as shown to give a similar effect, but the cut-out version is much easier to use.

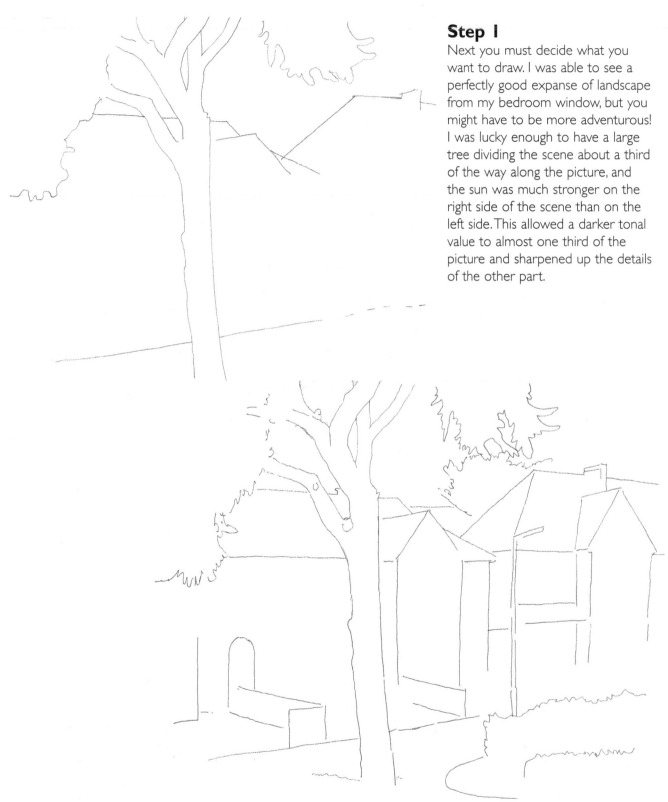

Step 1

Next you must decide what you want to draw. I was able to see a perfectly good expanse of landscape from my bedroom window, but you might have to be more adventurous! I was lucky enough to have a large tree dividing the scene about a third of the way along the picture, and the sun was much stronger on the right side of the scene than on the left side. This allowed a darker tonal value to almost one third of the picture and sharpened up the details of the other part.

Step 2

I drew the tree shape first and then the line of the rooftops afterwards. I worked over the left side of the work first and then concentrated on the details of the right side. This enabled me to decide just how dark the darker tones were going to be to create the right balance of interest.

Take your time on your own drawing, because the care and attention you give it are all part of working your way towards being an accomplished artist.

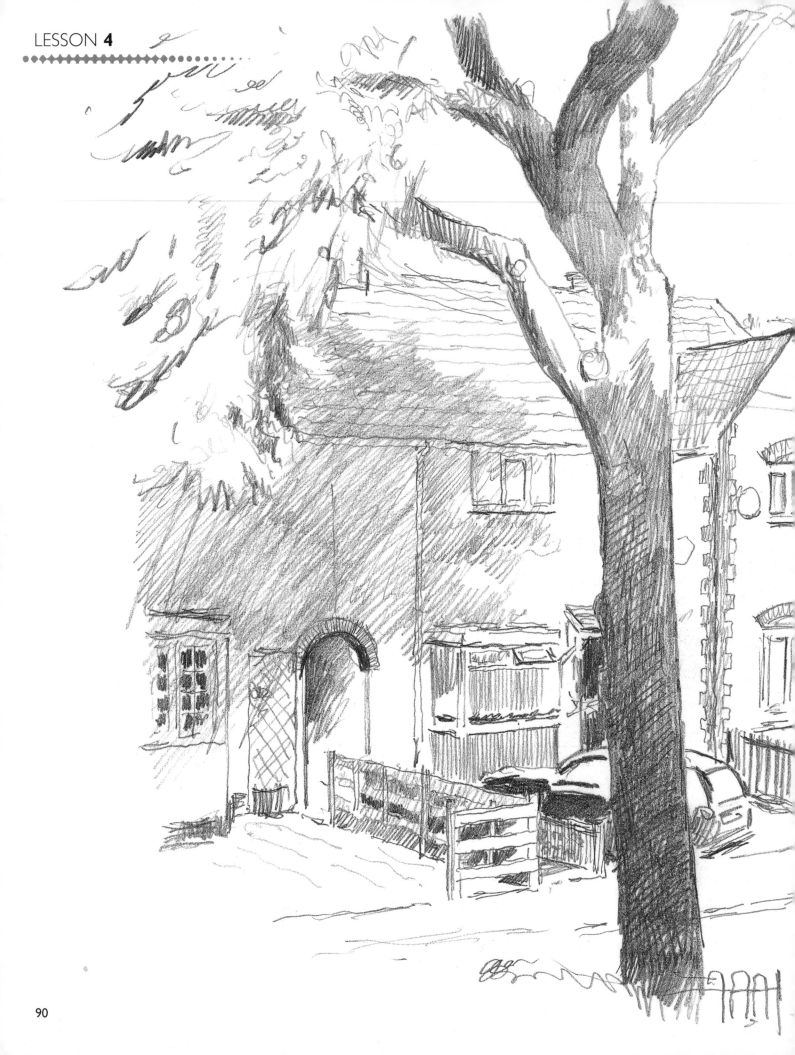

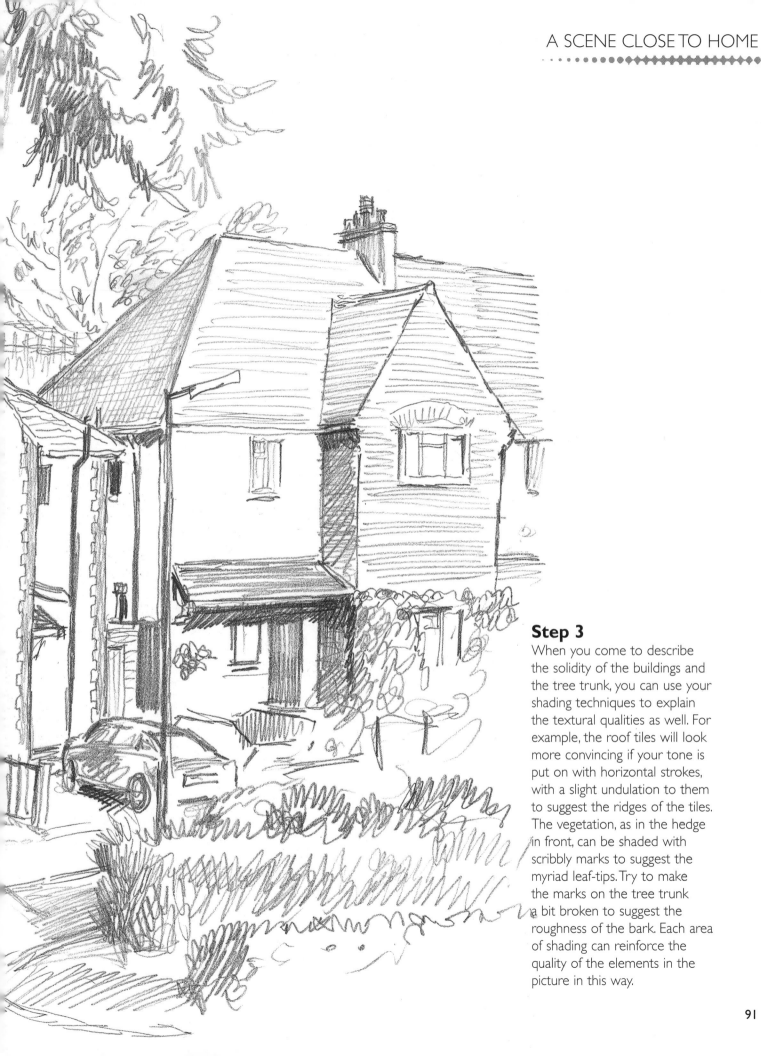

Step 3

When you come to describe the solidity of the buildings and the tree trunk, you can use your shading techniques to explain the textural qualities as well. For example, the roof tiles will look more convincing if your tone is put on with horizontal strokes, with a slight undulation to them to suggest the ridges of the tiles. The vegetation, as in the hedge in front, can be shaded with scribbly marks to suggest the myriad leaf-tips. Try to make the marks on the tree trunk a bit broken to suggest the roughness of the bark. Each area of shading can reinforce the quality of the elements in the picture in this way.

◼ AN URBAN SCENE

An urban scene can be just as picturesque and interesting as
the countryside. For a start, draw urban details that are easy
for you to see, just as you drew individual patches of water and
vegetation before embarking on your first landscape.

Preliminary drawings

I have made a selection of the upper
parts of a doorway with ironwork
protecting and decorating it, a set of
chimneypots, and finally a roof eave
with a window and drainpipes.
However, you don't have to limit
yourself to buildings – anything that
takes your attention as you are
wandering about is fair game, even
if it is just a dustbin by a gate or a
garden fence. You can find inspiration
and interest everywhere if you look
with an inquisitive eye.

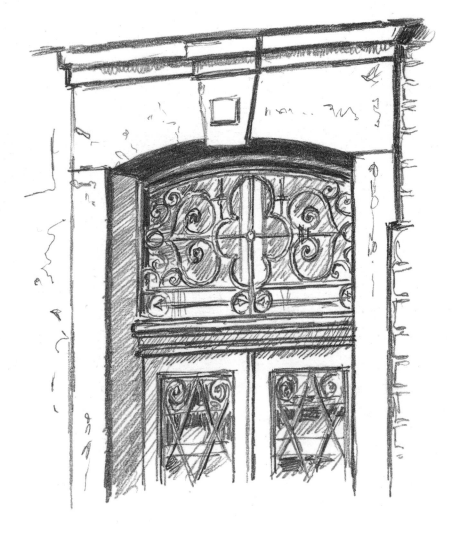

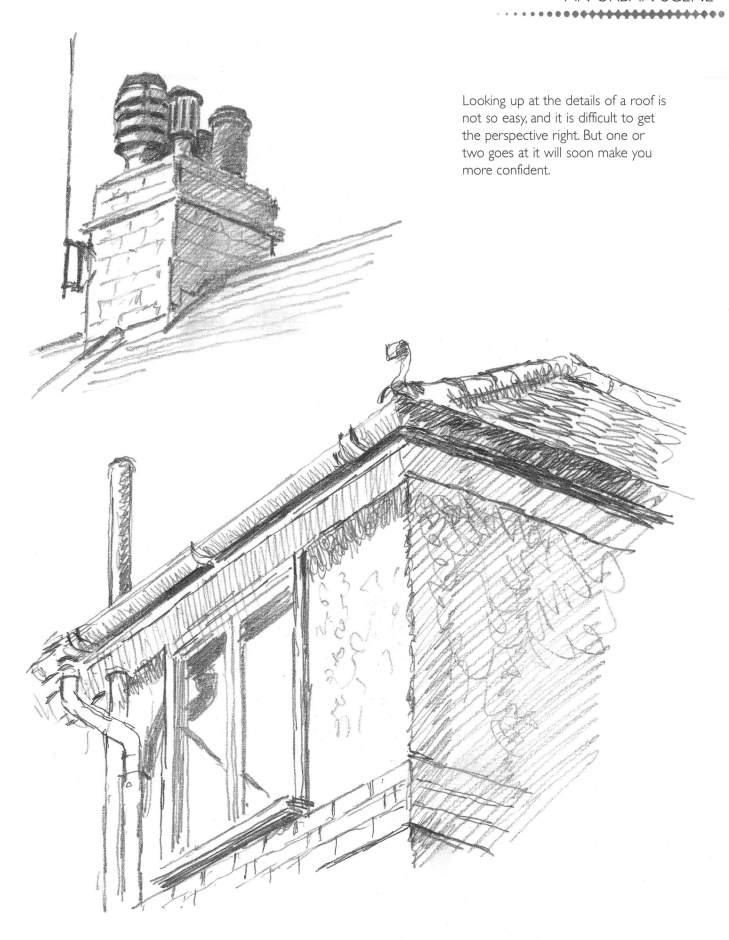

Looking up at the details of a roof is not so easy, and it is difficult to get the perspective right. But one or two goes at it will soon make you more confident.

Once you've spent some time accustoming yourself to urban details, you will probably decide you want to have a go at a typical urban scene. I went to central London on an autumn day and took up a viewpoint at the end of a short street in Soho with shops and restaurants on either side.

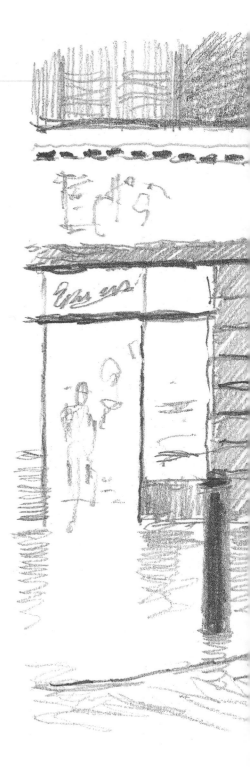

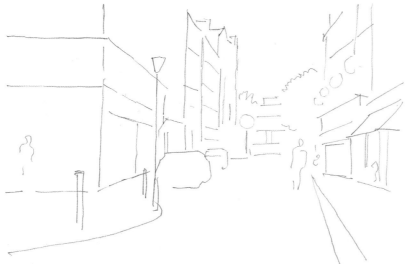

Step 1

First I sketched in the main shapes of the street, indicating parked cars and one or two figures. The same figures wouldn't be there when I finished, but there would be others that I could impose on the same spot.

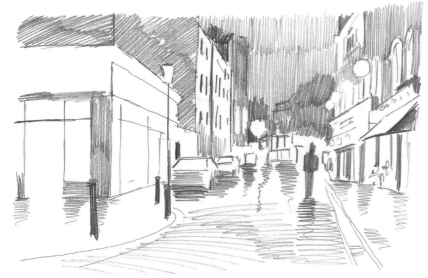

Step 2

During the time I was drawing the daylight started to fade and the streetlights came on, so I worked up the tonal differences between the illuminated shop windows and streetlights and the dark masses of buildings and trees in the distance. Darkening the sky made the lights appear that much brighter in contrast. I included the tones of the reflections on the damp pavements.

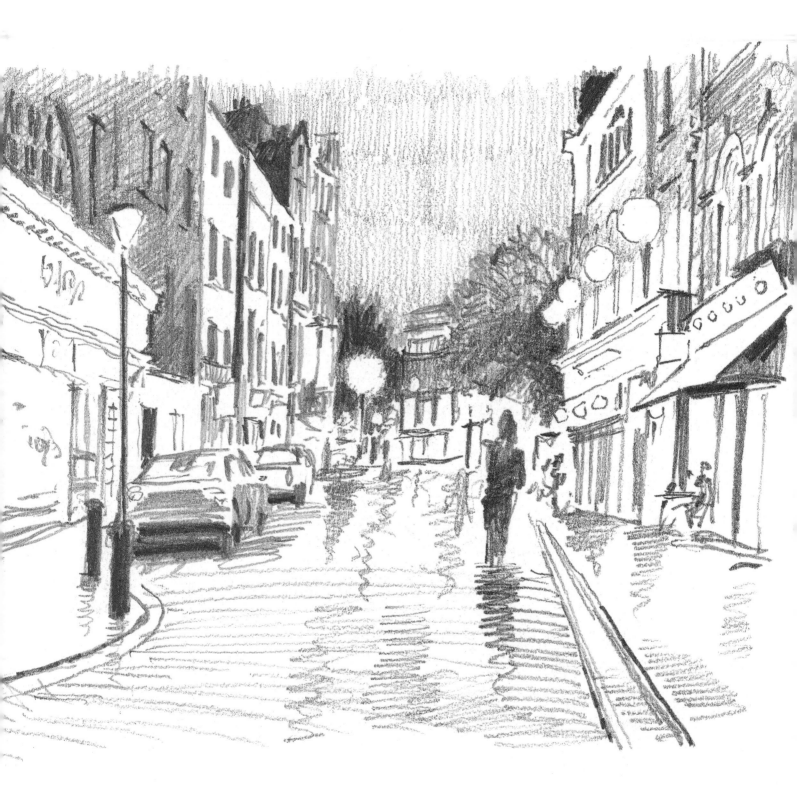

Step 3

Having built up the main areas, I could now work a little more subtly to bring out the atmosphere in the night street. Notice how the details of the windows in the buildings become mere dark marks along the receding facades of the houses. Finally, I put in the very darkest tones to sharpen up the whole scene.

■ COMBINING WATER AND ARCHITECTURE

In this exercise, you will set yourself a challenge by using your experience of drawing water and architecture in one scene. This may entail some planning on your part in order to find the right spot; I am lucky to live close to the River Thames, so there is plenty of choice for me in this respect. I picked a view of Hammersmith Bridge, which is in an urban area, so there is plenty to draw.

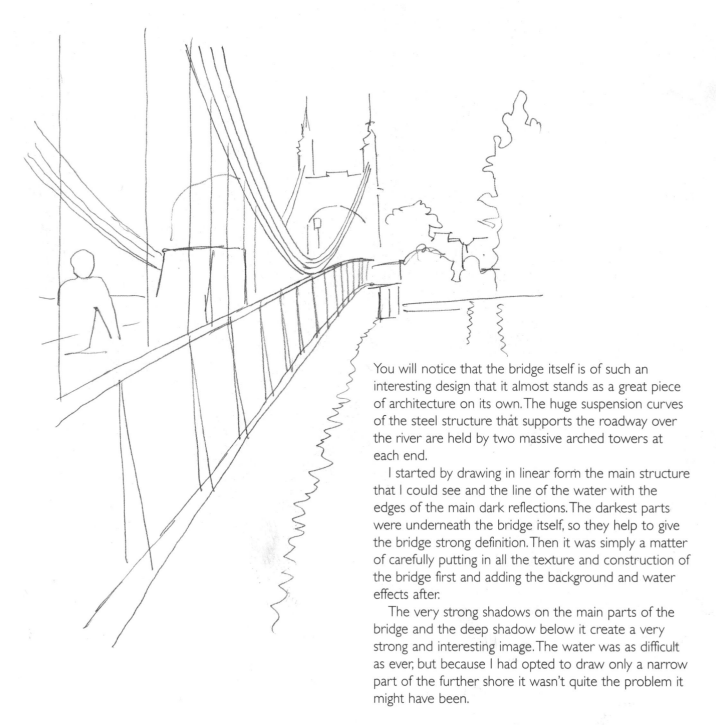

You will notice that the bridge itself is of such an interesting design that it almost stands as a great piece of architecture on its own. The huge suspension curves of the steel structure that supports the roadway over the river are held by two massive arched towers at each end.

I started by drawing in linear form the main structure that I could see and the line of the water with the edges of the main dark reflections. The darkest parts were underneath the bridge itself, so they help to give the bridge strong definition. Then it was simply a matter of carefully putting in all the texture and construction of the bridge first and adding the background and water effects after.

The very strong shadows on the main parts of the bridge and the deep shadow below it create a very strong and interesting image. The water was as difficult as ever, but because I had opted to draw only a narrow part of the further shore it wasn't quite the problem it might have been.

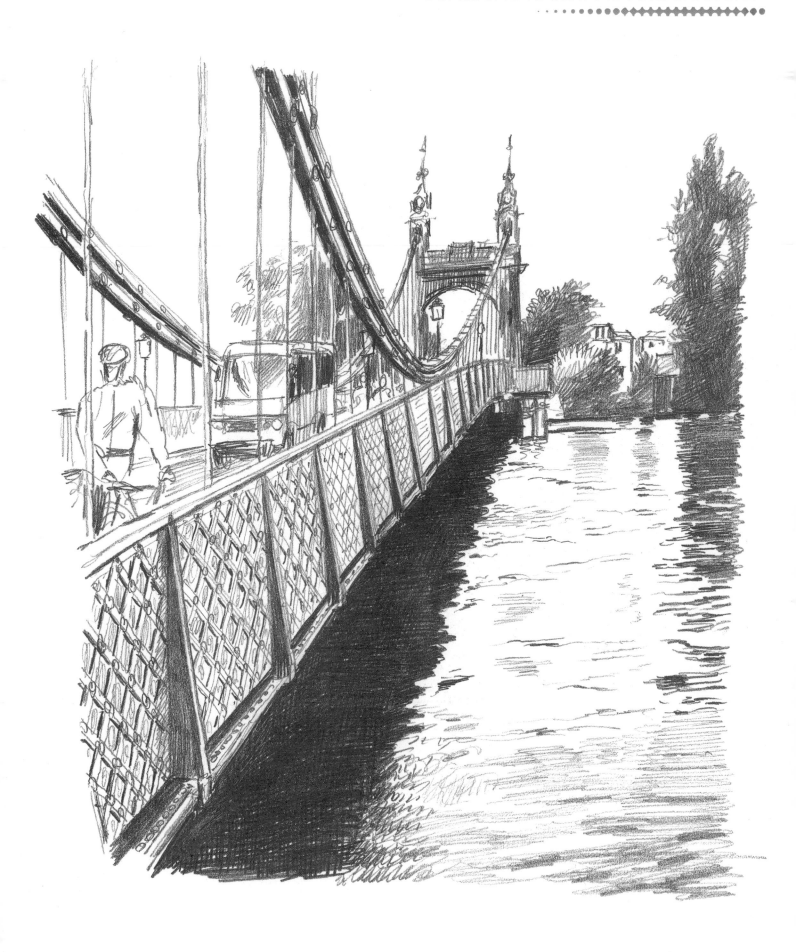

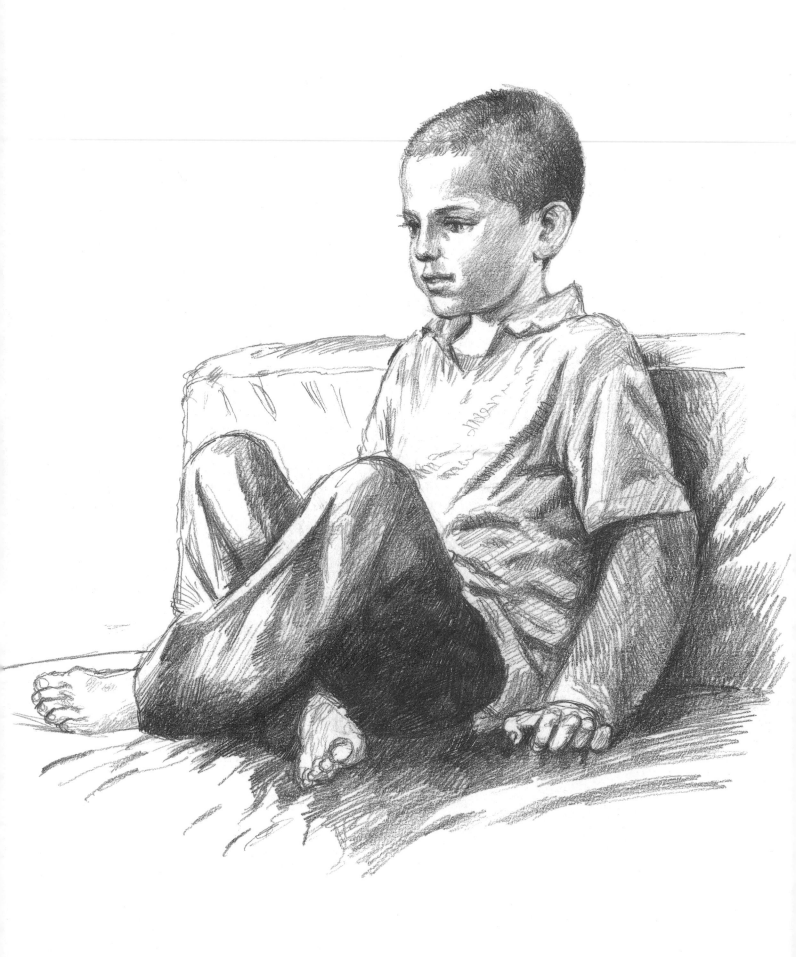

■ LESSON **5**

◆◆◆◆◆◆◆◆◆◆◆◆◆◆◆●●●●● ● ● ·

THE HUMAN FIGURE

In this lesson we come to one of the most interesting, most subtle and most taxing of our drawing challenges. The human figure is the one subject that we all think we know about, because we are humans ourselves. However, because of our close connection with the subject, it's easier not only to follow our preconceptions rather than relying on observation, but also then to realize we have got things wrong. It's consequently rather more difficult to satisfy our own demands of our skill, but that's not a bad thing because it pushes us to strive harder to achieve what we want.

There are many approaches to this field of drawing, and I have tried to include all the obvious ones. Eventually you will learn many more ways to draw the figure, but you have to start with a method that is easy to understand and achieve. You will see how to simplify your drawing and to get the main movement through the shape of the figure, and we will also look at some details, including the figure in perspective and how to analyse the shape.

Finally, of course, it will be your own observation that will increase your drawing skill in this subject, as in others. You will need the co-operation of your friends and family in this series of exercises, but you will find that most people are happy to oblige, especially if you can be expected to do a really good drawing of them.

◆◆◆◆◆◆◆◆◆◆◆◆◆◆◆●●●●● ● ● ·

THE PROPORTIONS OF THE HUMAN FIGURE

Obviously people vary in their exact proportions, but using the head as the basic unit, the average man or woman, fully grown, is about 7½ to 7¾ heads tall. However, most drawings and paintings of human beings can be drawn simply as if 8 units made up the height. This would probably be true of a tall person and so is not too out of proportion – in fact it was the measure generally used for beautiful or heroic figures in art history, so you will not find your models complaining! It is certainly an easier proportion to draw than 7½ units.

The male and female hardly differ at all in their height proportions, but there is a difference in width; the male figure is wider at the shoulders, the female wider at the hips.

Male figure: front view

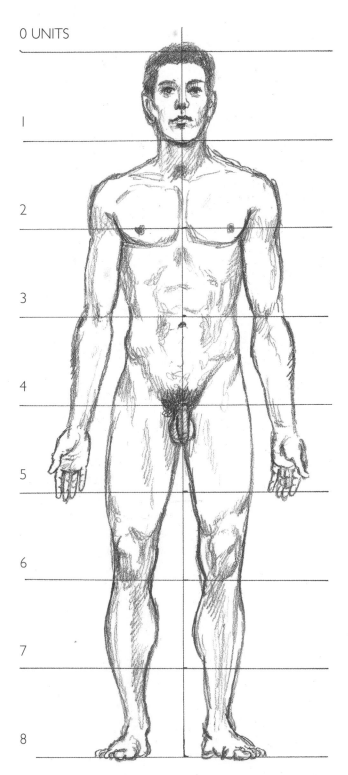

0 UNITS
1
2
3
4
5
6
7
8

Female figure: side view

Child (9–10 years old): front view

A child's head is much bigger in proportion to the body. At one year old it is about 3 to 1 and as they grow the proportions gradually approach those of an adult. At about 9 or 10 years old, a child will be about 6 units or heads to the full height.

0 UNITS

1

2

3

4

5

6

7

8

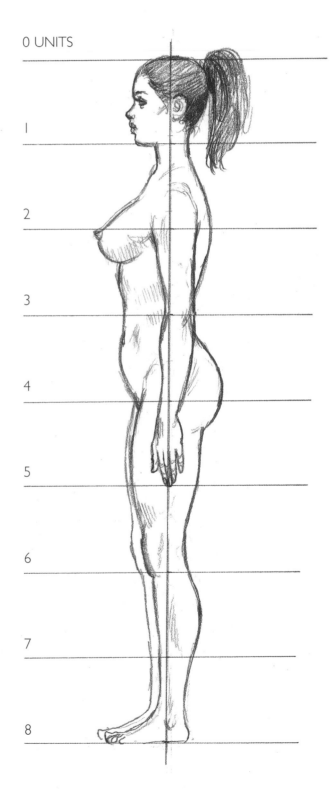

0 UNITS

1

2

3

4

5

6

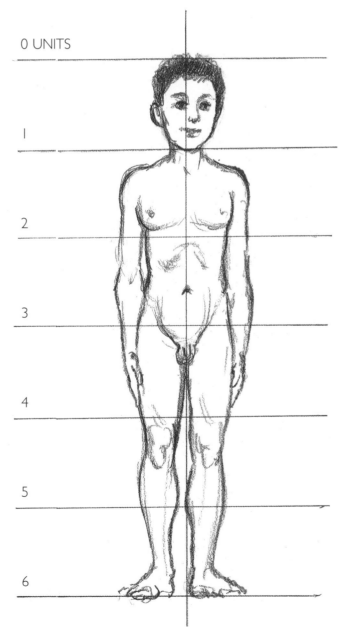

◼ DRAWING SIMPLE FIGURES

For looking at the human figure more extensively, you will find that a good supply of photographs of people in action can be very useful. While the best drawings are done only from life, using photographs, especially if you have taken them yourself, is not a bad substitute.

First of all, limit yourself strictly to the simplest way of showing the figure, which is almost like a blocked shape with a line through its length. In these figures the movement is not great, as befits a first attempt, and two of them were taken from photographs. However, simplify all the time when drawing figures because the movement is so difficult to catch that you don't have time for details. Try to do a few drawings like this, spending just 3–4 minutes on each one and making your lines fluid and instantaneous, even if at first the results look terrible. All artists start like that, and only time and repeated practice effect a change.

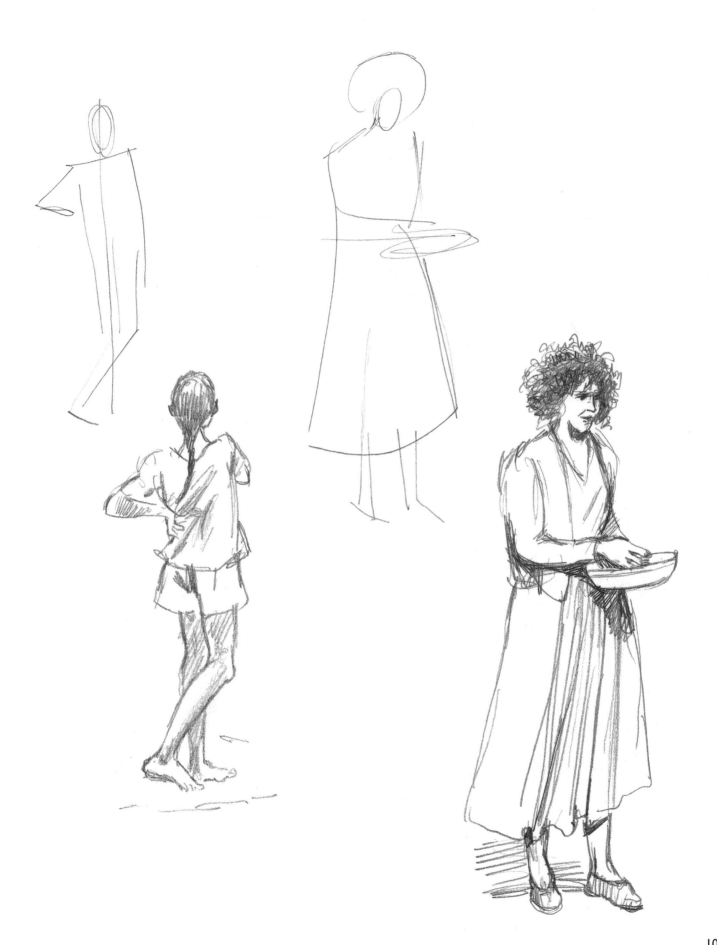

Line of movement

In the drawings on this page I have used the stick drawing technique, drawing only the line through the movement of the shape first, in order to get the feel of the flexibility of the human form.

Have a go at this first before you draw the figure more solidly, keeping the stick drawings at the side of your more considered drawings to guide you. Put in the figures as simply as you can, leaving out all details and limiting yourself to about 10 minutes per drawing.

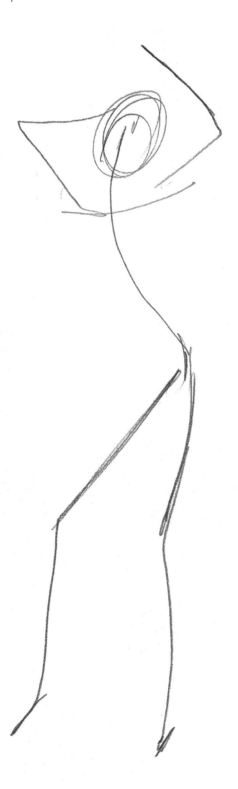

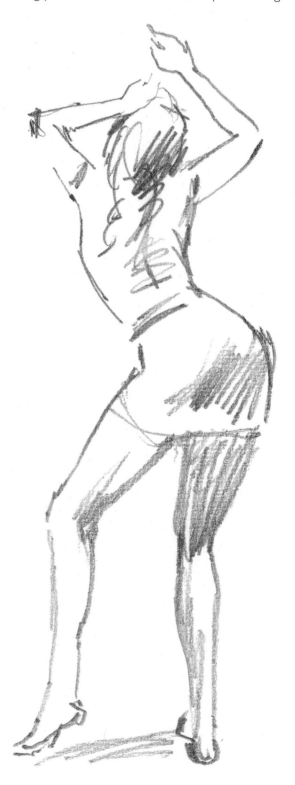

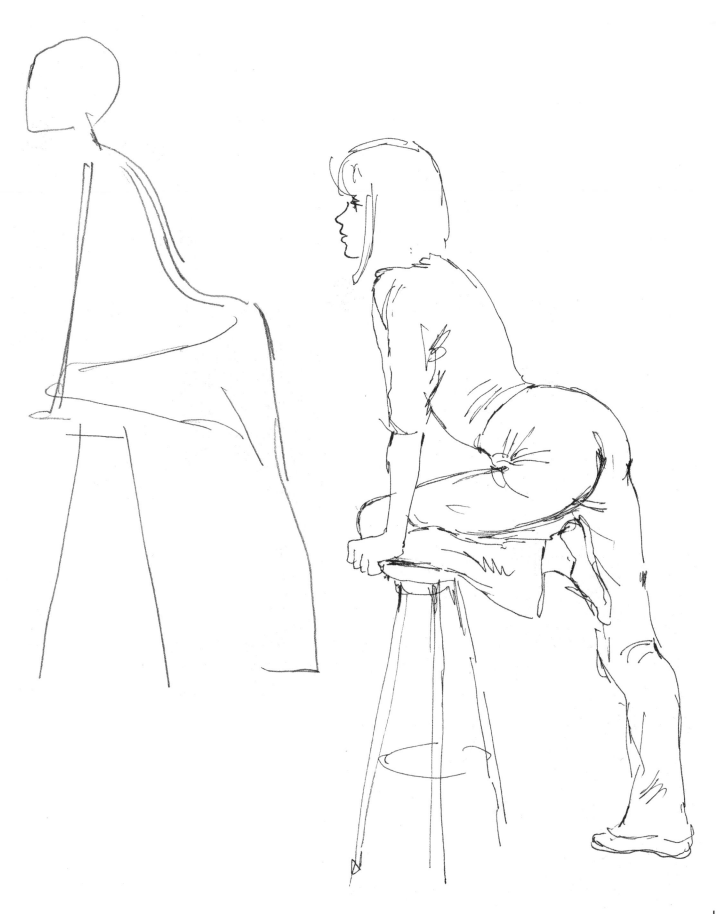

Blocking in figures

The next four drawings are approached in a slightly different way from those on the previous pages, because I have blocked in the main shape rather than taking a line through the movement. This makes me look at them in a slightly different way, because now I am concentrating on the solidity of the shapes. It helps

that these people are in more settled positions, so there is more time to draw them.

Once again there is no detail at all in these drawings – even the features are mere dashes of pencil to indicate their position rather than their shape. Make your own drawings of figures in more reposeful positions than you have tried so far.

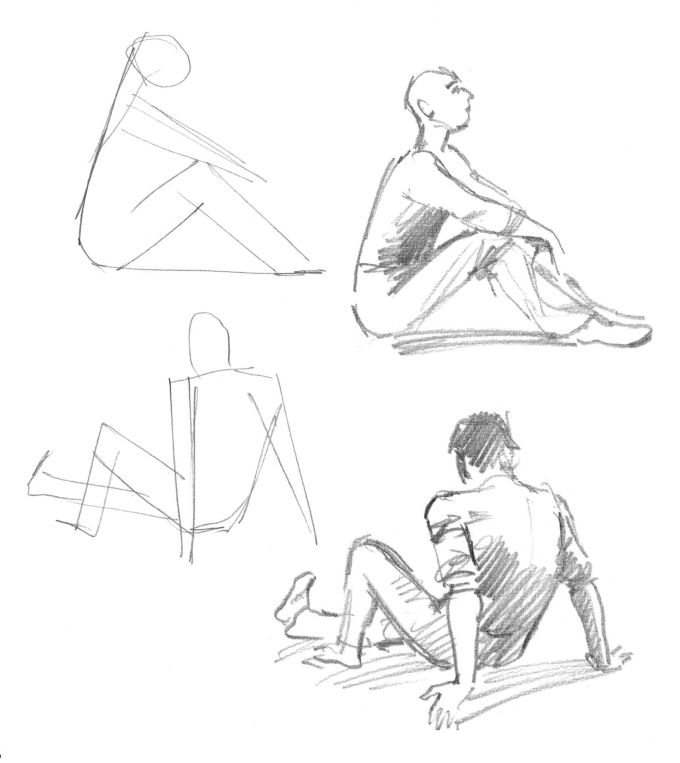

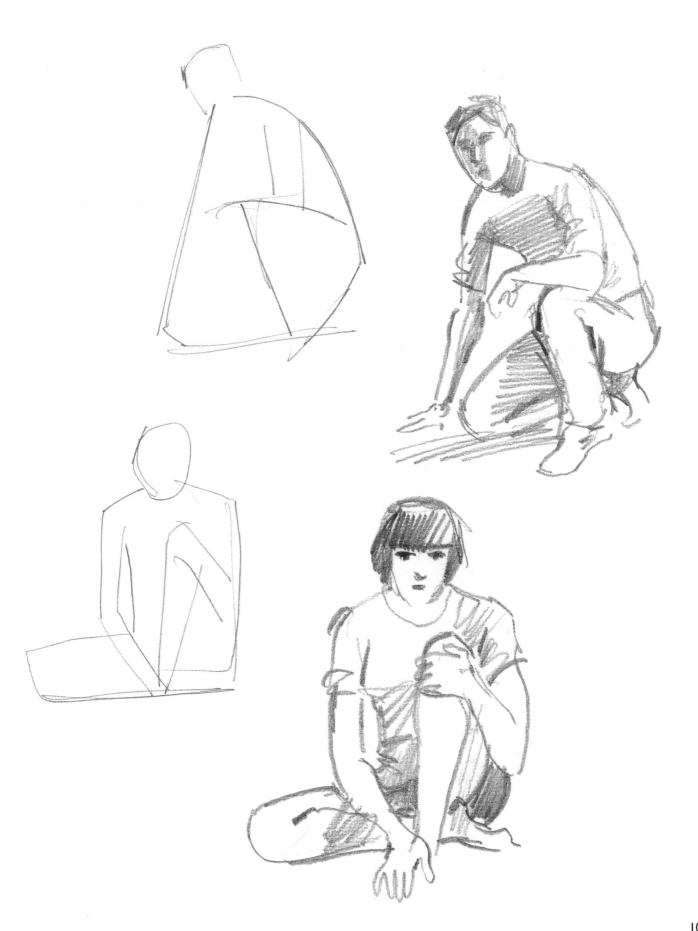

■ EXPRESSIVE FIGURES

Here we are still looking at the human form, but in poses that are less formal and more expressive. The four figures on this spread are not even shown in full, because my interest is in the gesticulating hands. Once again these might be easier for you to draw from photographs that have frozen the moment.

Block these in to start with as you did before, but pay particular attention to the position of the hands. One girl looks as if she is ticking off points on her fingers, one man is gesturing to draw attention to something, the other girl is in the process of combing her hair and the last man is sitting down to draw something . . . perhaps you!

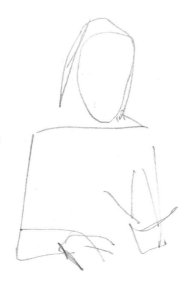

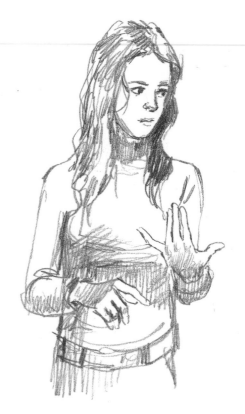

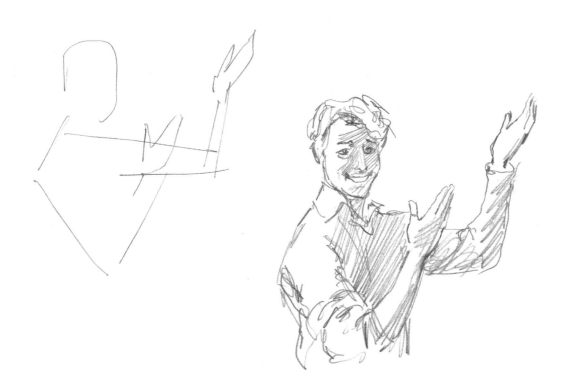

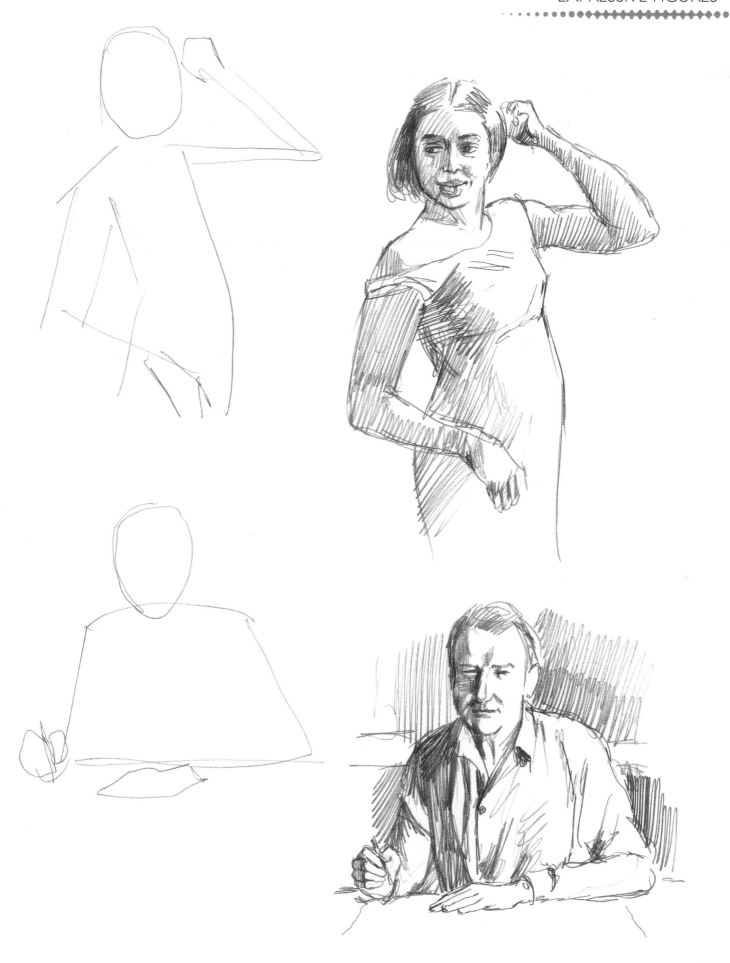

■ FORESHORTENED FIGURES

The next drawings look at figures which are lying and sitting in such a way that some of their limbs are foreshortened, making your task more difficult. You will have to look carefully at how the proportions of the limbs differ from how they would appear if the same figures were standing up.

Here, the first girl sits with her legs folded under her, supporting herself with her hands. Her feet and knees project forwards from her trunk and are shown proportionately larger.

The girl lying down holding her knees creates the problem of working out the proportion of both the arms and legs because of the angle we see them from.

In the case of the girl lying down with her head towards us, the legs appear much shorter and the head correspondingly larger than we tend to expect. Expectations are always a distraction in art, and it's better to try to reject them. Instead, remember to observe closely and draw what you can really see, not your assumptions about a subject.

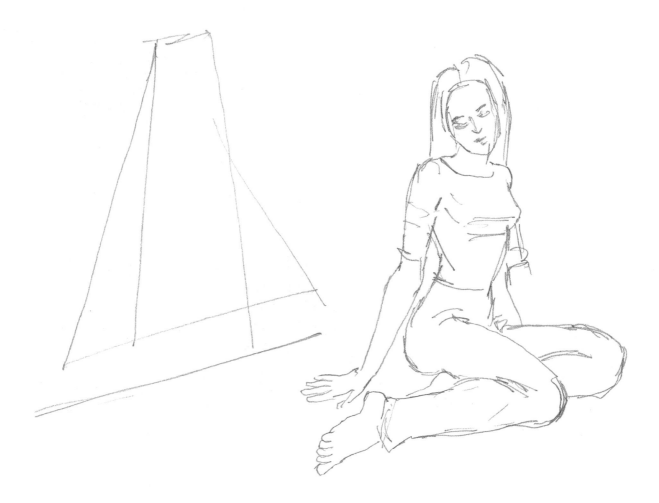

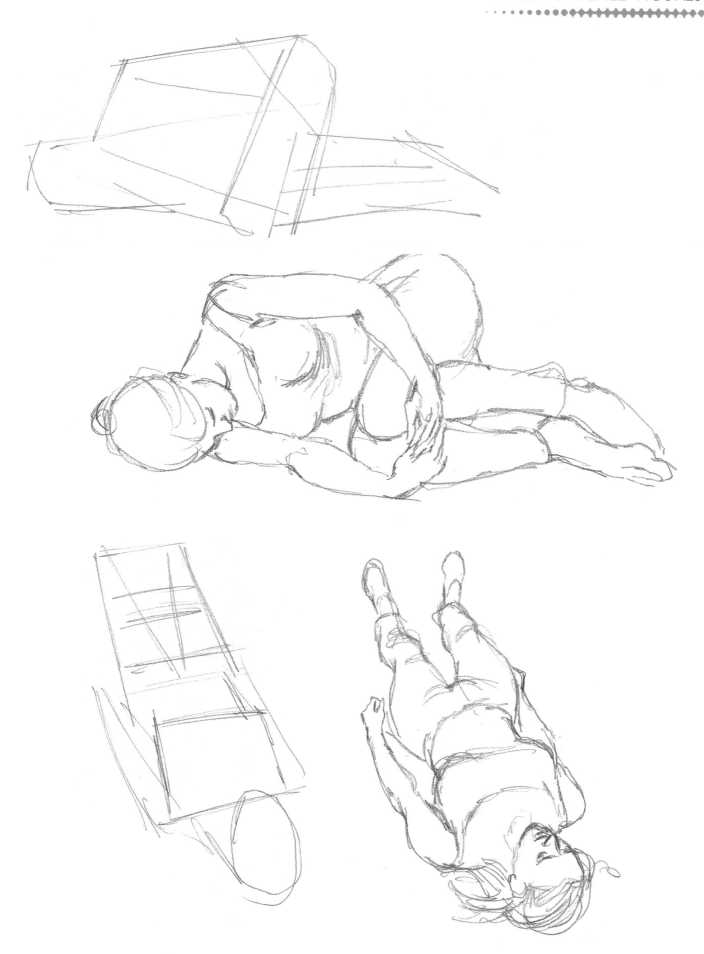

More foreshortened figures

Finally we have three male figures in poses where the foreshortening of the limbs needs to be noticed as you draw them. When you ask your friends or family to pose for you, make sure that sometimes they sit with their limbs advancing or receding to create this opportunity for you to draw in perspective.

The first figure, sitting on a stool, is relatively straightforward where the legs are concerned, but the folded arms pose a foreshortening problem.

The second man is seen almost from above, so that the arm he is resting on half disappears, and one bent lower-leg is almost hidden from our sight.

The last figure of a kneeling man poses problems both with the arms and the legs, so observe them carefully if you try this pose. These drawings are all more useful if done from real people posing for you, but if you can't get enough patient models, use photographs – but take them yourself. As before, don't forget to block the pose in before you try to put in all the details.

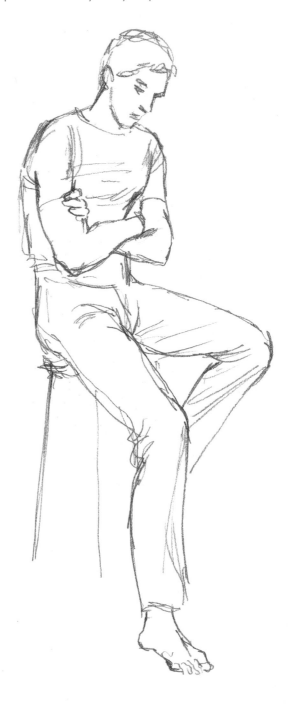

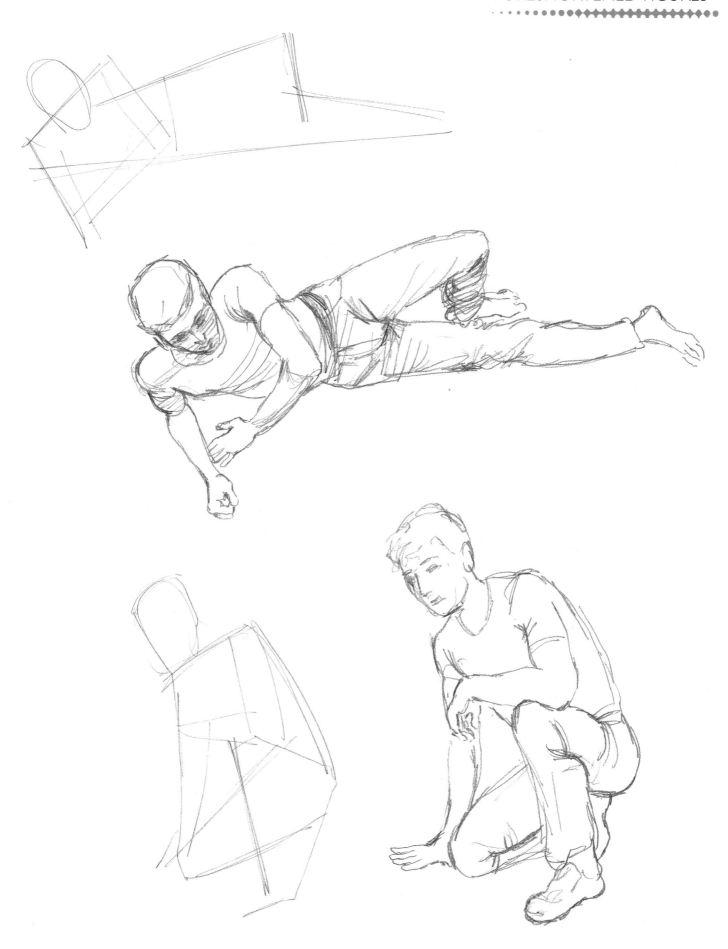

■ THE LIMBS AND EXTREMITIES

On these pages, we'll look at the limbs, hands and feet in more detail. You won't necessarily draw all these particular poses, but try as many as you can before moving on to the next stage. Again it is of more benefit if you can draw from life, and in most cases you could use yourself as the model with the use of a large mirror.

Arms and hands

First, draw some arms from different angles. Those that I've drawn are both feminine and masculine, but if you are drawing your own arms, that doesn't matter at the moment; male and female arms look different, but the basic anatomy is the same.

In my drawings I've shown both the use of tone and a more linear approach to define the form. No matter how many arms you draw, there will always be more to discover about their formation in different positions. If you become really interested in the construction of the human body, you'll find that a good book on anatomy for artists is invaluable.

The hand is a study in itself. Repeating the exercise of tracing round your own hand (see page 42) will remind you of its basic shape.

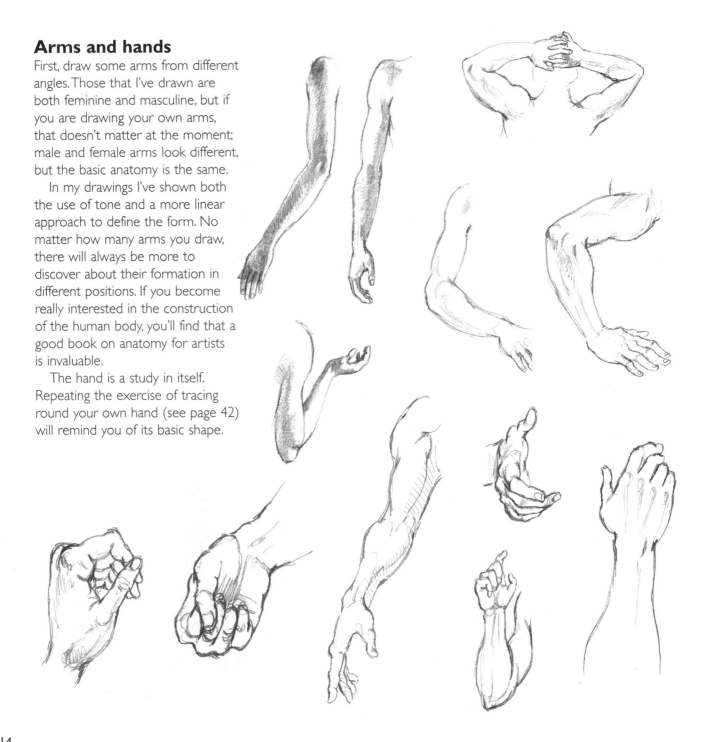

Legs and feet

To draw the legs and feet, again you can use your own seen in a mirror or ask people to pose for you. You will need to show the difference between female and male legs, which is evident in the softer, rounder forms of the former and the harder lines of the latter. However, the difference may not be so obvious on the legs of a female athlete compared to the legs of a sedentary male. The hardest part is to get the proportion between the upper and lower leg correct, and the drawings of the knee and ankle joints.

Draw the legs from various angles: front, back, side and crossed over each other. This helps you to see how the various groups of muscles behave from different angles. When the legs are under more tension the muscles will appear more prominent. The knee joint and the area where the foot joins the leg are quite tricky to get right and it is worth making several studies of them.

Feet are not too difficult in themselves, being less flexible than hands, but the difficult angles are drawing them from directly in front or from the rear.

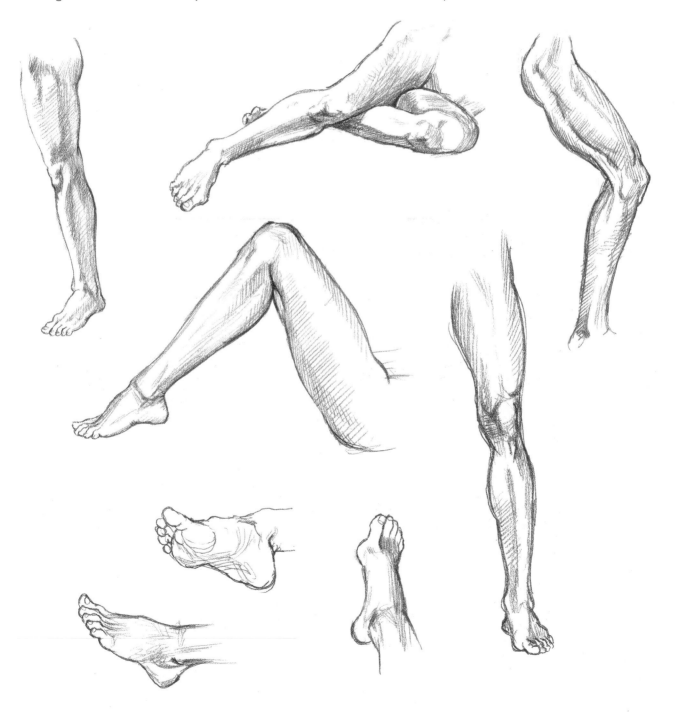

DRAWING THE WHOLE FIGURE

Drawing the complete human body is really the subject of a life class. Generally speaking, the best you will be able to coax from friends and family is a pose in a bathing costume, since other than the young and beautiful most people are too self-conscious to subject themselves to such close scrutiny. This is sufficient for a general view of the body, but if you need to study it more closely in order to understand the bones and muscles showing on the surface a tutored course in life drawing is the obvious answer. While these vary, most of the tuition in such classes is good, because they are usually run by expert art teachers. The complete body is definitely the hardest thing that you will ever draw, and you will find that after a time spent studying it your drawing of other things will also improve. So start with the details of bodies, and then graduate to the complete figure.

A standing position with no foreshortening is easiest, but you will also need to draw models sitting, reclining and also in various more complex poses where the limbs and torso are turned, folded and twisted to show how the different parts of the structure function together. Try to draw from models of different shapes, sizes and ages where possible. One very good way to gain an understanding of the structure of the body is to have the model sitting on a revolvable chair and gradually turn it around so that you are drawing the figure in the same pose from a variety of positions.

You will need to study the front and back of the torso carefully, as the musculature is vastly different from these two views. Also draw from both the head and foot ends of the reclining figure to see how foreshortening changes the way we see the shape of the human body – the conventional image in our minds is a standing figure, but of course the body looks very different when it is in other poses. Any study of the human figure will do wonders for your powers of concentration and your ability to draw any other subject.

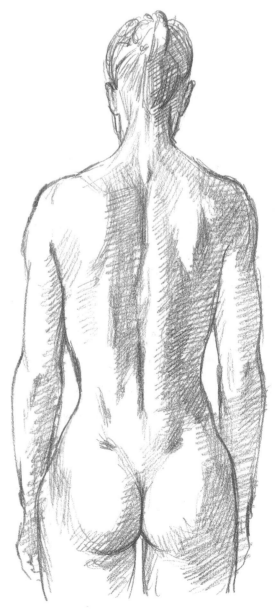

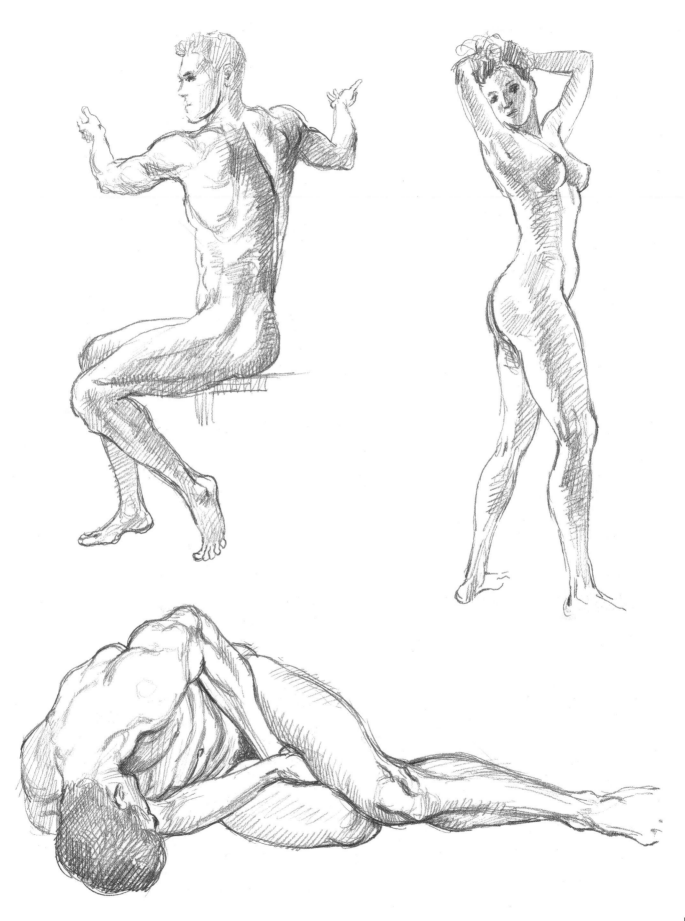

■ THE HEAD: PRACTICE

The following exercise will be to draw a complete portrait of someone, and you need practice on the head to make a success of this. Here I have given you a drawing of the head both in profile and full face, with measurements to give you the basic proportions. Although my example is a female head, the same proportions apply to the male. Of course these are generalities, but the differences in proportion in individual heads are so small that it is a good basic set of measurements.

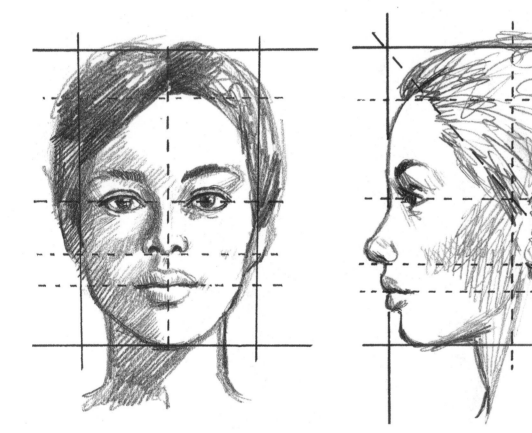

The full-face version shows that the head is longer vertically than horizontally. You can also see that the eyes are halfway down from the top of the head. The length of the nose is about half this again, but the mouth is closer to the nose than to the chin. The widest part of the head is just above the ears and the eyes are the same distance apart as the length of the eye from corner to corner.

On the profile drawing, the hairline is positioned at about half the area of the head on a diagonal basis. The shape of the head is about the same distance across horizontally as it is in length, ignoring the projection of the nose. The ear is just behind the halfway vertical. Note that both in profile and full face the distance of the mouth to the chin and the hairline to the top of the head is about one fifth of the whole length of the head.

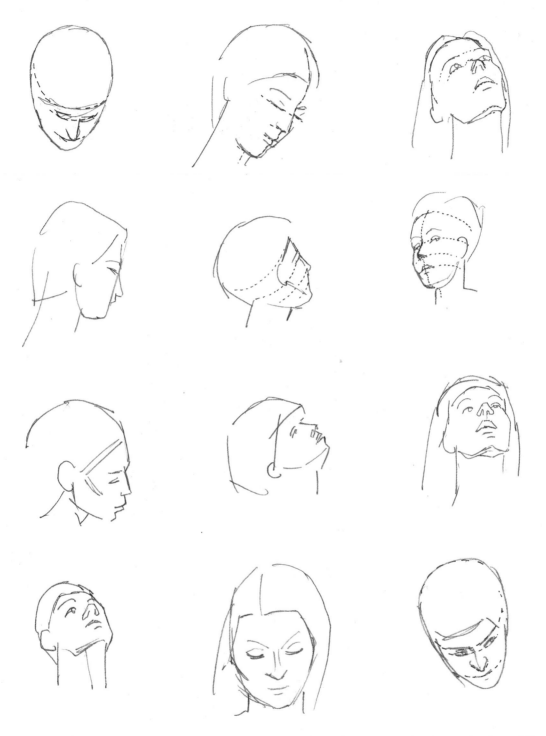

Now for a few examples of heads in different positions which you will need to study, because you won't necessarily find your subjects' heads in exactly the full-face or profile version. Some of these are seen from slightly below and some from slightly above. The former show the projection of the jaw and the nose seems to be shorter and almost blocking out some of the eye; the latter show more of the top of the head and the mouth tends to disappear under the projection of the nose.

These drawings are all done as blocked-out shapes, emphasizing the three-dimensional quality of the head and getting across the idea of the whole shape, not just the face. If you are a beginner this form of drawing is important for you because it begins to make you see the complete volume of the head, which few non-artists think about.

These drawings show other versions of heads in different positions, but this time with the hair and features put in more naturally. Try to draw as many different versions of heads as you can, because it will improve your ability to draw portraits in more depth.

Again do as many of them from life as you can, resorting to photographs if need be. Notice how the shadows on the faces give an extra dimension, not only to the form but also to the expressions.

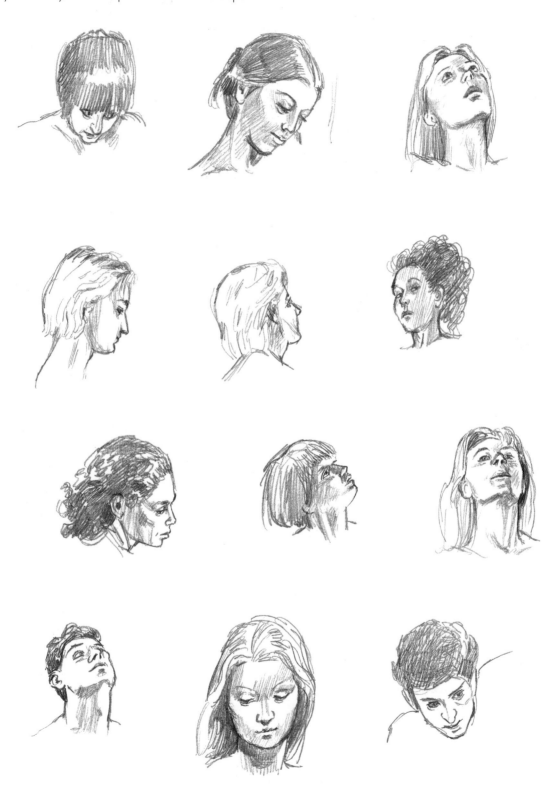

A FULL-FIGURE PORTRAIT

This exercise will seem like a reward for all your hard work so far on the human figure – drawing a complete portrait of someone who will be prepared to pose for you for a while. I took as my model my six-year-old grandson, who is not easy to keep in one position, but

I put him in front of the television to watch a film that I knew would interest him so he sat for a little longer than usual. That in itself is a lesson – make your models comfortable and happy and you will get more time to draw them!

Step 1
At first you will need to draw the main shape of the figure. Keep it very simple to start with and use your eraser, correcting as much as you can at this stage – it saves time later on.

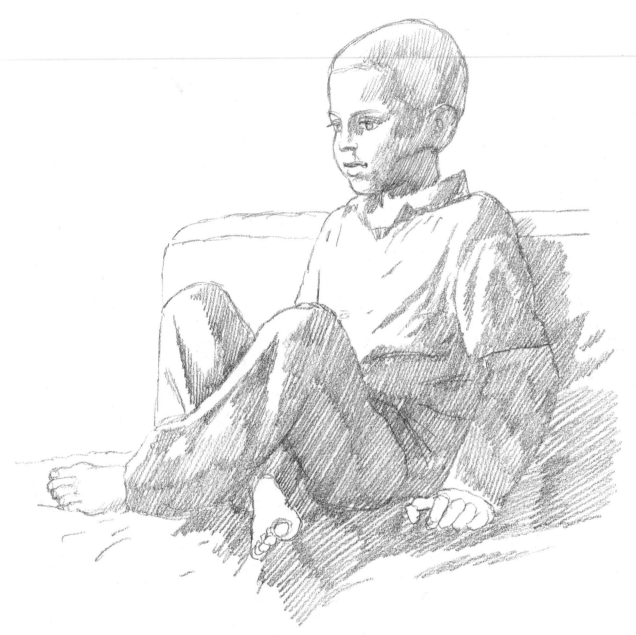

Step 2

The next stage is to put in all the shadows that seem relevant, again keeping everything simple – but it is at this stage that the face needs to become recognizable.

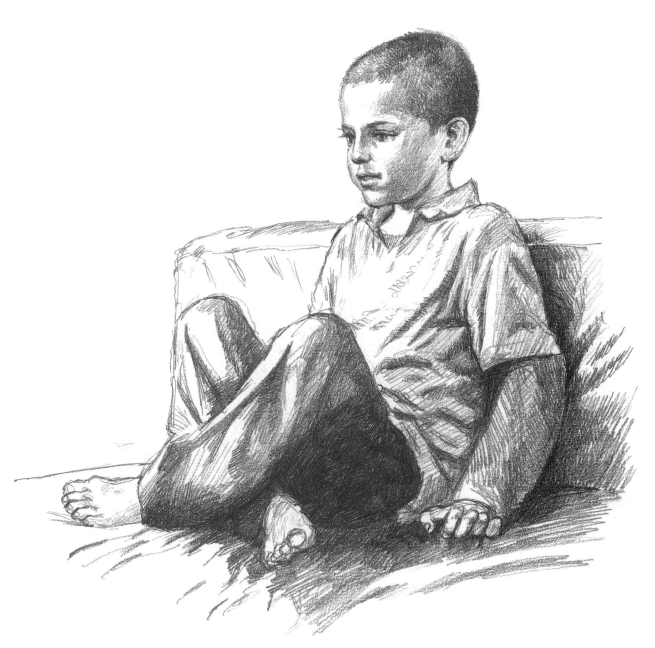

Step 3

Once you are sure everything is the right shape and in the correct proportion, begin to work into the picture to make it come to life. Take great care over the head, because this is where the picture becomes a portrait of a particular individual rather than of just anyone. This is not so difficult as it sounds because we all have this marvellous ability to recognize human faces, so you will automatically draw the features correctly if you really pay attention. Build up the tones in such a way as to stress the softness or hardness of the form.

Good luck in your efforts – even if you are not successful this time, the practice will enable you to do a lot better on the next occasion, and we'll be looking at portrait drawing in more detail on pages 248–273.

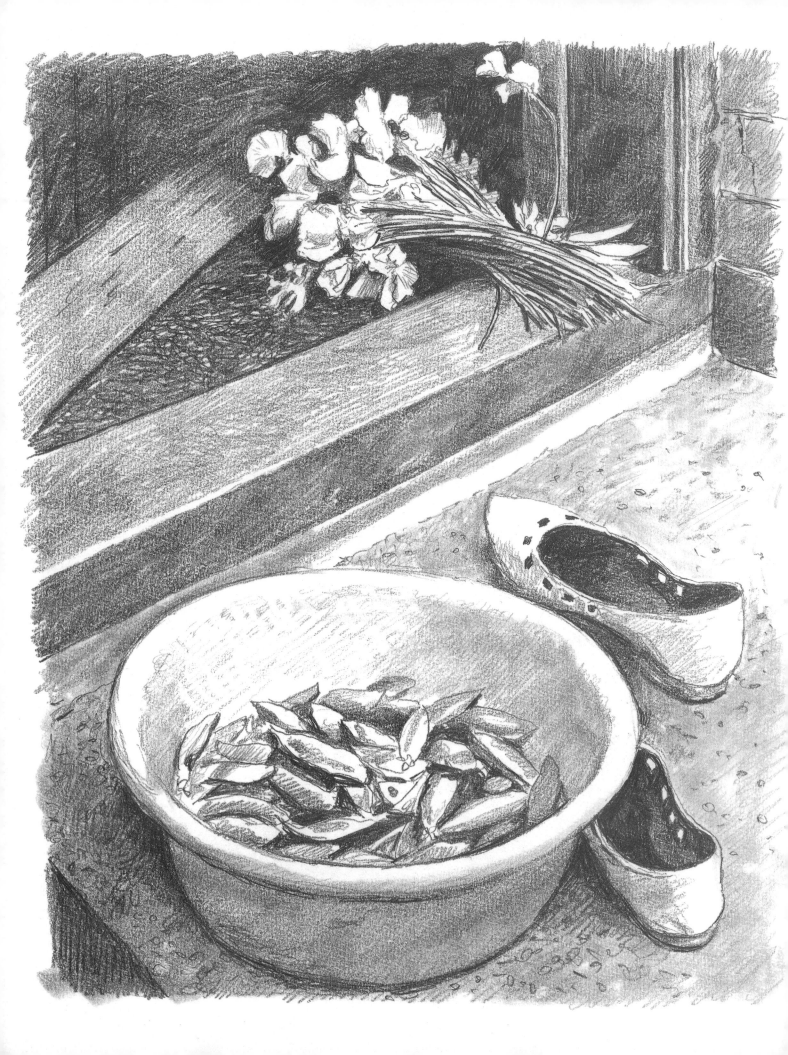

■ LESSON **6**

MATERIALS AND TECHNIQUES

In this series of exercises you will start to try out different mediums available for drawing, all of them traditional. In each I have demonstrated the mediums useful, but I have by no means exhausted the possibilities. While every medium has a different influence on the method of drawing, when you have become more confident with them through constant practice you will find it interesting to overlap your techniques and tools in the spirit of ongoing experimentation.

What will eventually dictate your choice of medium for any particular picture is how well it suits the subject matter and the way you like to draw. Even when you have found one you especially enjoy working with, don't stop there – keep on trying out different methods and mediums to expand your repertoire and become fluent in any you favour. This is all part of the artist's technical trade, and although that may sound a bit mundane, in fact it is where the fun intermingles with all the hard work.

PENCILS

In the first two exercises you will be exploring different types of pencil and the tools that accompany their use. You will need: pencils in grades B, 2B, 4B and 6B; a clutch, or propelling, pencil that takes an 0.5mm lead, which will give you a line of constant width; and a graphic stick of either 2B or 4B grade to use for large strokes and a soft build-up of tone.

You will also require an eraser to remove unwanted marks – but use this as little as possible unless you are deliberately drawing into a tonal area with it to create highlights. A kneadable putty eraser is good, but a soft normal eraser is useful as well; I use both types. Avoid very hard erasers, which tend to tear the surface of the paper.

A stump or paper stub, which is a tool designed for smudging pencil work, will help you to obtain a smooth tone of grey. The size isn't too important, but a thin one and a thicker one would be useful. You will only find these in art supplies shops.

A digital camera, if you have one, is useful for taking photographs of your subject matter to give an objective record that can inform your drawing, either at the start or afterwards to correct any obvious mistakes. This is not cheating, as artists have always used as many aids to their drawing as possible. After all, drawing itself is an illusion, so using other means of making the drawing more convincing is a good thing. Art cheats all the time.

Exercise 1

So start by drawing a simple still life of one or two objects. As you can see, I chose a bottle and wine glass, placing them close together so that there is an overlap of shapes. Draw yours as easily as possible, with a wavering, softly defined set of lines that gradually begin to show the shape of the objects. This is line drawing at its most enjoyable and easiest. It allows you to make approximate marks that do not have to finally define the shapes at once but allow you to explore into the representation, so don't get too fixed on a single idea.

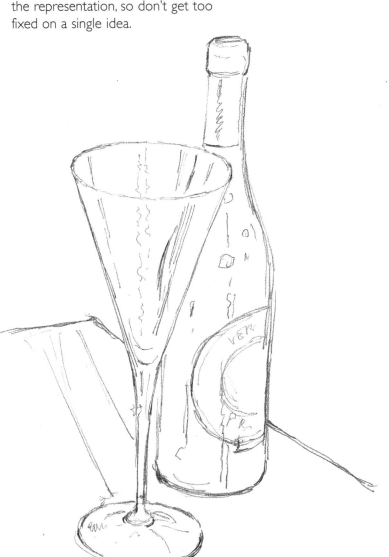

Having tried that, now have a go at drawing the same objects again from the same point of view, only this time more definitely. You have done your exploratory drawing and now have a much better idea of how the picture should look, so you can take the time to be more precise. Use your eraser for correction until you have a simple line drawing that looks convincing.

Exercise 2

Now try a larger composition that will take your drawing skills a bit further, while not being so difficult that the result is likely to be disappointing for you – it's easy to be discouraged if you overreach yourself as a beginner, and that doesn't help your confidence grow. I have chosen a basket of apples, pears and tangerines, which is complex enough to be a challenge without being downright hard to do. First of all, map out the main shapes rather in the way that you did with the first line drawing. Use your eraser at this point to correct any obvious mistakes before moving on.

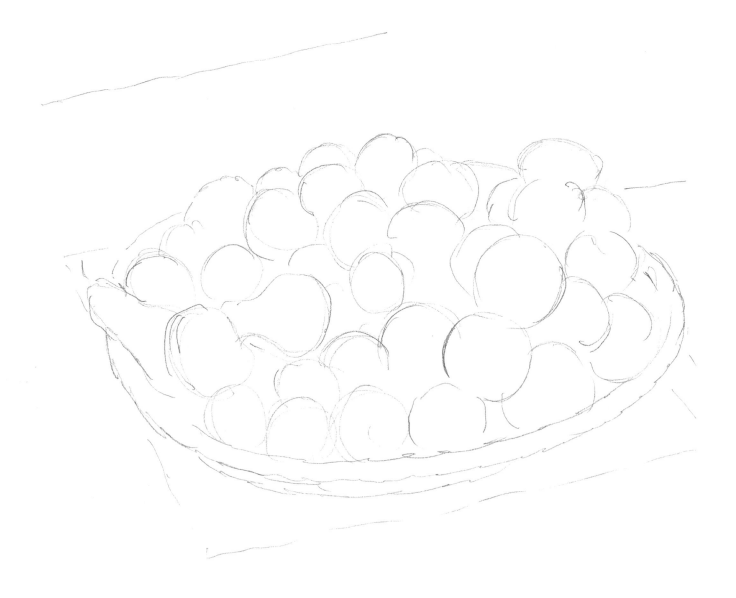

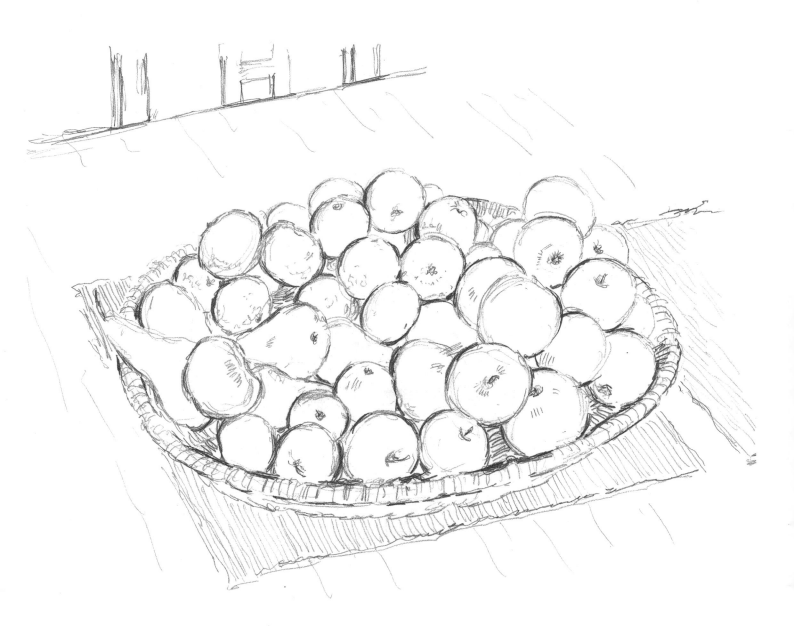

When you are satisfied with your outline go over it carefully, building the denser tones around the shapes of the fruit and basket so that you begin to show a more intense version of their volume. Don't build up a lot of tone, however – keep the drawing to the least possible needed to show the solidity of the shapes. This is rather like the way Cézanne built up the substance of his drawings.

PENCIL: ADDING TONE

Exercise 1

Now we go for the tonal values of a drawing – that is, in this next drawing you will start in the same way by delineating the outline first and then going on to build up the drawing tonally in areas of shading and texture. Here the point is not to emphasize the edge, or linear look, of the drawing, but the light and shade at the expense of the line. When you have finished, the drawing should look as though there are no obvious lines, just areas of tone in different depths.

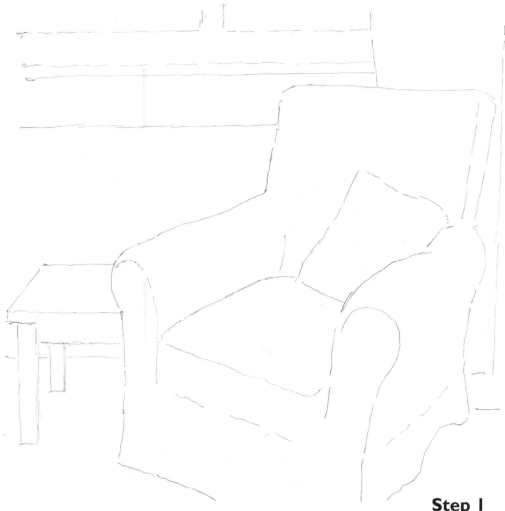

Step 1

I have chosen an armchair under the light of a window because the shapes are large and relatively simple. This enables me to avoid becoming too caught up in the details of the linear form, as all the shapes are easy to draw. Keep your own outlines as simple as possible and avoid any fiddly detail.

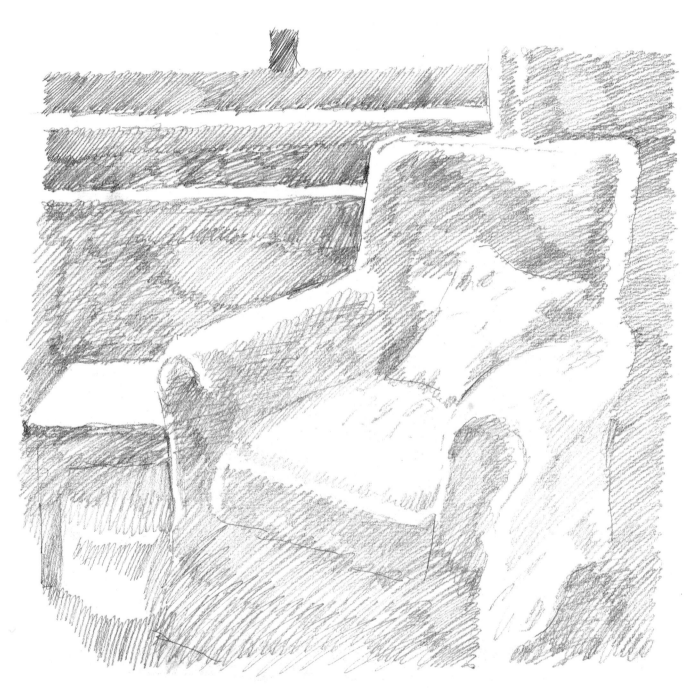

Step 2

Now choose a tone that corresponds to the lightest tone in the picture other than the highlights, and put this uniformly over every area except where there are highlights, leaving those as untouched white paper.

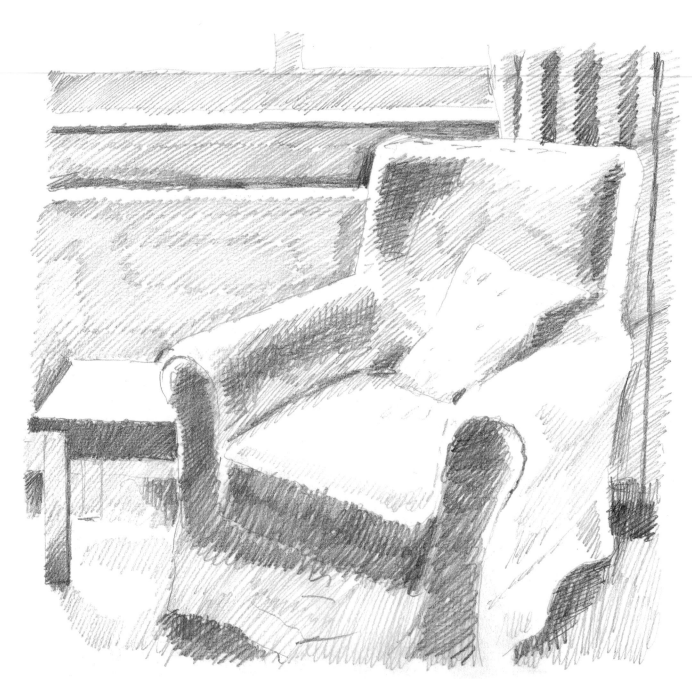

Step 3

Having done this, you no longer have the outline as the dominant characteristic but large areas of light tone to deal with. Now, very carefully, build up the darker tones until you have a well-defined mass of tonal values that show you the main shapes of the form.

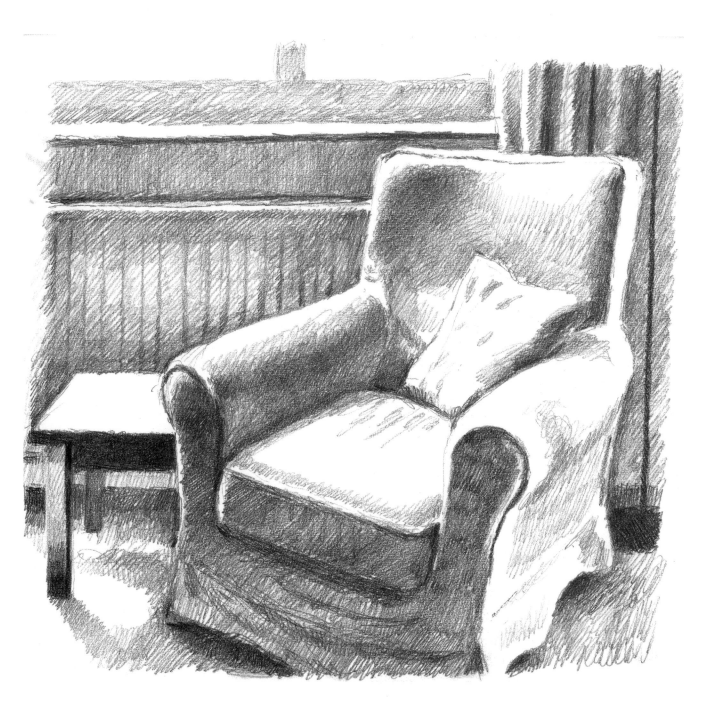

Step 4

The rest of your task is to gradually build up each area of tone until the greater subtleties of the form begin to show. Continue until you are satisfied that your drawing looks like the actual forms in front of you. This can take a long time – maybe two or three hours – but it's great fun and very valuable to your practice.

Exercise 2

For the final exercise in this practice in pencil drawing, I have drawn a complete composition of an accidental still life of a bowl of pea-pods, a pair of shoes and a bunch of flowers lying by a doorstep. In this drawing the process is similar to the ones that you have just gone through, but there is no emphasis on either line or tone – everything is used to achieve the most convincing portrayal of the subject.

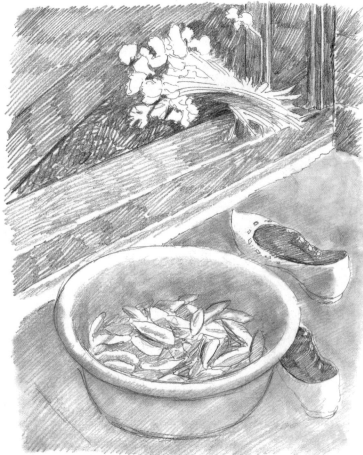

First make an outline drawing to define the main shapes, then build up both line and tone until you achieve a believable picture of the scene. Any tricks are permissible in this drawing, including the use of an eraser to define some of the lighter areas, which may become obscured by tone.

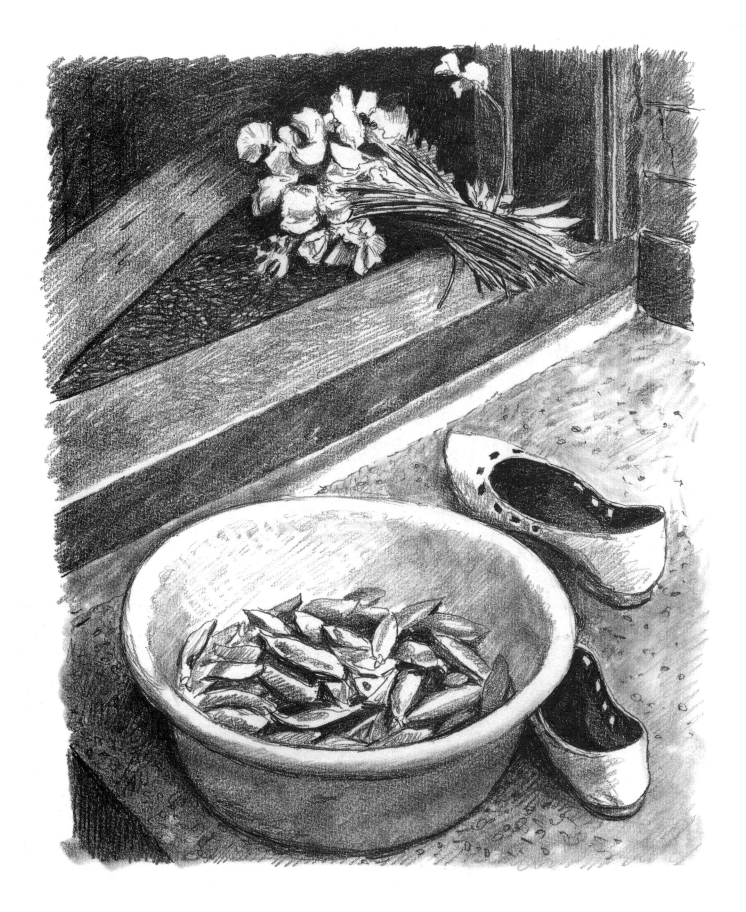

■ PASTELS

Pastel is a time-honoured medium in all its various guises, which include soft chalks and charcoal. The very softest pastels, which are usually rounded in section, are favoured by many artists, but they are expensive and are used up quite quickly. There are harder versions which are very good; these usually come in a rectangular section.

The type of charcoal most often used is known as willow charcoal, which has a very soft texture. This can be employed for any kind of drawing but tends to work best on a large scale. You can smudge it with your fingers or a tissue, or use a stump as with pencil drawing. Ideally, you should equip yourself with sticks of varying width and try them out first on a spare piece of paper as charcoal is quite crumbly if used too heavily – indeed, one of its great advantages is that it makes you handle your medium lightly. It can also cover the paper quickly and is quite easy to erase.

Conté is a form of compressed pastel or charcoal which is simple to use and doesn't crumble too easily. It has always been popular for drawing purposes. It also comes in a pencil form, sometimes called charcoal pencils. These are not quite so versatile as the stick form but are cleaner to handle.

Charcoal and pastel smudge easily, so you will need some good fixative to spray over your drawing after it is finished. This is available from art supplies shops.

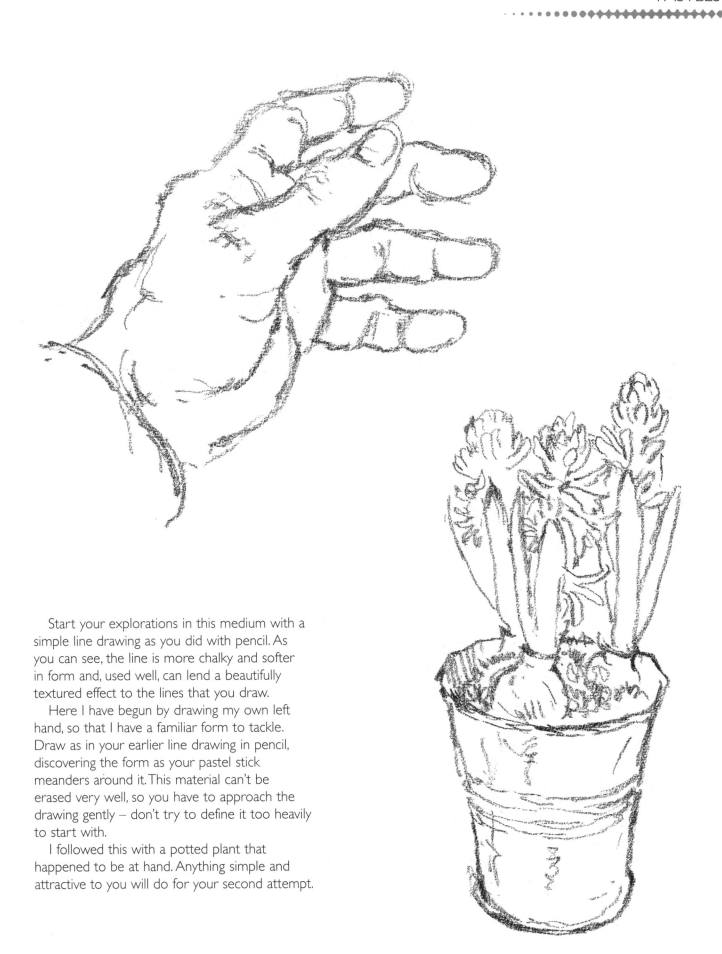

Start your explorations in this medium with a simple line drawing as you did with pencil. As you can see, the line is more chalky and softer in form and, used well, can lend a beautifully textured effect to the lines that you draw.

Here I have begun by drawing my own left hand, so that I have a familiar form to tackle. Draw as in your earlier line drawing in pencil, discovering the form as your pastel stick meanders around it. This material can't be erased very well, so you have to approach the drawing gently – don't try to define it too heavily to start with.

I followed this with a potted plant that happened to be at hand. Anything simple and attractive to you will do for your second attempt.

■ PASTEL: ADDING TONE

Exercise 1

To make the next stage easier, draw from a photograph
rather than from a real person. Make sure the
photograph is a good one with plenty of tone in it. One
of the problems with using photographs for reference is
that they never give you as much information as your
eye gains from real life, but at this stage that's an
advantage because it allows you to analyse the tones
more easily.

Remembering that in this medium you cannot erase
your lines much, draw in the main outline shapes of the
face and head.

Then, as you did with the chair,
put a single tone across the
whole picture where there is
tone on the photograph,
keeping it as light as possible.

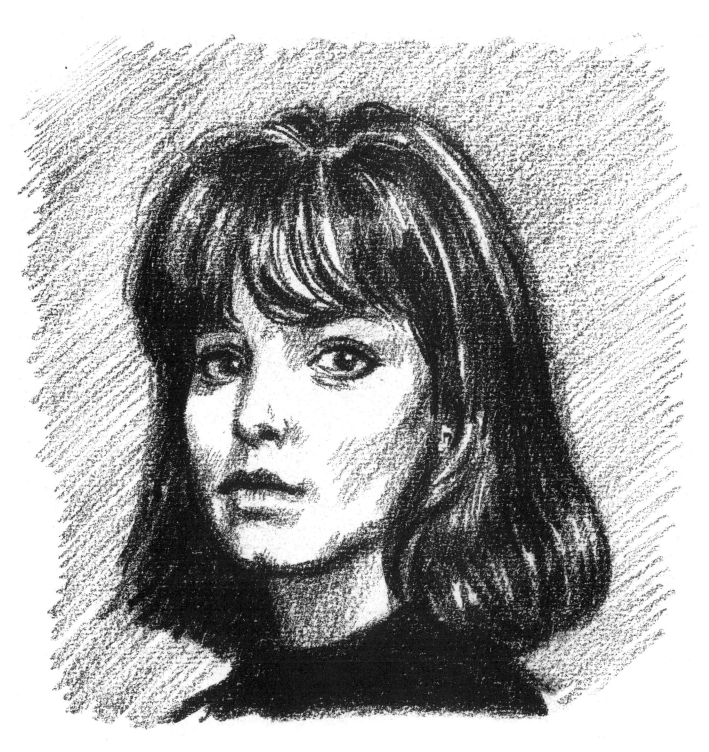

Lastly, build up the stronger tones so that the picture
starts to look like the photo you have been copying.

Exercise 2

Now try a simple still life that will test your skills with the medium acquired so far. I took a group of three jugs sitting on a dresser with a dark background.

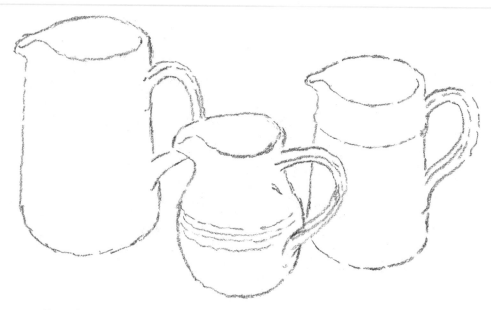

First draw in the main shapes as usual. Be gentle in your handling of the pastel or conté and as careful as possible to get the shapes right.

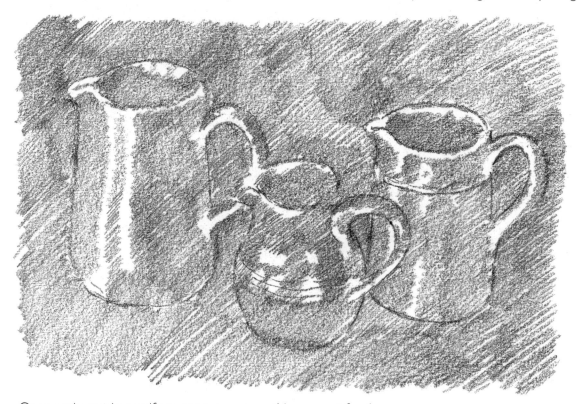

Once again, put in a uniform tone over everything except for the areas caught by the light. In my example the jugs were quite dark in tone but of course, with a relatively shiny surface, the highlights are very bright.

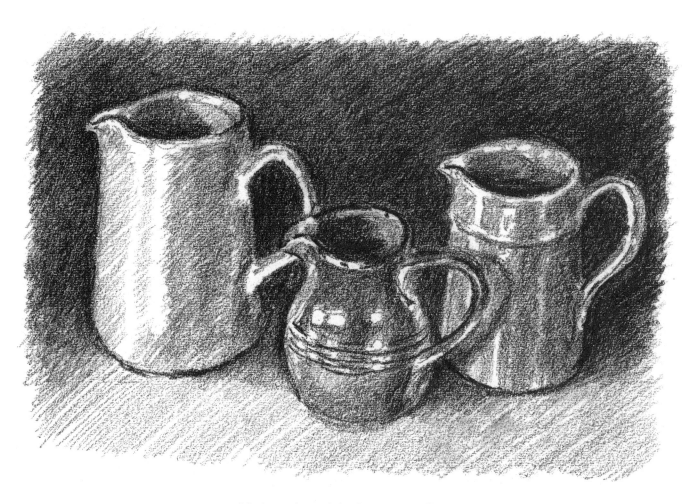

Having achieved the basic area of line and tone, now build up the tones until your effect is as near to what you can see as possible. Notice how the medium gives a very solid and textured look to the drawing – you will be able to see why this medium is a favourite with many draughtsmen. Don't forget to fix your drawings to prevent them from being smudged.

■ PEN AND INK

In this medium the line is paramount, and the tonal areas are built up with multiple lines or other marks. Because of this it is a slow medium for large drawings, but ideal for very small ones on account of the fineness of its marks.

There are many varieties of pen and ink to use, the traditional one being Indian ink applied with a dip pen. This ink is available in both permanent and watersoluble forms. I find the acrylic versions of it less good because they tend to gum up the pen nib rather rapidly. Indian ink is very black and definite, but the watersoluble type can be thinned to almost any degree of tone.

You will need to use a dip pen with a fine pointed nib designed for drawing, as opposed to calligraphy, for example. These can be bought in art supplies shops and other specialist outlets. The nibs come in several sizes and qualities of fineness, so you might have to experiment before you find the size you prefer. I always use the finest point I can obtain, but that's my preference. The flexibility of the nibs varies, which again is a matter of experimentation to find what suits you best.

There are also numerous graphic pens with their own ink supply and nibs in various grades of fineness. The one I use the most is the finest one, which is 0.1, but I sometimes also use grades 0.3, 0.5 and 0.8. Again you should try out different sizes to see which you prefer. The only drawback to these pens is that you have to throw them away when they run out of ink. A bottle of ink and a dip pen will last much longer and can be finer even than a 0.1.

For large areas of black you will need a large marker pen. These come in varying sizes and use the same sort of ink as the finer graphic pens.

Now for some drawing. First try this sphere or ball, apparently sitting on a surface with a dark background. This was not drawn from life at the time but is a construct based on observation as to how light shows the shape of a spherical object. Notice how the texture of the tones is built up with numerous fine lines crossing over each other. This technique, called cross-hatching, can be controlled to show both light and dark tones – if you persevered you could ultimately achieve a solidly black surface.

The trick of this type of illusion is to space your lines carefully so that the difference between the darkest and lightest tones is subtly graduated. Notice how

putting the sphere against a dark background helps to throw it forward in the apparent space, and how the crescent of tone defining the sphere is darkest not at the very edge but slightly in from it. This imitates the reflection from the surface of the plane the sphere is resting on.

Next try a straight line drawing of a person in exactly the same way that you did with the pencil drawing – but remember that you can't fix errors with an eraser and go gently, using very delicate lines to explore the shape of the head.

Finally, draw some ordinary household objects from life, again restricting yourself to basic line drawing.

A STILL LIFE IN PEN AND INK

In this exercise you are going to take on the challenge of drawing a complete composition in pen and ink. Don't attempt a large-scale drawing at first – when you are more practised in the medium you can expand the size of your drawings, but it will take time.

I took a fairly simple still-life composition which does however have quite dark tones in it. This means that I had to work quite fast to get all the areas of tone built up to my satisfaction. If you want to avoid a lot of mark-making, choose a more brightly lit subject.

One of the tricky things about ink is its finality, which means that before you start on the ink drawing you may want to draw the outline in pencil to ensure that you have got the shapes right. This is how most commercial drawing in ink is done. You can then rub out the pencil before you proceed with the rest of the drawing. Drawing in ink without first drawing in pencil is fun, but is something you can try out when the result is less critical.

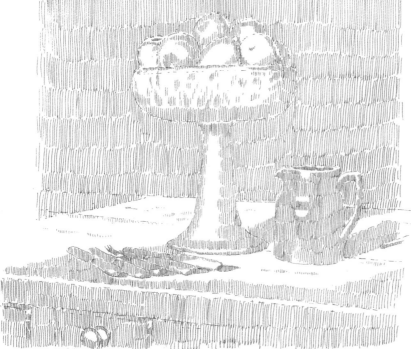

Having produced a pencil outline of your composition, go over it very lightly in ink as shown here.

Then, as before, build a simple light tone over all the parts that are not highlighted, using vertical lines. As you can see the outline almost disappears when you do this, so don't make your lines too heavy or you will find it hard to see your composition amid the tone.

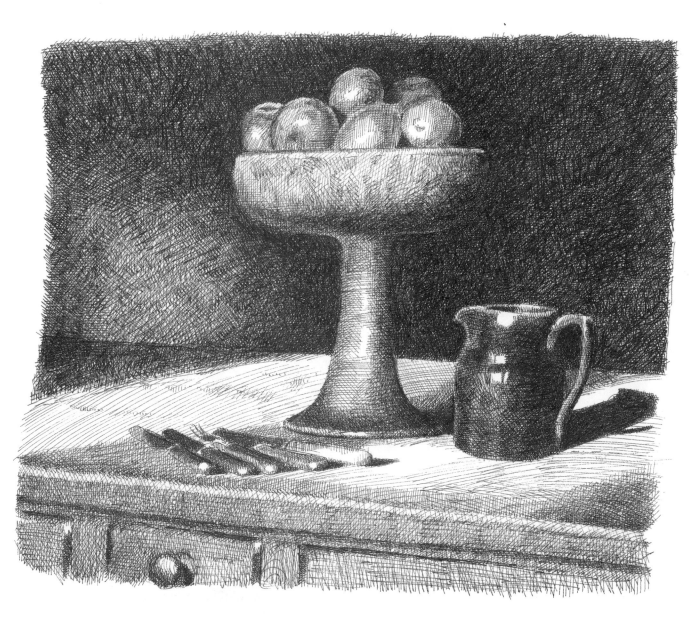

Now comes the build-up. Put in the slightly darker tone with multiple diagonal lines and then the next darkest with horizontal lines and so on, with lines going in the opposite diagonal to build even denser shadows. When you have done lines vertically, horizontally and in both diagonals, you will have to use strokes going in as many directions as you can to build up the very darkest shadows. Use curved lines as well and scribbly marks to fill up any areas that look too light in tone. This will all take quite some time, so you have to be prepared to put aside time for this medium.

■ BRUSH AND WASH

The technique of brush and wash is rather like traditional watercolour painting but without the colour, being only black and tones of grey. In my opinion the best medium is a black watercolour pigment, but some people prefer a diluted ink.

For working in this medium you will need: black watercolour pigment or black watersoluble ink; a china or plastic watercolour palette in which to dilute your pigment or ink; a jar for water, preferably glass so that you can easily see when you need to change the water (for a long session of work two jars are useful); and at least two brushes, sizes 2 and 10, to start with (later you may wish to add a size 6 and a really fat brush, especially as you get more expert). These should ideally be sable round brushes, which hold the most liquid and come to the best point and are correspondingly expensive, but if you don't want to spend large sums until you are sure you enjoy using the medium you can buy squirrel hair, or even nylon, which are adequate for a short time but lose their point fairly soon.

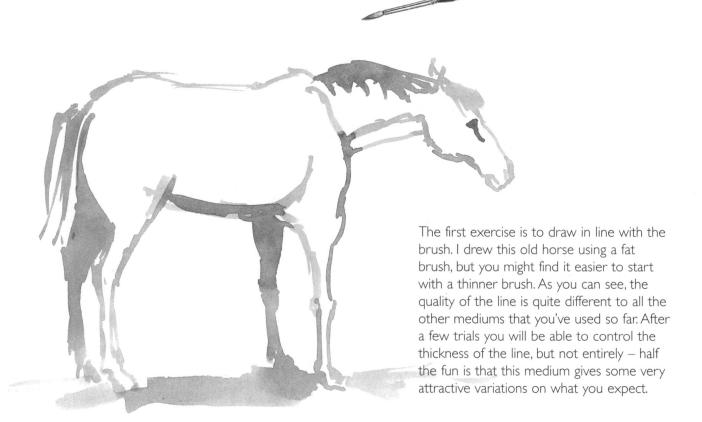

The first exercise is to draw in line with the brush. I drew this old horse using a fat brush, but you might find it easier to start with a thinner brush. As you can see, the quality of the line is quite different to all the other mediums that you've used so far. After a few trials you will be able to control the thickness of the line, but not entirely – half the fun is that this medium gives some very attractive variations on what you expect.

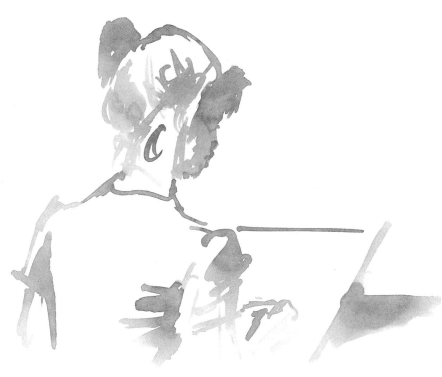

Then I drew a young girl practising her own drawing, again using the variation in the thickness of line to advantage. I wasn't too concerned about the light and shade in these first drawings, but sometimes when I saw an obvious area of tone I put it in with a quick flick of the brush. The small tube of paint was done in exactly the same way.

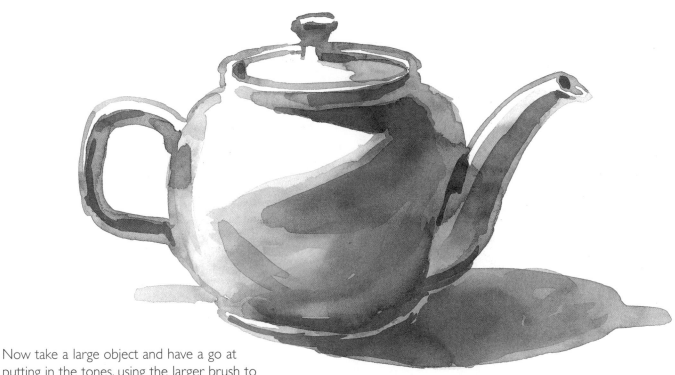

Now take a large object and have a go at putting in the tones, using the larger brush to apply your liquid quickly enough before it dries. The blending of tones is quite easy when it is still wet, but for the darker, more defined marks I waited until my paint had dried. You have to be both fast and patient with this medium.

■ A STILL LIFE IN BRUSH AND WASH

Having had some practice, you should feel confident enough with your handling of the brush to try something a bit more ambitious. I have chosen to use the same still life that figures in the pen and ink section. This way you can see how vastly the two techniques differ, while both arriving at an interesting result.

First you will have to draw out the shapes you are going to use with the thinnest brush, but if you are still doubtful of your ability to do this, just draw in pencil first and then go over it with the brush. Erase any pencil work left showing before you continue.

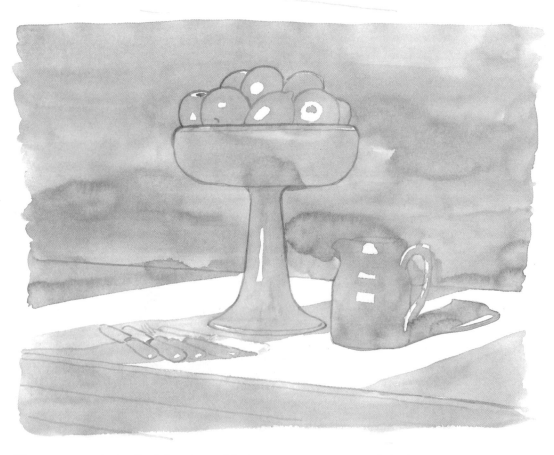

Then, once again, lay the lightest possible tone over every area of shadow in the picture. Leave only the very brightest areas of paper white and make sure you do not cover them over in subsequent layers.

Now gradually build up the tones until you get to the deepest black where it is needed. Be careful here, as it is easy to darken tone too quickly and then find you have overdone it. And there you have your complete composition, which you can compare with your pencil, pastel and pen and ink drawings.

■ **MIXED MEDIA**

The last technique we are going to explore in this lesson is working with mixed media, combining some or all of the techniques used so far and also introducing collage with paper.

The first subject is simple enough and I've chosen it as one that lends itself to a variety of mediums. This is a fairly flat, graphic kind of drawing, which I delineated carefully in a thin pencil line. Then I proceeded to draw in the hair and facial features with indelible ink from a graphic pen No. 0.1.

Next I took a pencil and drew in the texture of the jumper and the folds of the skirt, trying not to let the various mediums overlap each other. The only exception to this is on the face, where I put in a little shading.

Following this I painted in the background tone and the face and arms. Once that had dried I went over the face and arms again, because the skin tone is darker than the background. Finally I added the dark, rough-textured doorframe to the side using pastel, then fixed it to prevent it from smudging over the rest of the drawing.

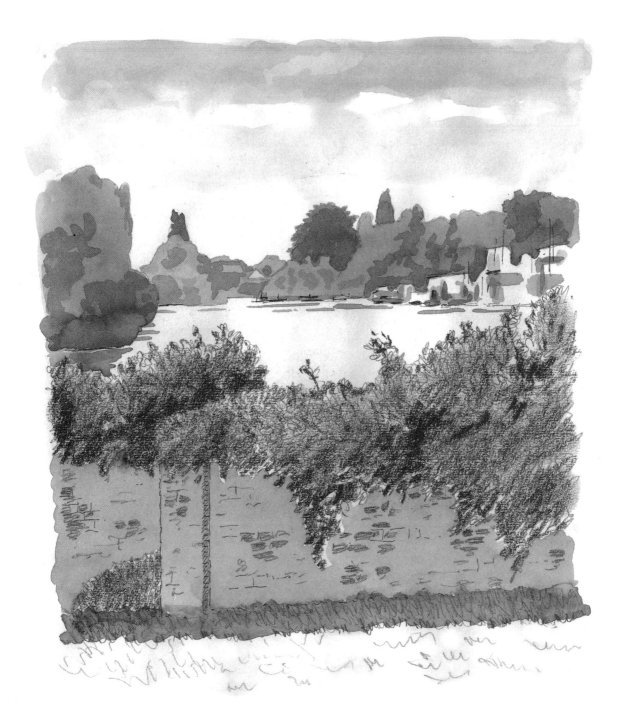

Next up is a similar exercise but with a small landscape, which you can try out from life. This view along the River Thames near Twickenham was drawn in summer, which in my view is the best time for landscape in England. Using a pencil, I lightly sketched the outline of the whole scene and then proceeded to work from the top downwards.

All the area above the foreground wall was done in wash and brush, achieving as much subtlety in the scene as I could. I then added a few pen and ink marks to the boats gathered by the side of the river. I carefully built up a texture in pencil over the whole of the vegetation growing over the wall, and put in some similar marks to indicate the brickwork on the wall and grass on the lawn.

Having done this I then covered the area of the wall and its shadow on the grass using a watercolour wash, making the shadow slightly darker than the wall.

Finally I scrawled in the wall vegetation with a charcoal pencil in order to give it a coarser texture than that of all the other vegetation, smudging it slightly with my thumb.

This larger composition is of architecture and trees in Eccleston Square in London. Choose a similar scene of buildings and trees near to your own home – one that you can stand back from to view it at a reasonable distance.

Here I started by placing on the left-hand side of the picture a piece of paper that was cut out on the inner side and torn on the outer. I stuck this down with paper glue so that I could work on top of it.

Using a pencil, I drew in all the main lines of the windows, trees and railings. Then I went over all the details of the buildings in pen and ink, some parts quite sketchily and other parts more well-defined.

With the conté pencil I marked in the large trees and vegetation, and some of the tones on the collage. Then, with a brush, I washed in the larger shadows on all the buildings and over the conté scribble of the trees and other vegetation. I used two tones of watercolour wash to achieve an effect of depth.

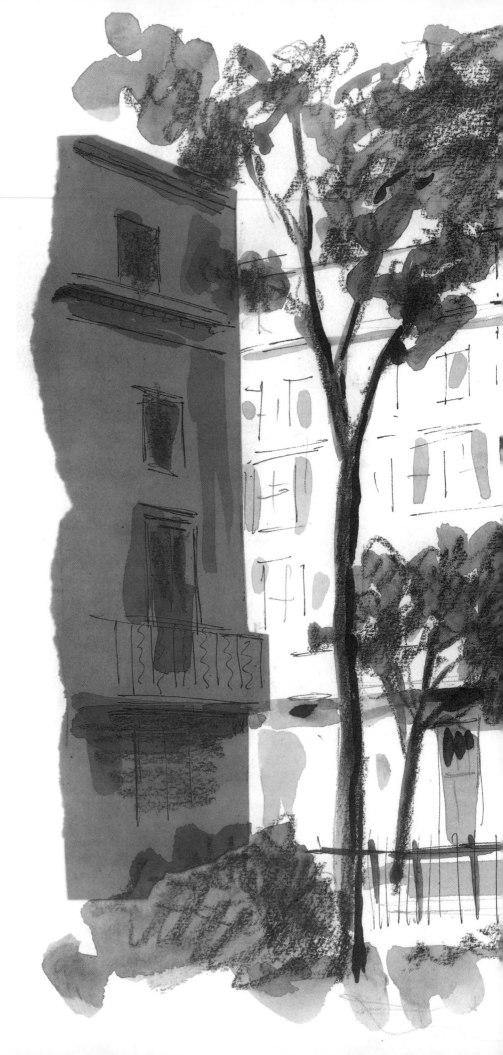

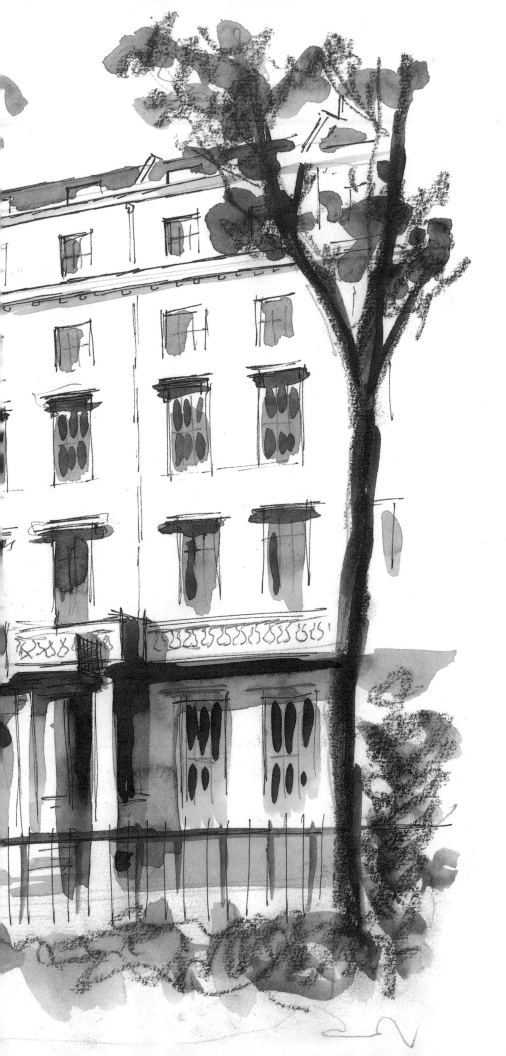

■ LESSON **7**

PERSPECTIVE AND FORESHORTENING

As yet we have only considered perspective very briefly, so this lesson deals with it in more detail as it's an essential part of drawing visually believable pictures. The principles are not too difficult to understand and master, but some practice will be required before it becomes second nature and you are able to use it almost without thinking about it.

The first stages of learning about perspective are very theoretical and until you begin to apply it in practice you'll probably find it rather confusing; it's also not totally convincing without the application of direct observation as well. That is why those computer-generated apparently three-dimensional pictures always look slightly unreal. They work at a glance but if you have time to study them they don't have quite the subtlety that the observed world does.

With a bit of practice at drawing perspective you'll soon begin to see how it works in real life and you'll be able to make all the subtle adjustments that help to make your drawings more convincing. It may seem a rather dry topic, but do make sure you can handle this systematic rendering of the visual world before you get into the habit of drawing things that just don't look quite right to the viewer.

■ LOOKING AT PERSPECTIVE

The art of perspective is to convince the eye that it is looking at a scene in three dimensions, with depth and space. Here I have devised a series of exercises which, if copied exactly, will give you a good idea of how perspective views may be drawn.

ONE-POINT PERSPECTIVE

The first exercise deals with what is called one-point perspective. This means that there is only one point on the horizon line that all the main lines of the composition lead to. All other lines will be either horizontal or vertical.

Start by drawing the horizon line across the page from left to right; in real life, the horizon will always be at your eye level. Make sure that it is parallel with the top and bottom edge of the paper. Now, from a point in the centre of this horizon, mark your one and only vanishing point. From this point draw five angled lines, two to the left and three to the right of the vanishing point.

Next, carefully put in six vertical lines that are parallel with the sides of the paper and perpendicular to the horizon, two to the left of the vanishing point and four to the right. These will represent the facades of three large blocks that will appear to stand in the space between the horizon and the foreground.

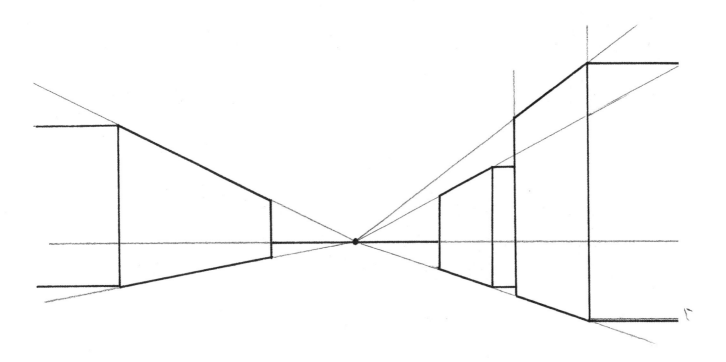

Finally, you will need to put in six horizontal lines that start from the top and bottom of these verticals, on the left striking off to the left and on the right striking off to the right. Now, when you rub out your guidelines, you will have what appear to be three large blocks set in the space described.

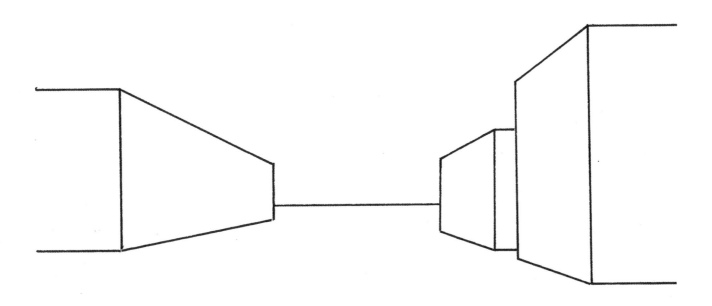

TWO-POINT PERSPECTIVE

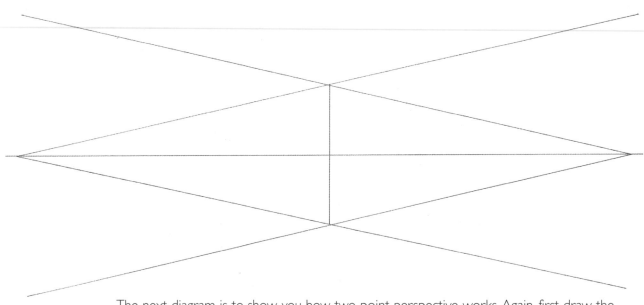

The next diagram is to show you how two-point perspective works. Again, first draw the horizon line across the page, making sure that it is parallel to the top and bottom edges of the paper. Then mark two vanishing points, one on the far left and one on the far right. In the centre draw a shorter vertical line, perpendicular to the horizon and bisecting it, as shown. Now draw lines from the vanishing points to meet the top and bottom of the vertical line at the centre, and extend them across the page, as shown.

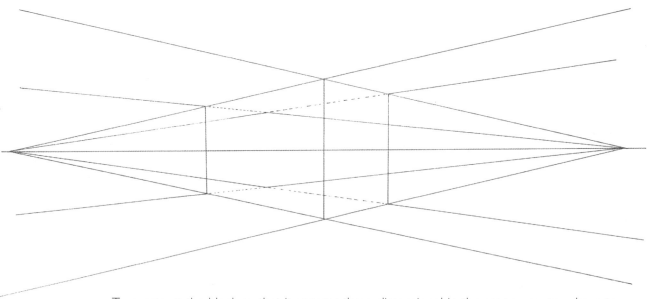

To construct the block so that it appears three-dimensional in the scene, you now have to draw two more verticals, parallel to the first, the one to the left further from it than the one to the right. End them both at the lines of perspective, top and bottom, that you have already drawn. Then from the two vanishing points draw two more perspective lines from the left crossing over to meet the top and bottom of the vertical on the right, and from the right to meet the top and bottom of the vertical on the left. This produces a framework for the block apparently set in space.

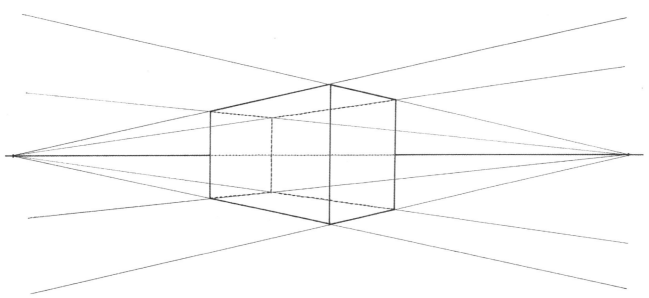

To complete the illusion of a transparent block you will need to draw in the last vertical, which would be hidden if the block were solid. This spans the points where the last sets of perspective lines cross each other. So once again you have drawn an apparently three-dimensional block, but this time transparent.

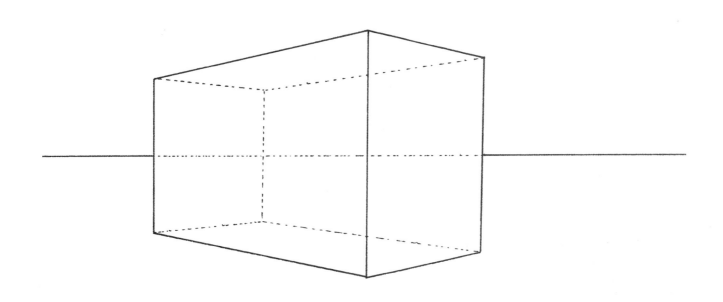

THREE-POINT PERSPECTIVE

Three-point perspective is not often used, but I am demonstrating it here as it helps to complete your understanding of how perspective works. It applies to drawing very tall buildings, and is not so easy to see in real life unless you are standing near the foot of one.

First, as before, draw a horizon line across the paper, and after fixing two vanishing points to the left and right, join them to a long vertical drawn in the centre as before at the top and bottom, only the top point should be as far up as you can get on the paper, while the lower point should be close to the eye-level line. This, as you can see, creates a very tall quadrilateral.

Now draw two lines either side of the central vertical so that they incline equally inwards at the top, as if you had a third vertical vanishing point somewhere high above the horizon – so high above, in fact, that you would need an enormous sheet of paper to accommodate it.

Draw in some more lines from the two vanishing points that you can see to indicate different levels on the surface of this tall block, so that it looks like a sky-scraper.

This diagram is more like the form you might actually see, but it would require a massive sheet of paper to actually draw it as a complete diagram.

A few more off-vertical lines on one side of the block will increase the drama of the perspective and will give an impression of a tall building, seen from below. Of course, the angularity of the block is vastly exaggerated, but one can get the idea. Remember, perspective is only a way of helping to cheat the eye to believe in the solidity of buildings and the depth of space – it tends to break down if you try to take it too literally.

▪ **A PERSPECTIVE DIAGRAM**

This purely diagrammatic exercise is intended to give you practice in drawing perspective, so that eventually you will be able to draw it without all the construction lines because your mind has absorbed its principles. The co-ordination of the eye and mind is melded by repetition and practice.

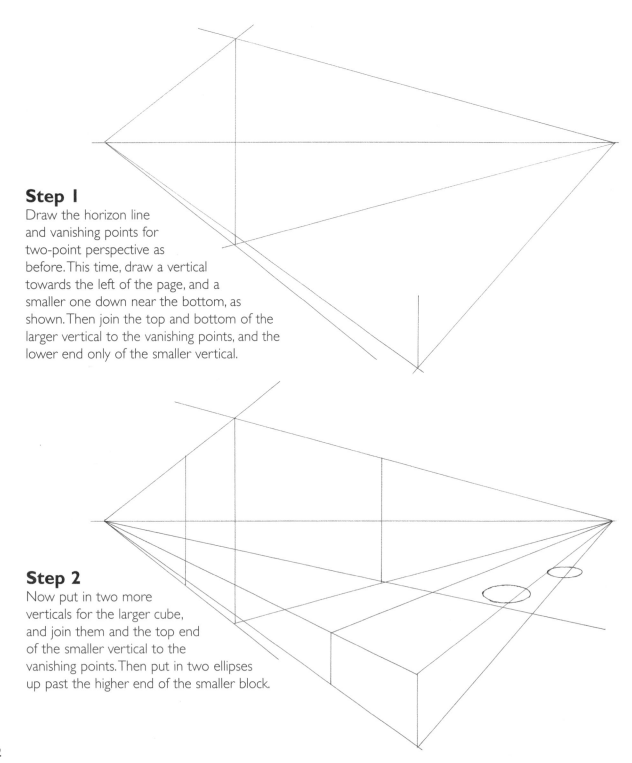

Step 1

Draw the horizon line and vanishing points for two-point perspective as before. This time, draw a vertical towards the left of the page, and a smaller one down near the bottom, as shown. Then join the top and bottom of the larger vertical to the vanishing points, and the lower end only of the smaller vertical.

Step 2

Now put in two more verticals for the larger cube, and join them and the top end of the smaller vertical to the vanishing points. Then put in two ellipses up past the higher end of the smaller block.

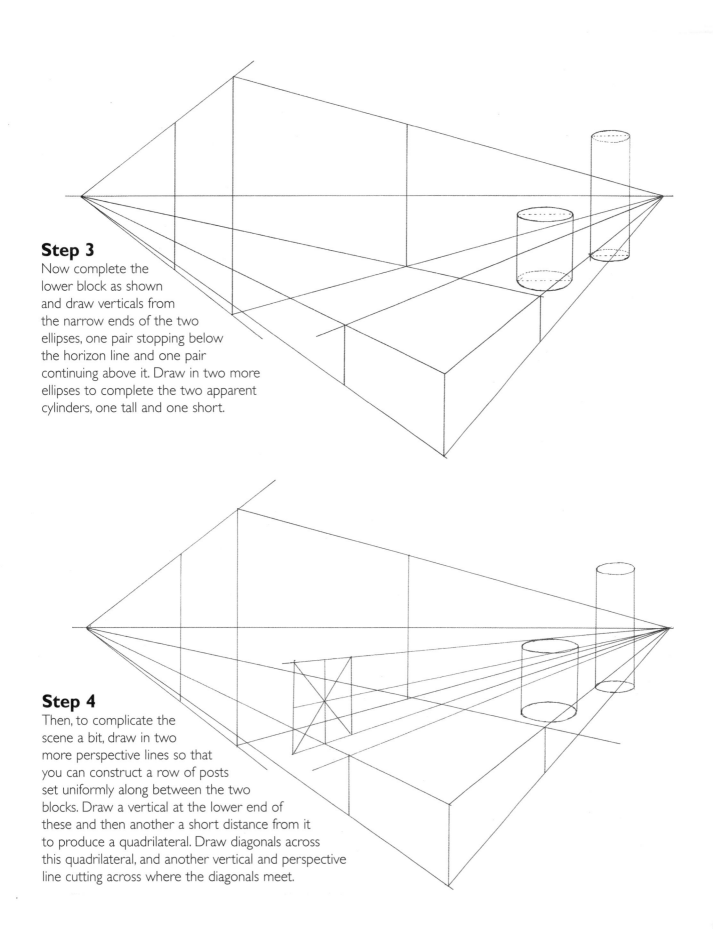

Step 3

Now complete the lower block as shown and draw verticals from the narrow ends of the two ellipses, one pair stopping below the horizon line and one pair continuing above it. Draw in two more ellipses to complete the two apparent cylinders, one tall and one short.

Step 4

Then, to complicate the scene a bit, draw in two more perspective lines so that you can construct a row of posts set uniformly along between the two blocks. Draw a vertical at the lower end of these and then another a short distance from it to produce a quadrilateral. Draw diagonals across this quadrilateral, and another vertical and perspective line cutting across where the diagonals meet.

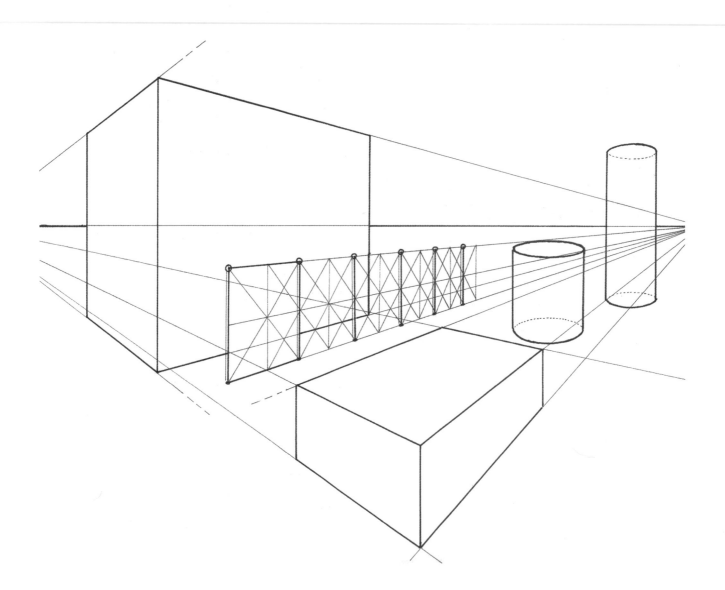

Step 5

Using the method shown on page 163 to draw a row of posts in perspective, keep producing diagonals that use the next central point to construct another vertical until you have a whole row of them.

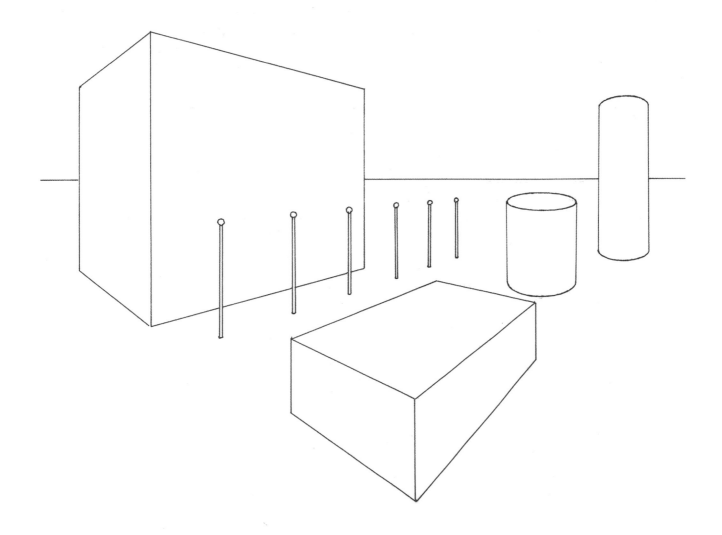

Step 6

When you have erased your construction lines the whole diagram should look like this. This exercise can take a bit of time, but it is well worth trying out to consolidate your perspective drawing skills. The result should be solid-looking and convince the eye.

A SCENE IN PERSPECTIVE

Using the techniques of showing perspective that you've just been learning, you are now going to draw an urban scene. You should have largely got the hang of how to construct the drawing of architectural forms so that you can produce a convincing picture, but if you're not satisfied with the end result, don't be discouraged – everything will slot into place with repetition of the basics.

This is essentially a perspective exercise, but approached in an artistic rather than scientific way.

Your eyes will give you all the information that you need to draw accurately, but your perspective studies will help the mind to make more sense of it and ease the process of drawing. Choose a location that is easy for you to draw and check on the weather before you start to ensure that rain or wind won't make things more difficult for you.

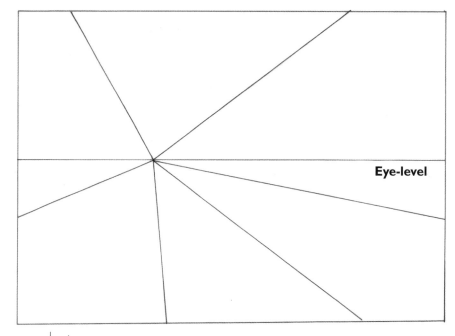

Here is an outline drawing of a street by the Arno river in Florence, Italy. I haven't included any human figures or cars to make it easier to see the perspective.

Now look at this diagram of the perspective lines that underlie the original drawing, consisting merely of the horizon line and the main lines that join at the vanishing point. These should inform your own drawing, even if you don't actually put them all in with a ruler. So your task is to find a street scene and, if it looks too complex, simplify by leaving out any street furniture and buildings that confuse you. Draw from life, at the scene, bearing in mind what you now know about perspective construction.

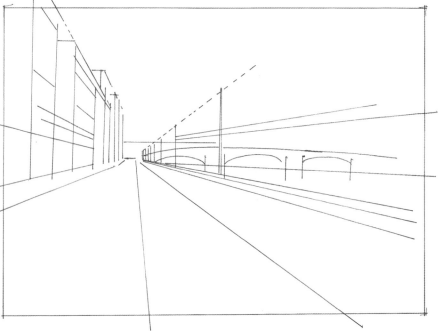

Put in the main shapes first and the details later, when you are sure that the main blocks of the scene are reasonably convincing.

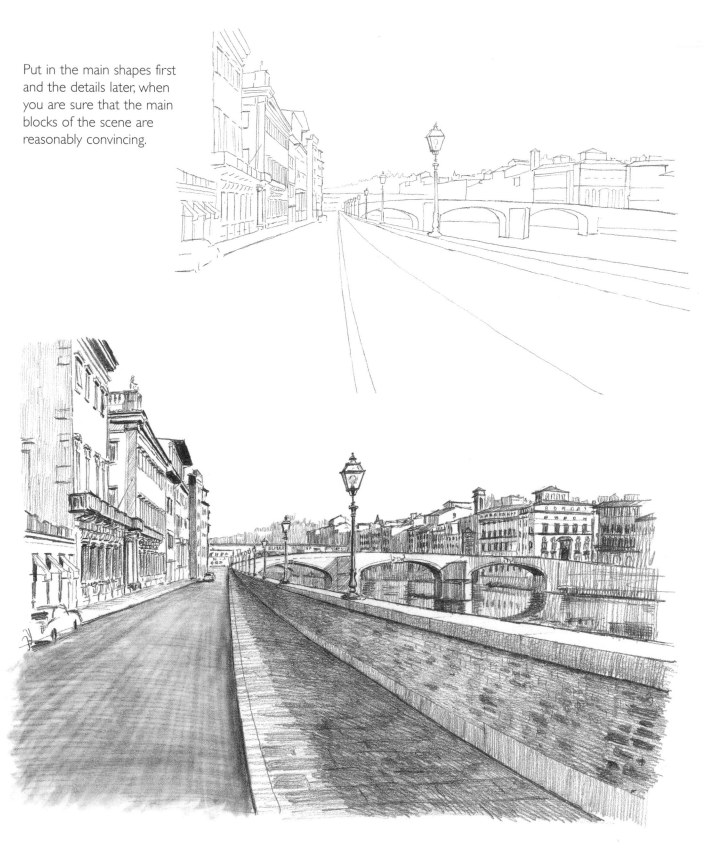

When you have added all the detail you need, put in the tonal areas, using textures to differentiate the various surfaces of the scene. I have given the roadway a smoother texture than elsewhere by smudging the pencil marks with a stump. Notice also how the more distant features have less definition than those in the foreground, which helps to convince the eye of the picture's three-dimensional quality.

FORESHORTENING THE HUMAN FIGURE

Here we are concerned with the effects of perspective on the human body when it is seen from an extreme angle. While you may never want to draw someone lying flat out vertically towards you, it will often be the case that you will draw poses where some parts of the figure are closer to you than others, and the same rules of perspective apply. So the exercise here is to find someone to lie on the ground or on a couch, as flat as possible, preferably on their back. Your position should be seated so that you can see them from the feet and then the head, from an eye-level not far above them.

When you first try this exercise in drawing, the difficulty is in being convinced by the way the legs or head seem to disappear from view, so that there is hardly any length to them in the drawing. It can look unnaturally distorted if you are unused to considering perspective. Nevertheless, your eyes are very good at seeing accurately, and it is only your ideas that make it hard for you to believe what you see. Notice on the male figure how the area covered by the legs and feet is larger than the area of the torso and head, even though we know that, if seen standing up, they would be similar in size.

Also, on the female figure, the head and shoulders seem very big compared to the size of the rest of the body, which recedes from the viewer. It underlines the fact that we perceive objects close to us as larger than those further away. For example, bend your arm, look at your open palm in front of you and watch the size of your hand apparently grow as you bring it towards your nose.

So, when you start to draw your recumbent figure, you may need to draw two lines indicating the way the figure diminishes as it recedes from your viewing point. My two first sketches give you some idea how this might work.

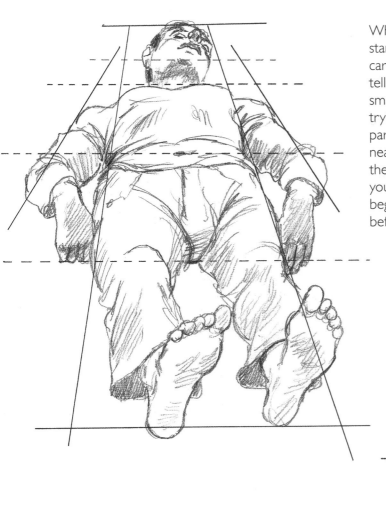

When you have blocked in the main forms quite simply, start to draw in the larger shapes, remembering to carefully follow what you observe, not what your mind tells you. Don't be tempted at this stage to put in any small detail; simplicity and accuracy is what you are trying to achieve. Once again, measure how the far parts of the body appear to you in comparison with the nearest parts to ensure that you don't start to enlarge the former or diminish the latter to accord with what you think the human body should look like – many beginners do just this, and it takes a bit of practice before the message sinks in to the mental processes.

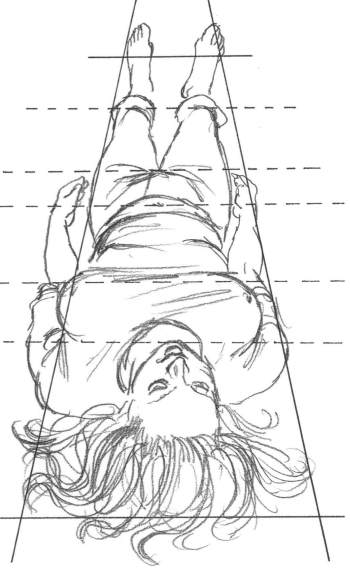

Having arrived at a drawing that you are
convinced is similar to your view of the figure,
proceed to draw in as much detail as you wish,
as long as your model is prepared to stay in
that position for you. It may mean persuading
your model to pose for you on another
occasion, but you should draw someone from
both the foot and head end. It's an interesting
and difficult exercise, but if you didn't find it
difficult you wouldn't be learning anything;
when things become easier, that's the payoff
for the efforts you have put in.

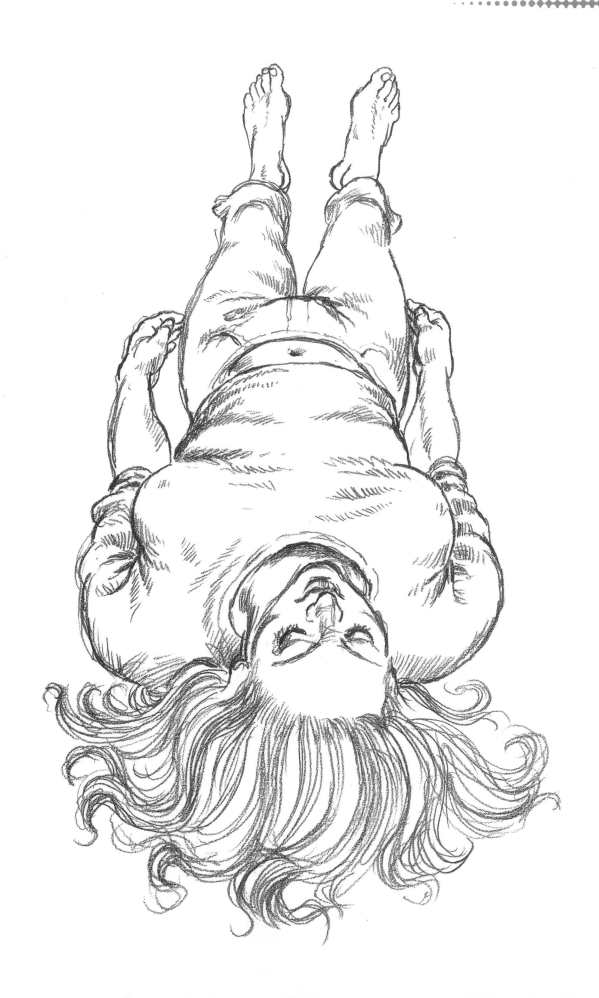

■ AN INDOOR SCENE IN PERSPECTIVE

The final perspective exercise is simpler to stage than the previous ones, because you only have to look around you at the room you are in to see your next subject. That doesn't mean that the task is any easier when it comes to drawing it, but at least you have now had quite a bit of practice of drawing in perspective, so you will be much more confident of tackling the problem.

Step 1

First of all, look at this initial sketch of an interior. It will be immediately obvious to you from your studies so far that this scene is using perspective lines to construct the drawing.

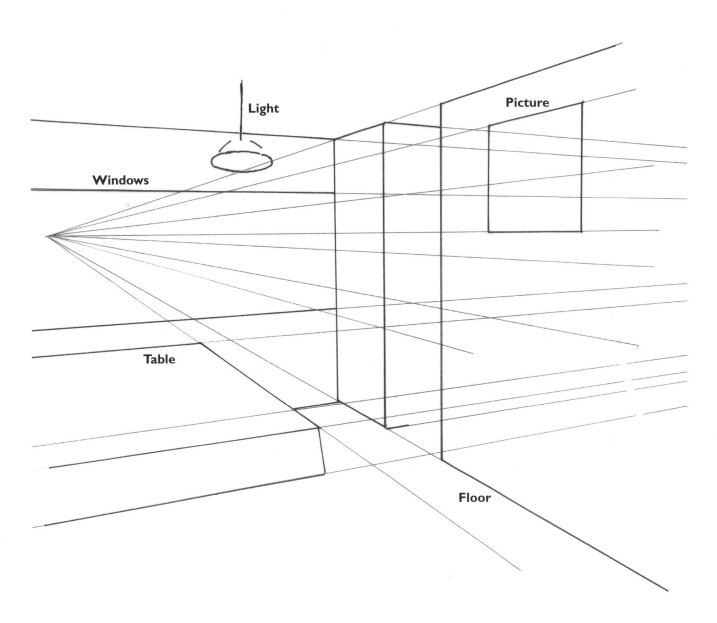

Step 2

The next diagram shows perspective lines laid over the sketch to help verify my view of the room. You will find that the hardest parts of your own room to see properly are those at the periphery of your vision, in which there is often some slight distortion that would look odd in the drawing. You may have to correct or ignore some of the apparent image at the very edge of your vision.

Step 3

Once you've constructed a sketch that you think holds the image correctly, begin to put in the main outlines of the room and furniture within your field of vision. However, if there are any complicated pieces of furniture or objects that make things more difficult, remove them from view or simply leave them out of your drawing. All artists learn to adjust the scene in front of them in order to simplify it or make it more interesting and compositionally satisfying; you can see this in the topographical work of Turner, Canaletto or Guardi, for example. The lines of perspective should enable you to get the proportions of the objects in the scene accurate.

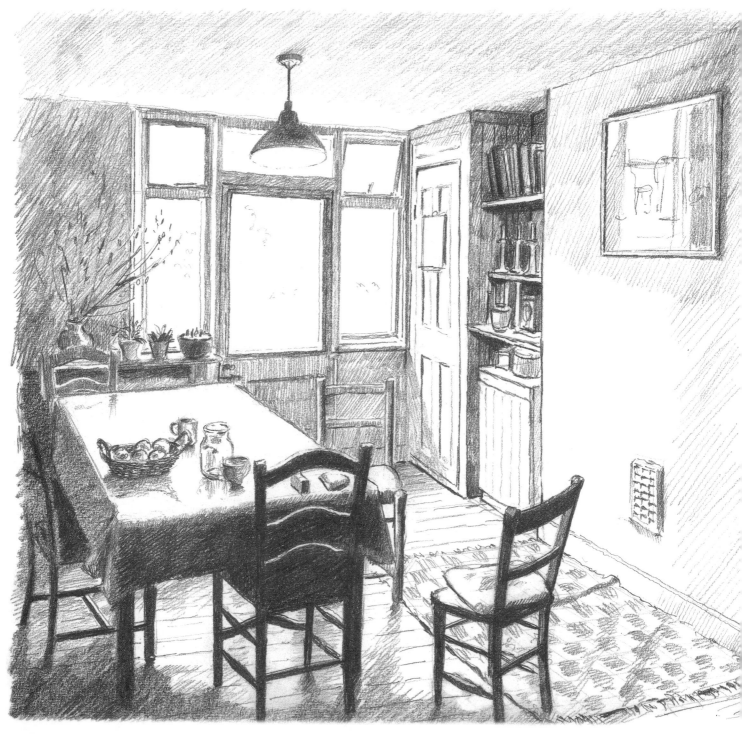

Step 4

You can then work on the tonal values of the scene to give it atmosphere and depth. If you have to leave it and come back later, check that the furniture hasn't been moved and that the angle of light is similar to the time before – if the weather is sunny and you try to resume at a different time of day you will potentially find the lights and darks very differently placed. The lighting in my scene is partly from the windows and partly from the overhead electric light. Notice how I have built up the tone to a strong black in the chairs nearest to my viewpoint.

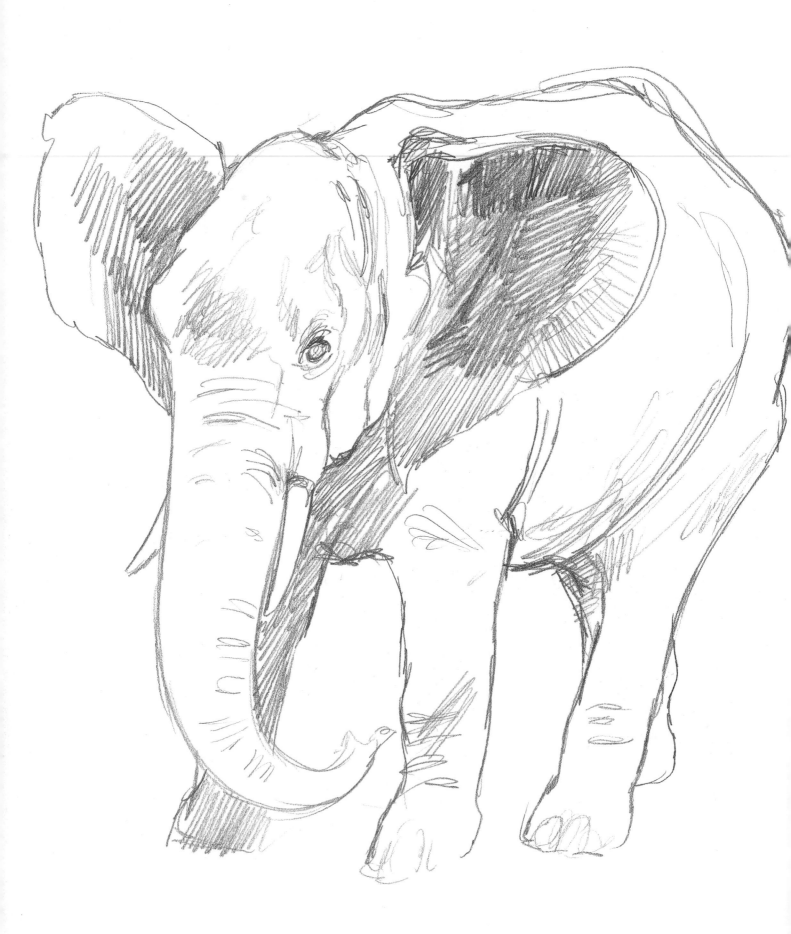

■ LESSON **8**

THE ANIMAL WORLD

Drawing animals is not unlike drawing human figures in that you will find yourself dealing with the same issues of getting the proportions correct and showing foreshortening where the angle of view demands it. The major difference, of course, is that you won't be able to persuade any animal to stay patiently in a pose you choose. Indeed, many won't remain still long enough for you to manage any more than a quick sketch. This means that you have to start drawing quickly and go for only the most obvious shapes first, even in the case of a sleeping animal, as most tend to move quickly once awake.

This is an area of drawing where photography is particularly useful, especially for supplementing swift sketches done at the same time. Taking photographs of the animals in similar poses to the ones you have tried to capture will give you the information to do a more finished drawing. However, it's probable that to familiarize yourself with drawing animals you will have to start by resorting to books or magazines that give you either detailed photographs of animals or drawings by artists who have specialized in the subject.

It is never wrong to copy more accomplished artists, since this has always been the traditional way to learn how to draw. In Renaissance studios, the masters would keep drawings in sketchbooks that were used by their assistants to inform their own drawings and paintings – so do try drawing from other sources as well as directly from life so that you can get a good deal of practice in picturing animals.

■ SKETCHING FROM PHOTOGRAPHS

You may have heard that artists should always draw from life rather than from photographic references, and it's true that relying entirely on photographs is not a good way to proceed. However, used judiciously, they are more of a help than a hindrance, especially where you have a constantly moving subject. The problem only comes when you slavishly copy them and produce drawings that lack the animation and freshness that comes from working from life, in the belief that exactitude is all that matters.

 If you already have books with large, good-quality pictures of animals in them you are ahead of the game. If not, try your local bookstore or indeed your newsagents, which is bound to have some magazines dedicated to household pets, horses, wildlife and so on. Local museums and nature reserves often have books and magazines with animal pictures in them, too.

Choose some photographs that aren't too challenging in their angle of view and start by keeping your drawings very simple, putting in only the main shapes. These examples are just to give you an idea how that can be done. Notice how the penguin is a very simple elongated pillow shape, with a beak and feet at each end. The owl is even simpler, characterized by its big eyes. The giraffe is an elongated angular shape, with a very long neck and legs related to the size of the body. The rhinoceros, on the contrary, is a very compact shape, with just the addition of the jutting square head and the legs.

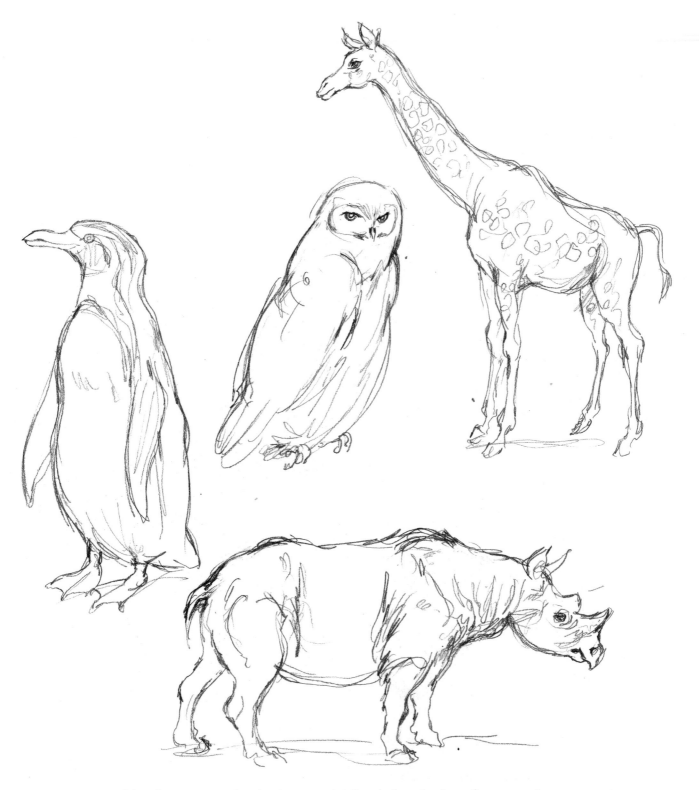

Now have a go at drawing in more detail and allow the line of your pencil to follow the obvious contours and patterns of the animals. Don't worry about a great deal of naturalism at this stage – just concentrate on getting the feel of the animal's shape in a sympathetic way, roughly indicating the texture of skin, fur and feather with your line as you do so.

Now try some fish and a snake, because these are fairly simple to draw – use mine for reference if you don't have photographs. Once again don't try to be exact on the detail but go for the main shapes and try to give them the right feel in the fluid way that you draw them. This is all very good practice, as it helps you to bring some expression to your work. The snake is a bit harder than it looks, but as long as you observe its curves and folds carefully you will soon be able to make it look convincing.

DRAWING FROM LIFE

The next step is to draw animals from life, encouraged by the confidence you've gained by working from photographs. Most of the time you won't be able to complete your drawings, not least because many animals will move away as a result of your showing too much interest in them for their comfort. However, domesticated animals can usually be observed when they are sleeping or just relaxing, and this is an ideal opportunity for you. Even so, it's a good idea to take a quick photograph so that you still have some reference if they decide to go.

Birds

I've started with birds because although they aren't often motionless, they have fairly straightforward shapes and can be drawn quickly. Once again, go for a very simplified drawing first as I've shown here, so that even if they move you have got something down on paper. Taking a quick look and remembering what you saw is a very good discipline.

If you get the chance, put in as much detail as you can, taking your own photographs to help you remember. Tone can often be the way to help show the substance of the animal.

Cats

Domestic cats are very useful models as they are very
somnolent – most sleep for about 16 hours a day.
Consequently, you should have plenty of time for fairly detailed
studies and because of their furry coat and relaxed, graceful
forms they tend to present easy, fluid shapes to draw. Draw the
main shape of the pose in a very simple way, as you can see in
these examples, and add the heads and legs to that.

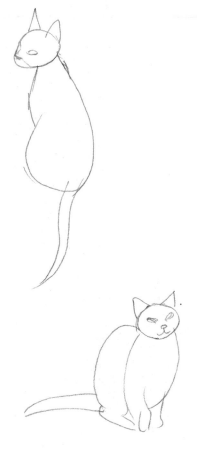

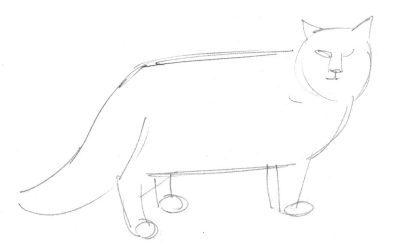

Next, show the texture of the fur with multiple strokes
of the pencil. Indicating the coat markings will make the
drawing look much more like a portrait of that
particular animal. The eyes and nose are important, and
as they are very close to each other you shouldn't find
it too difficult to see the right proportions.

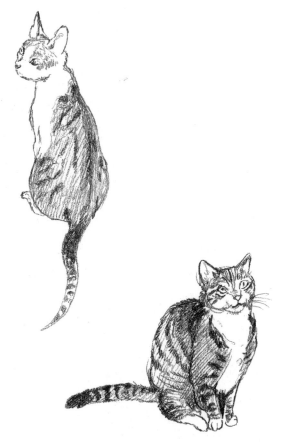

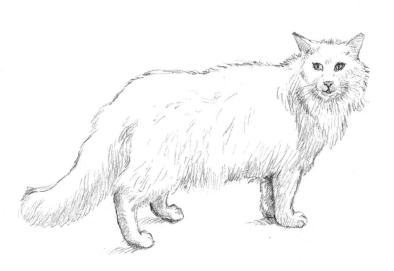

When you feel confident enough, have a try at more active animals and see how far you can take the drawing. Go for the main outline first and then as much as you can include in the time you've got.

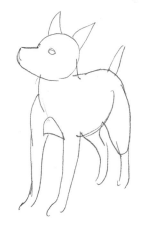

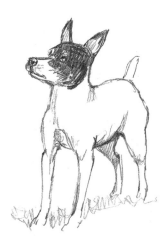

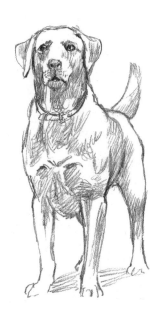

Dogs

Dogs spend less time asleep than cats but, while awake, tend to be much more co-operative. They vary much more in appearance, so you will need to check the proportions with each new breed to make it recognizable. As before, draw the main shape simply at first and add detail in the time you are given.

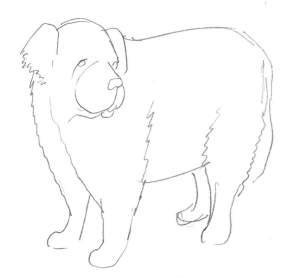

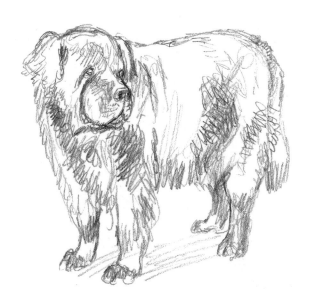

Farm animals

Have a go at drawing farm animals if you are in the countryside, or even in town if there is a city farm near by. Luckily sheep and cows don't move too fast, and they keep adopting the same poses. Again, note the different characteristics belonging to the breed rather than just reproducing your idea of what a cow or sheep should look like. Practice makes perfect, so keep your sketchbook with you wherever possible and even if you have only two or three minutes to do a thumbnail sketch it is still excellent drawing practice.

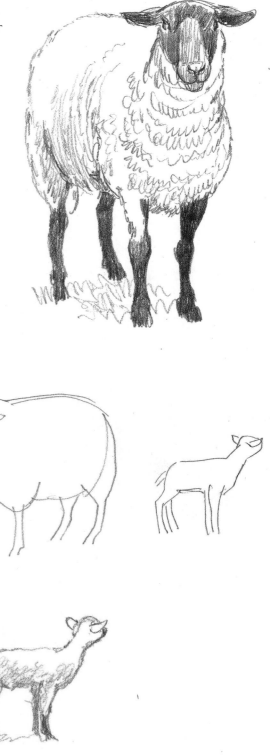

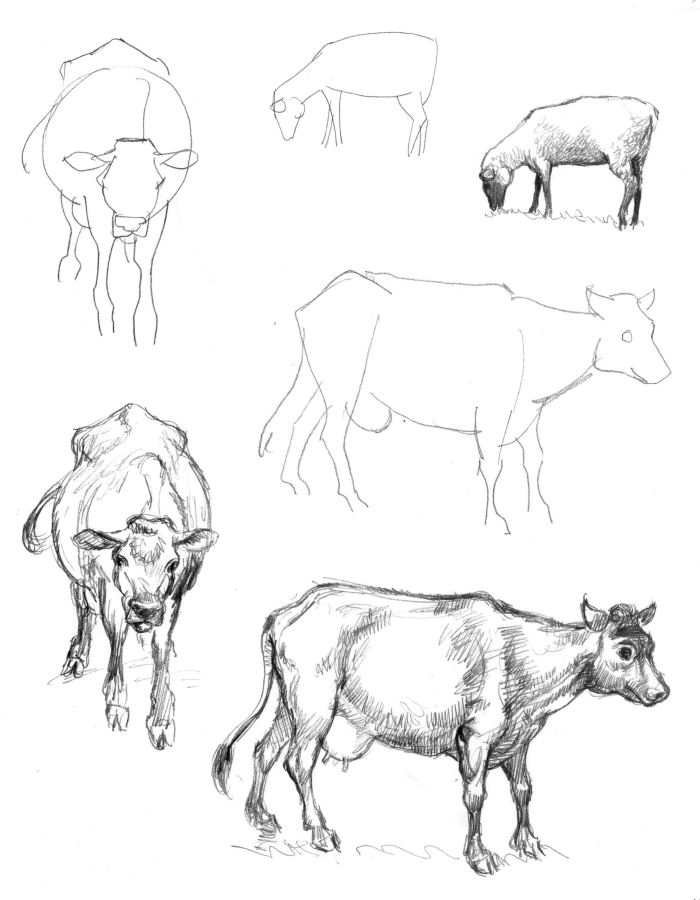

Horses

Along with large farm animals like cows, horses are probably one of the easiest large animals to find for drawing from life. You may have to return to drawing from photographs for this exercise, but if you are near a stables, do take the opportunity to draw from life as much as you can. Drawing horses from life is not too difficult but they do gently move around, and so most of your drawing will resemble the first two sketches shown below. However after drawing several sketches like these you may be able to get some more detail, as the horse takes up similar positions.

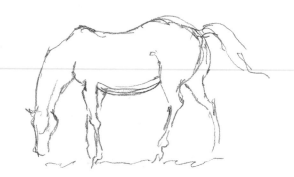

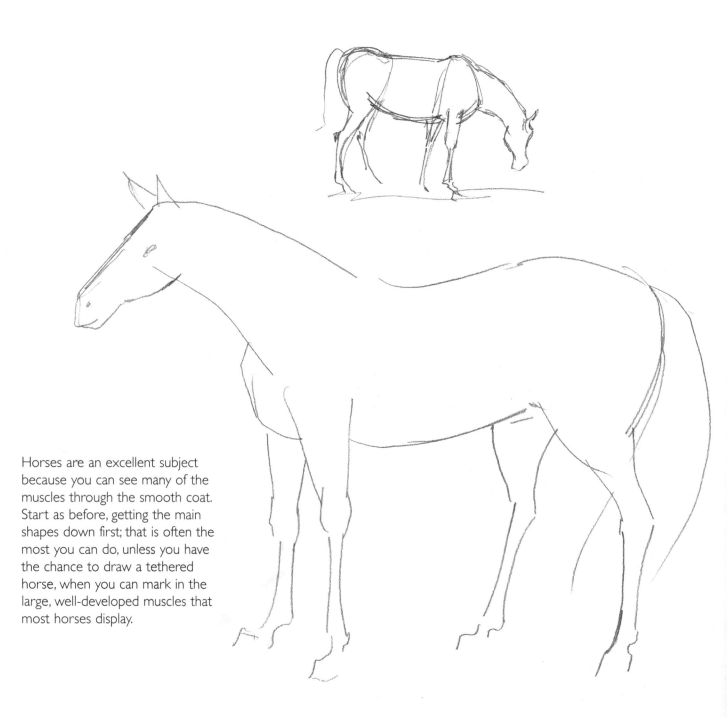

Horses are an excellent subject because you can see many of the muscles through the smooth coat. Start as before, getting the main shapes down first; that is often the most you can do, unless you have the chance to draw a tethered horse, when you can mark in the large, well-developed muscles that most horses display.

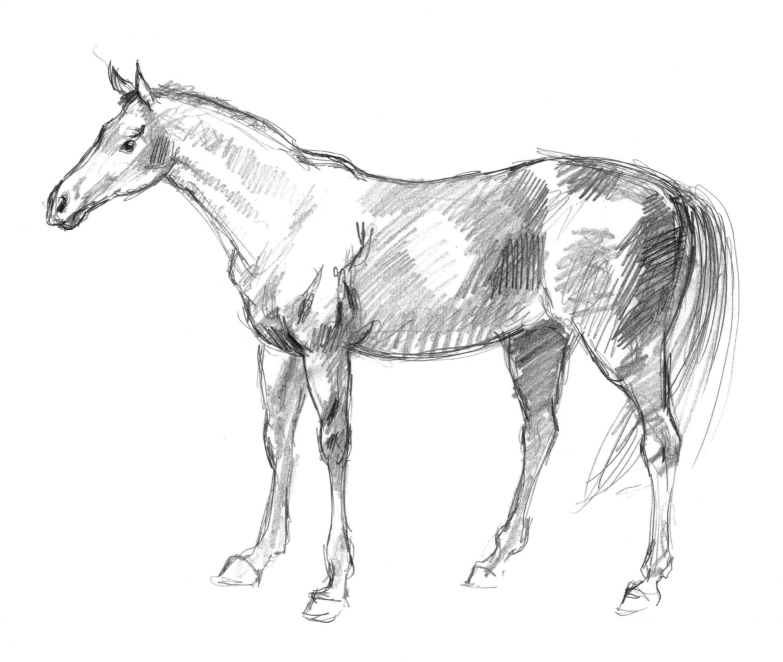

As you add detail to your drawing, don't be afraid to mark the muscles in strongly and quickly – you can treat them with a greater degree of subtlety when you are more practised.

A horse's prime motivation is to graze, so you should have no difficulty in sustained studies of them doing that — it's an alert pose with the head up that you have to be fast to capture. Photographing them at the same time gives you extra information that you can add to your drawings later.

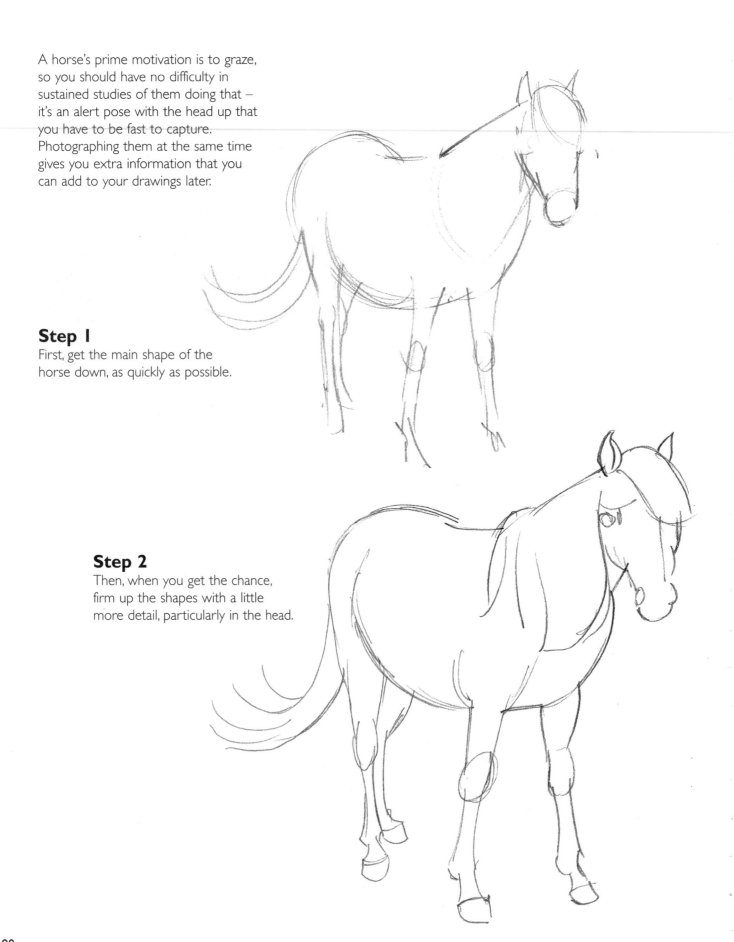

Step 1

First, get the main shape of the horse down, as quickly as possible.

Step 2

Then, when you get the chance, firm up the shapes with a little more detail, particularly in the head.

Step 3

Finally, add some details of tone and texture to help give a more solid look. Some areas, like between the legs near the chest and on the ears and nose, can be put in more intensely to contrast with the white areas on the horse's flank.

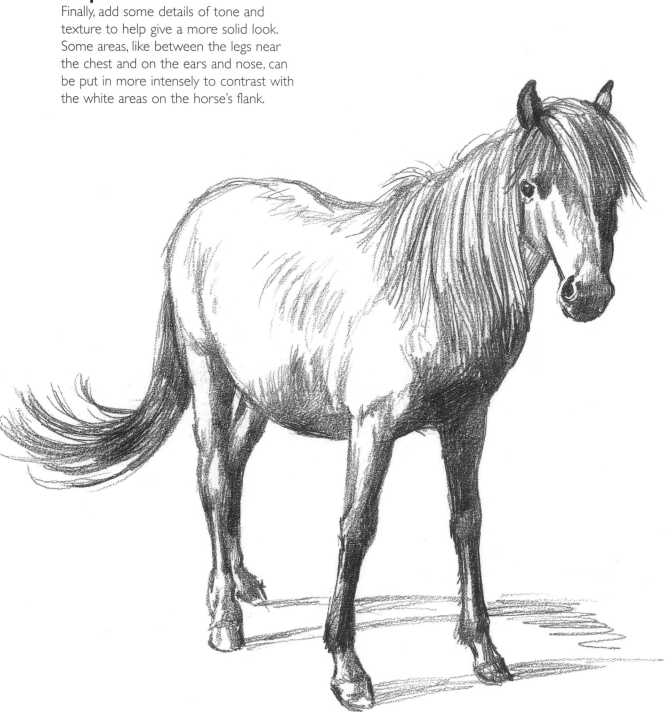

More unusual animals

Unless you go to a safari park, animals such as lions and elephants usually have limited opportunity to move about much and you may not have a wide choice of viewpoint. However, you should find a range of poses to draw. As you will be viewing these animals from a distance, detail is less important than with domestic animals, but inform your drawings with photographic reference as well to help your accuracy.

The elephant is a large enough animal to be drawn with smooth, fluid lines, adding areas of tone where the deepest shadows are, such as inside the huge ears and beneath the trunk.

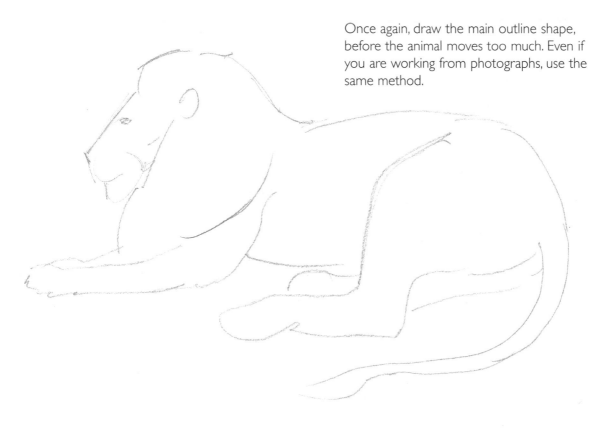

Once again, draw the main outline shape, before the animal moves too much. Even if you are working from photographs, use the same method.

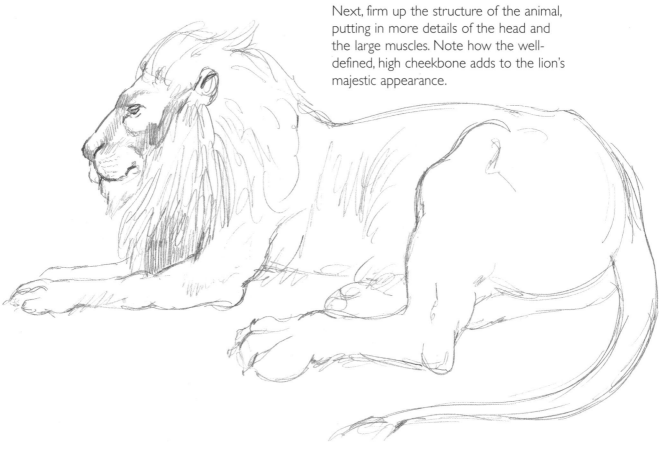

Next, firm up the structure of the animal, putting in more details of the head and the large muscles. Note how the well-defined, high cheekbone adds to the lion's majestic appearance.

◼ HERDS OF ANIMALS

Drawing animals in larger numbers may strike you as harder at first, but in fact it can be easier. One of the most significant things about herds and flocks is that all their members share the same habits, so when one moves out of a pose that you are drawing another will conveniently adopt a very similar position, giving you another chance to complete your work.

Here I have shown herds of deer and sheep and, to change the task slightly, a flock of seagulls. The latter group is harder in one way because of course they are in constant movement. However, their shapes are relatively simple and they all swirl around in much the same way, so that after a while you begin to see how you can draw them more easily.

Sheep are fairly slow in their movements, and among the most docile of your models. Deer, on the other hand, are rather nervous of people getting close to them, but because you will have to draw them from some way off you will more easily be able to reduce their shapes to the simplest formula.

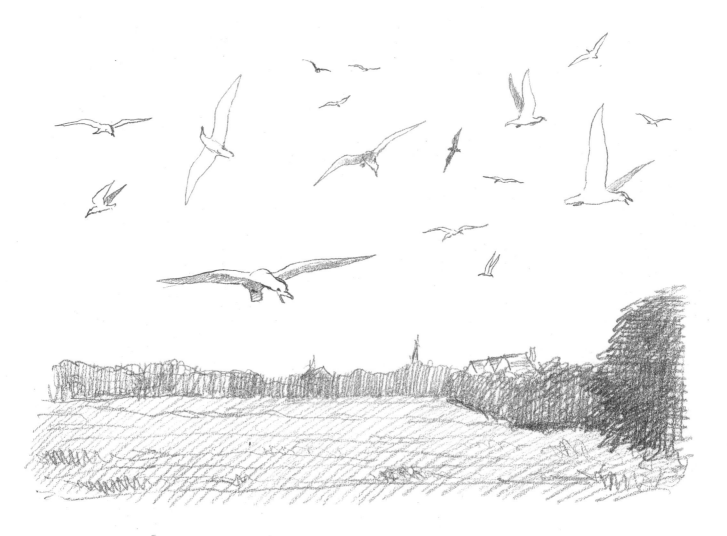

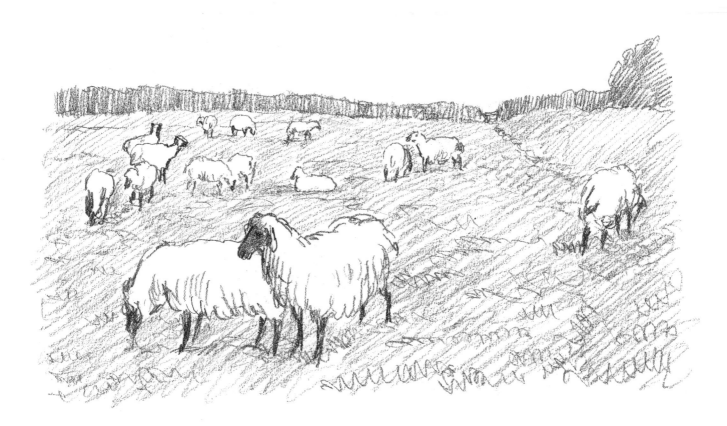

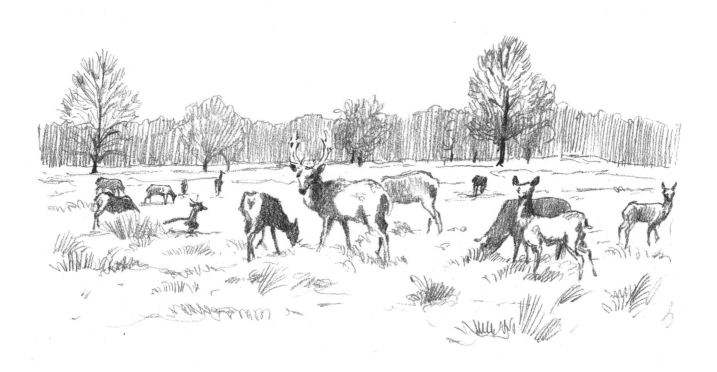

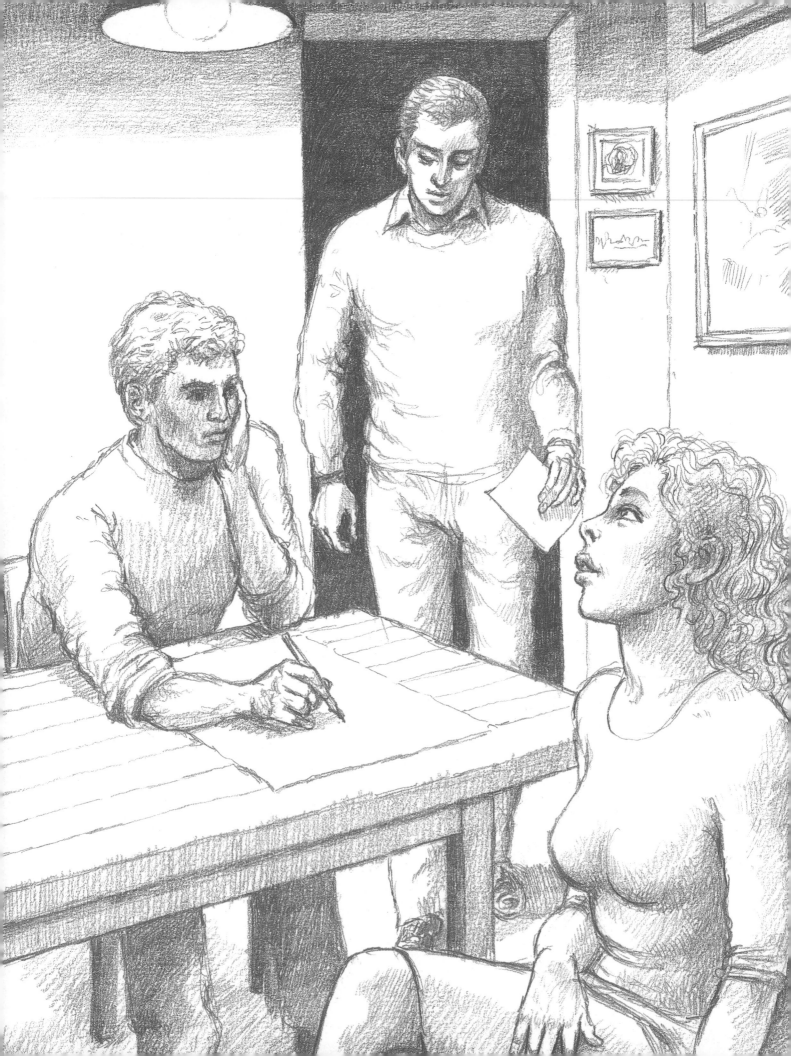

■ LESSON **9**

CREATING COMPOSITION

The most creative possibilities for an artist come from the process of composition. No matter how well you have learned to draw objects, animals, figures or landscapes, until you have considered the question of composition you have arrived at satisfying pictures only by accident. The intellectual process of determining how the individual elements of a picture hang together is what differentiates the accomplished artist from the beginner.

There are many routes by which to arrive at a strong composition and this lesson will not by any means be exhausting all the possibilities, but you will discover several time-honoured methods of going about it. Of course an artist soon develops an eye to arranging his or her elements in such a way that the result is interesting, but there are techniques to provide guidance in this.

It is often a question of balance, or sometimes imbalance, that gives a composition its power. This lesson discusses how to divide the surface of your picture in such a way that it will give an interesting balance of shapes and ends with a specific exercise in practising a composition that should help you to get to grips with the basics.

COMPOSITIONS BY MASTER ARTISTS

A good way to start understanding the composition of pictures is to look at the work of the masters. Here we'll consider the way various works have been composed, using geometric shapes to show the format. Once you've grasped the basic principles, your best plan for developing your compositional skills is to copy good works of art from books and prints, or in local public galleries. Most galleries will allow you to make copies of the work on the walls as long as you don't inconvenience other people.

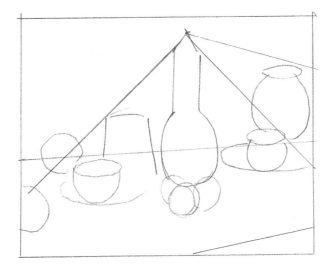

Our first example is a still life by Vincent van Gogh of cups, fruit, jugs and a coffee-pot. Notice how the whole composition is arranged like a pyramid or triangle, which is quite a common device.

Look through your art books and magazines for a picture based on a similar composition and make an outline drawing of it – my choice is just to give an example, and you will learn more by identifying your own. You shouldn't have a problem in finding a suitable picture.

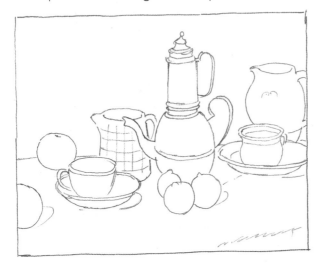

Having drawn it up in line, go ahead and put in all the tones that you can – but the important part of this exercise is to realize the composition and draw it in outline.

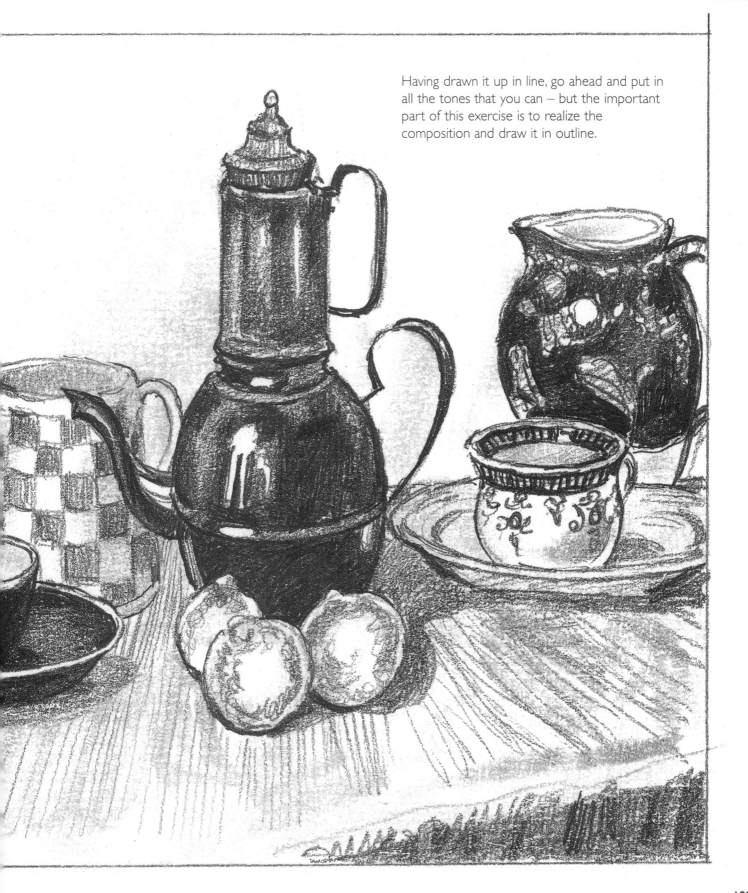

My next example is a work by John Piper, for which I have shown the perspective lines that govern the composition. You will see there are two large blocks, one on the edge of the picture and one off-centre, connected by a recessed part of the building which creates a hollow centre.

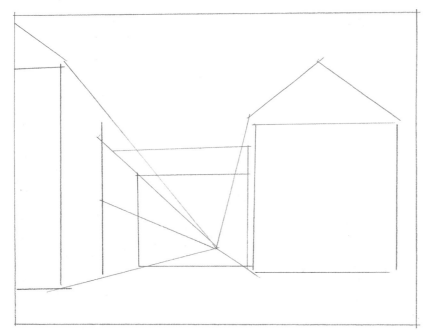

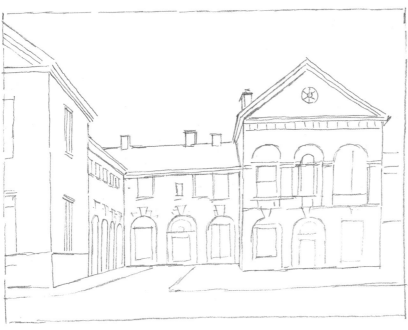

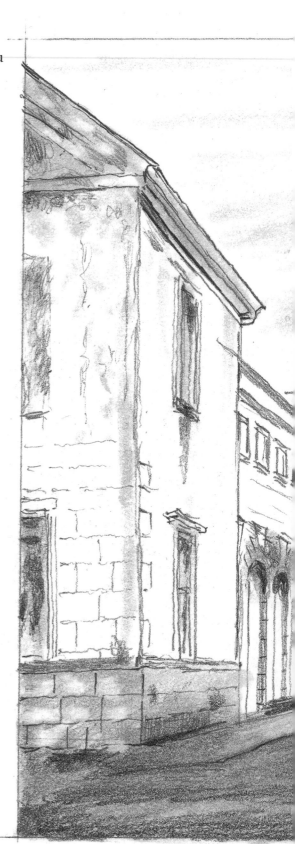

Now you've seen the composition in its essentials, draw it out in line. Then, as before, continue with the tonal values until the picture is finished.

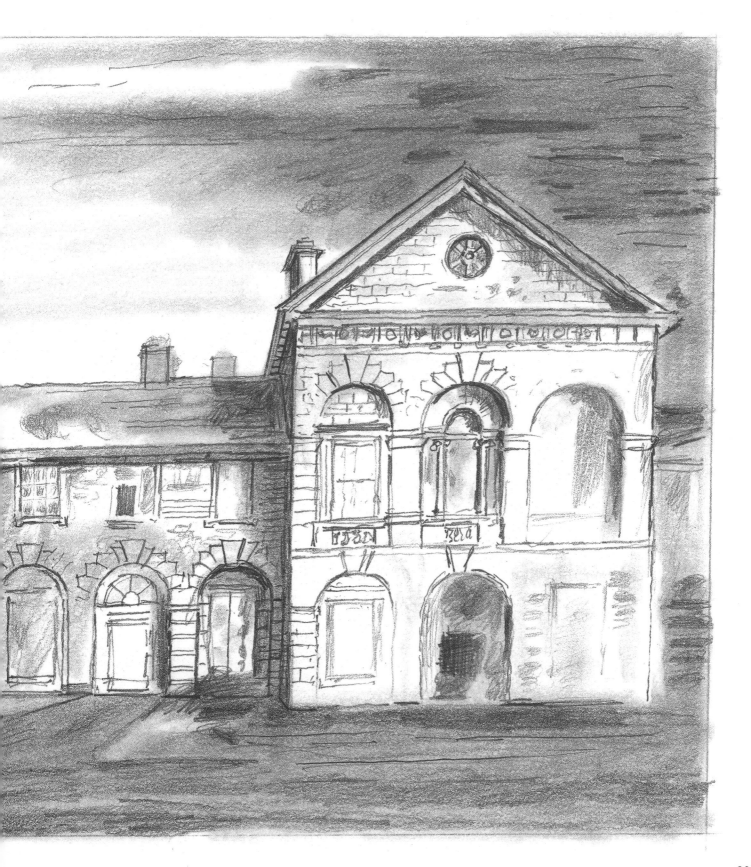

The next example is à picture of Pegwell Bay by
William Dyce, a Victorian artist. Here the composition
is a very simple halfway horizon with a range of chalk
cliffs jutting into it. All the action in the picture is in
the lower half, with various areas of rock and sand on
which people are gathering shells and so forth. Most
of the significant action is in the immediate
foreground. The ladies in their crinolines make
pleasing large simple shapes.

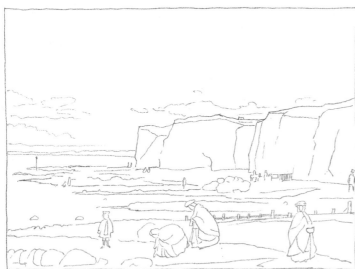

Draw out the scene in outline as before and then put in the
tone. In this picture it is fairly even and light, so you can probably
do most of it with linear marks.

Next, a work by Richard Wilson of the top of Cader Idris in Wales. This design is mainly a large triangle, broken by the curve of a lake and the sweep of more mountain to one side. The curve is repeated twice in a mound below the lake and another body of water lower down to the left.

Because of the dramatic view, the tones are important as they show the sharp triangle of the peak above the lake, silhouetted against the sky. If you still have time, have a go at copying this scene.

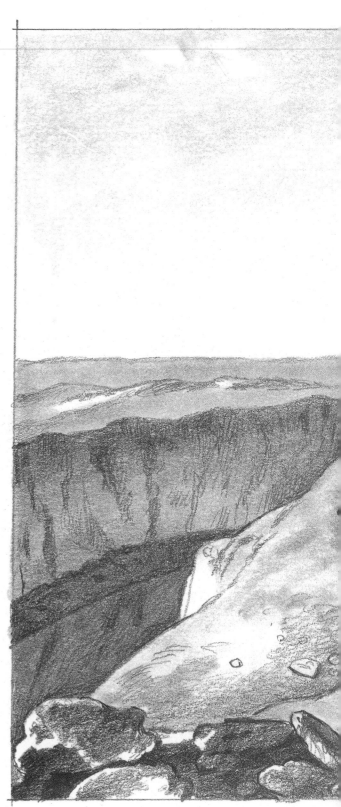

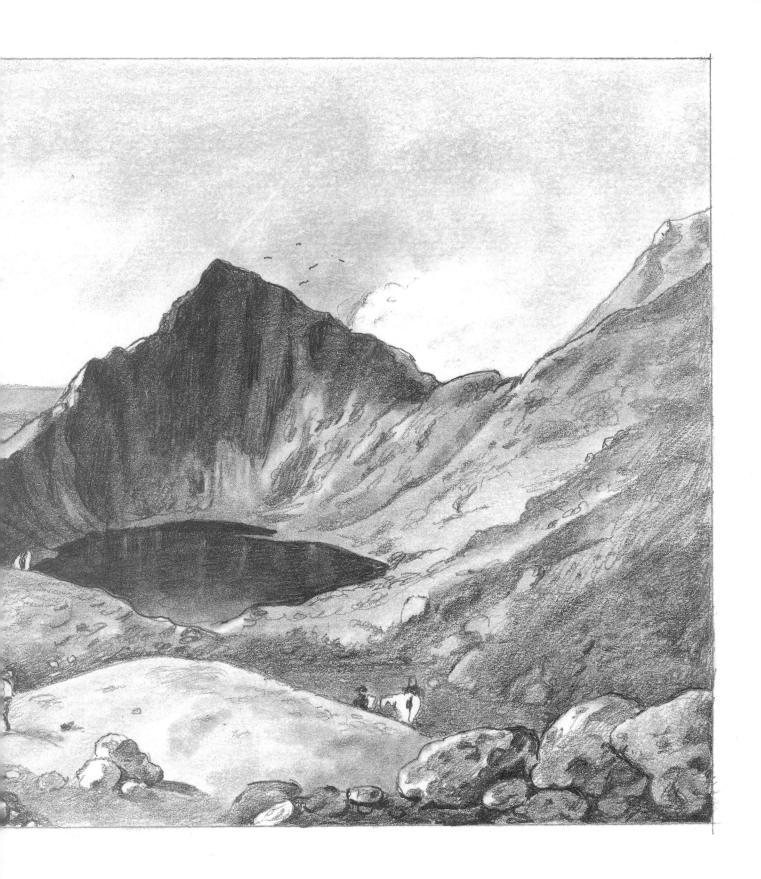

The next example is of a townscape by Walter Sickert, which is defined by the perspective of the street winding away on the left and the foreground shopfront at the right edge – thus, two perspective depths which work to the left and right of the picture.

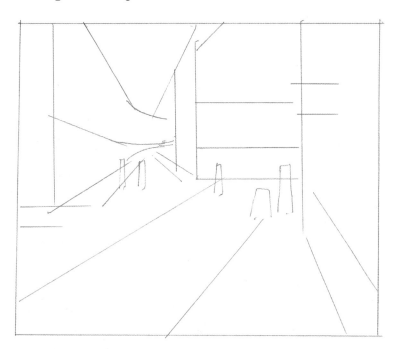

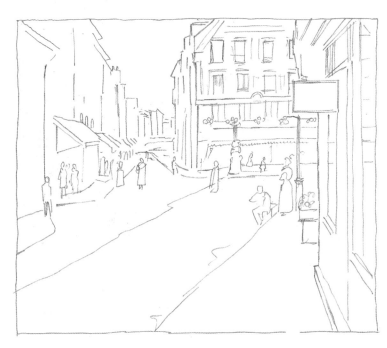

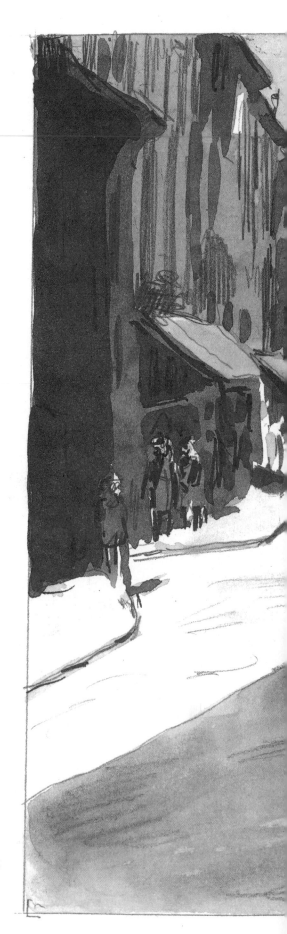

When you come to look at the tonal values you can see how the dark cast shadow of the buildings to the right divides the big open space of the foreground street diagonally. It all helps to draw the eye into the centre of the picture and then on down into the far street.

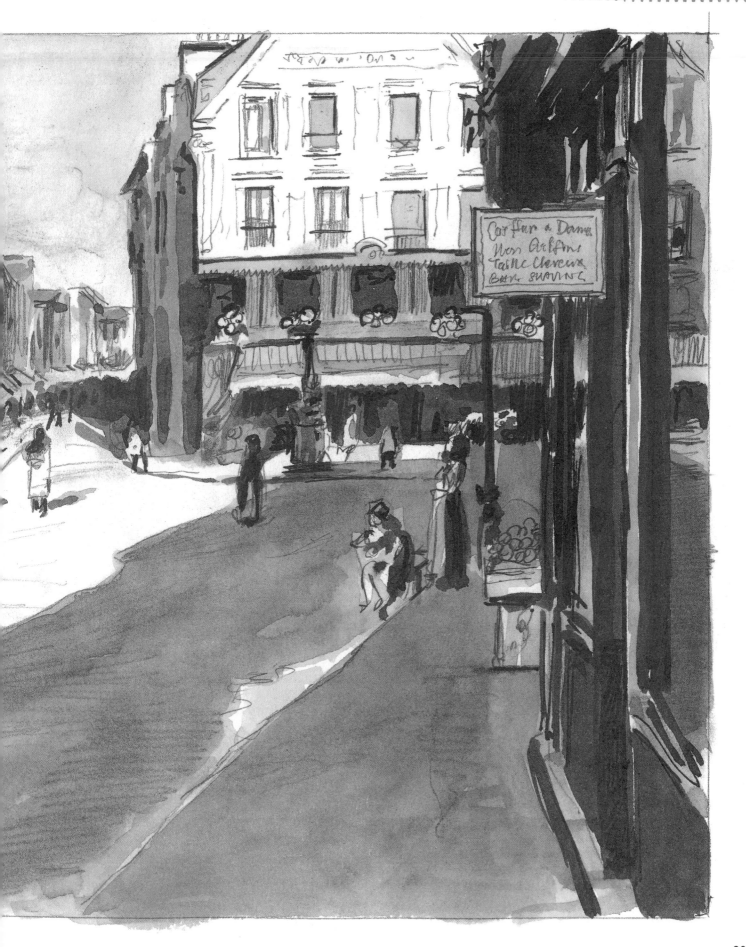

Our final example is by the famous Spanish master Diego Velásquez, who painted this picture of a woman in the process of cooking eggs. The whole scene is played out against a dark background, so that the figure of the woman is thrown forward, while the figure of the young boy almost disappears and he appears as a disembodied head and two hands. This allows the curve of the various utensils, including the ones he is holding, to form a curve across the picture ending at his face. This clever device attracts the attention to the contrast and connection between the two people.

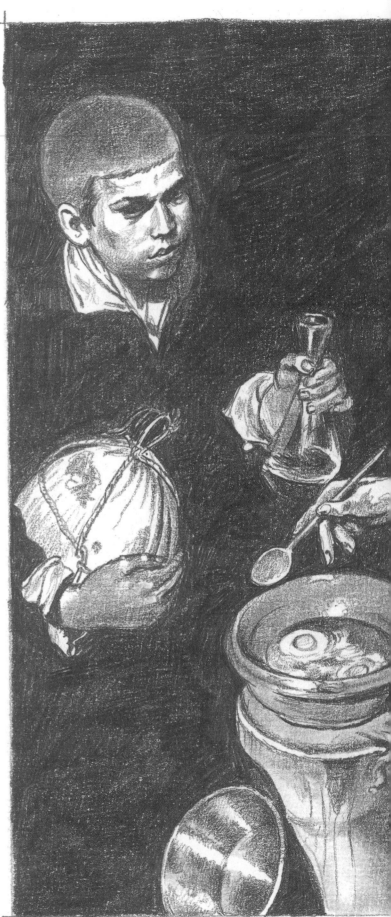

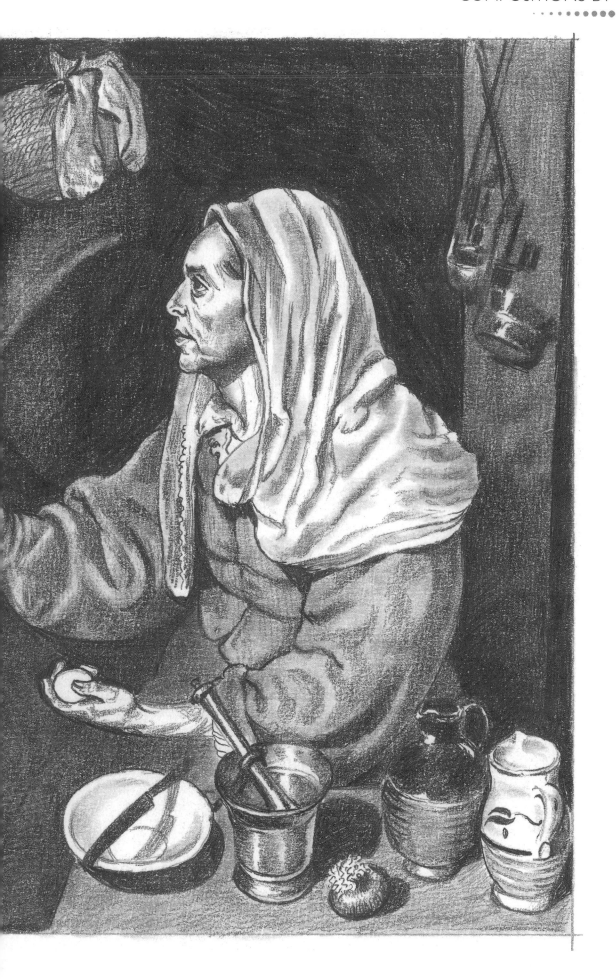

■ CREATING A BALANCED COMPOSITION

DIVIDING THE PAGE

This exercise is concerned with dividing up your page so that you may construct a balanced composition on it. It's not by any means the only way to do it, but it's probably the simplest at this stage of your development.

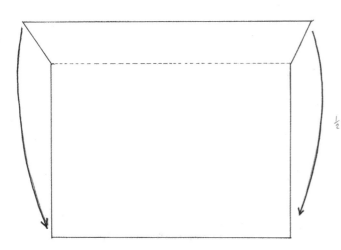 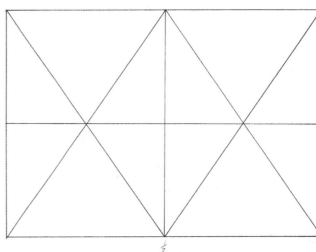

The first step is to take your A3 or A4 paper and fold it in half. Be exact about this, because your other measurements rely on it. Unfold the paper and draw a line along the fold, then divide both rectangles with diagonals from corner to corner. Where they cross, draw a line horizontally across the whole paper from centre to centre, extending to the edges. You now have your paper divided in half vertically and horizontally, without measuring anything – a simple device but effective.

You can now draw two diagonals across the whole paper from the corners. They should cross each other at the centre point if your lines are precise enough.

Your last divisions are to draw horizontals and verticals from where the main big diagonal cuts across the two sets of diagonals of the half pages. These will be the third divisions of the page which already has the halves and quarter divisions. You now have a template to divide any piece of paper of the same size into half, quarters and thirds, and the next examples will show you simple ways in which to use it to create compositions.

Dividing the page: practice

The first composition is one where a tree stands one-third from the right and two-thirds from the left of the scene. Its roots are at the lowest quarter mark. Across the picture at the lower third mark is a fence that appears to stretch about halfway. The horizon in the background is one-third from the top of the picture. There is a lone tree in the distance which is about one-third away from the left hand side of the composition. As you can see, it all looks a satisfactory balance.

The next picture is a still life which uses a similar format. This time the largest vase is on the left third vertical, one-quarter from the top and one-quarter from the bottom. The rest of the objects are mainly on the right-hand vertical, with the ones projecting out at the third and halfway marks. Once again this creates a well-balanced composition.

The two remaining pictures are both in a landscape format. First, a figure composition with two people, one sitting and one standing. The standing figure is one-third from the right edge of the picture and almost touches the top and bottom edge. The seated figure is near a wall that projects from the left-hand side of the picture to a third of the way across. This very simple design already gives an interesting tension between the two figures.

The last example is of a townscape in which one foreground building projects from the right to about one-third across, and from the top of the picture to about one-third from the lower edge. The other main block is projecting from the left to about one-third of the way across, with the top one-quarter from the top edge of the picture and the bottom edge at the halfway point. I've then put a lone block in the distant piazza at the halfway mark vertically and just below the quarter mark horizontally. A little vegetation in the lower left at the quarter horizontally could soften the hard edges of the buildings.

As you can see from these examples, a simple reduction of your page to thirds, quarters and halves can give you a number of compositional schemes to play with.

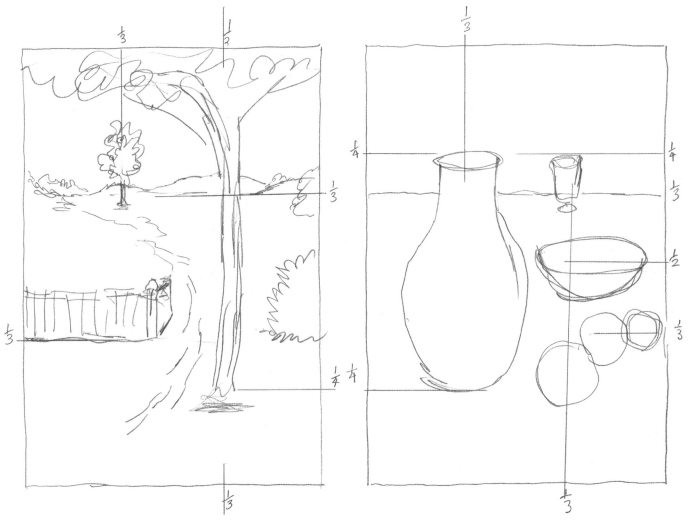

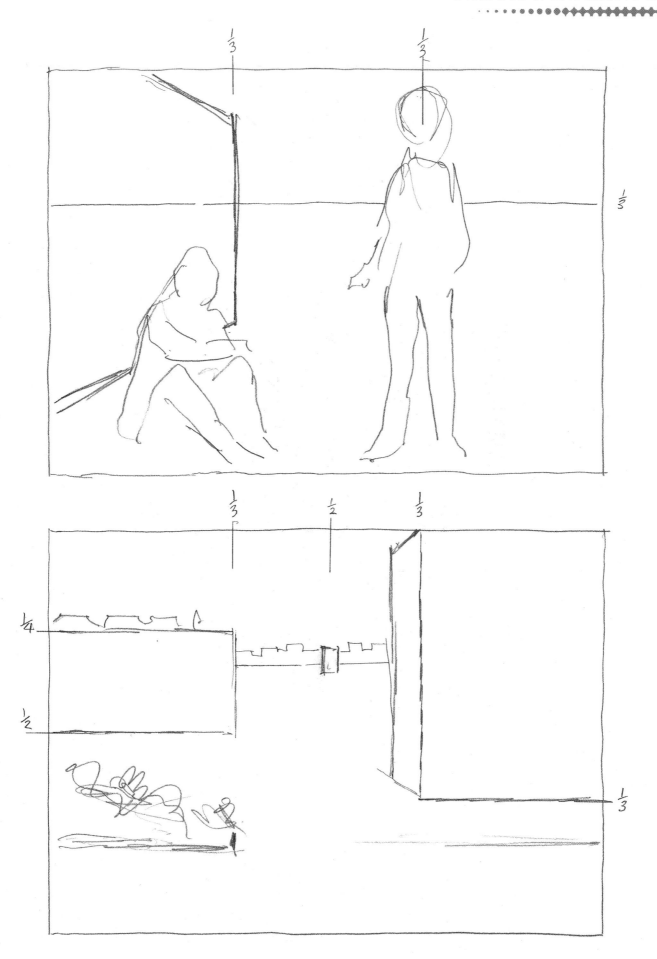

■ DESIGNING A FIGURE COMPOSITION

Now we are going to have a go at producing a complete figure composition. This will be done in a very practical way, with me drawing up a composition that you may want to copy, or you may wish to do something similar without necessarily reproducing my picture. I will show you step by step how I might go about it, and you can then apply the same system to your own creation.

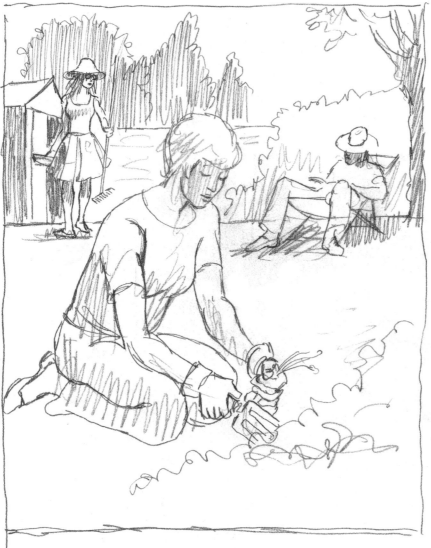

Step 1

I've started by using two slightly different formats, imagining a simple scene that I know well. If you want to make your own picture think of something familiar in your life, as it will lend verisimilitude to the composition.

In one picture I've put three figures in a garden setting. The nearest figure is a woman kneeling by a flowerbed with a garden tool in her hand. She is almost centre but just off to the left to create some space on the right. In that space is a male figure sitting in a deckchair, rather far back in the scene. To the left of the main figure is another woman walking towards her. The trees in the next garden go across the picture at about a third of the way from the top.

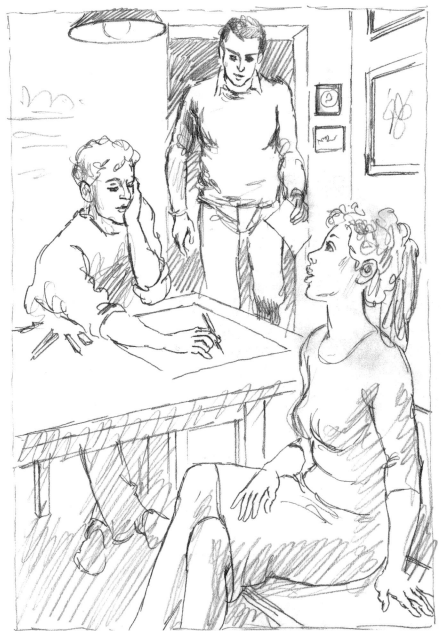

Again taking a familiar scene, I decided to draw an artist with a model, adding another figure to complicate the matter a little. I placed the artist at a table which juts across the centre of the space, with him behind it and his model in front to the right. I made his model a girl and the other figure a male walking forward into the room from another room.

The model is the largest figure, and her feet are not visible. She sits in the right-hand corner of the picture, taking up about one-third of the scene diagonally across the picture. The artist is the next nearest but he is hidden by the table from his waist up. The third figure is almost in the centre of the picture, but further back as though coming through a doorway. This is design number two.

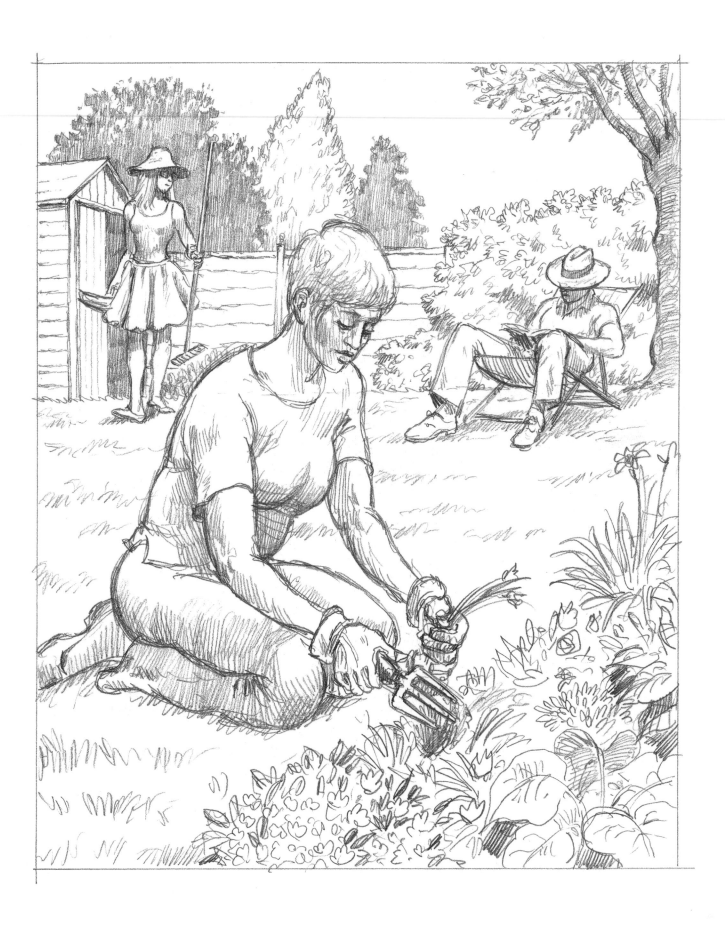

Step 2

Having produced a rough draft of the pictures, I still couldn't make up my mind which one to follow, so I drew them both up more seriously in greater detail. This may take you some time, and it's the stage where you decide exactly what everything is going to look like. You may decide halfway through drawing one picture that you prefer the other one, and if so you can stop and just concentrate on the one of your choice. Stopping short with one of them doesn't matter – this is an exercise in coming to your final decision.

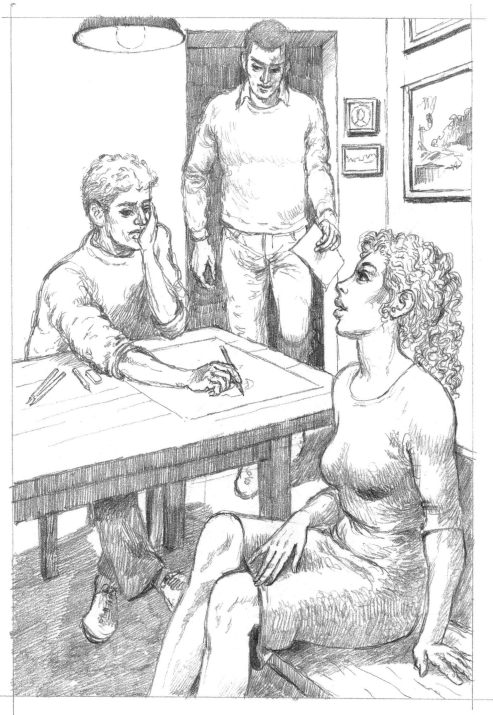

Step 3

My decision was to go with the artist drawing the model, and now I needed to consider it in more detail.

First I decided what the main figure would really look like. Ideally I would find a person to model for me, and after getting her to sit in the correct pose for my composition I would carefully draw her from life. If that were not possible I would work from my own previous drawings or use photographic reference.

As you can see I drew her head twice in different positions and also made a sketch of her nearest hand. All this acted as useful information for the final picture.

Then I moved on to the other two figures, getting some idea of how the artist would look and how the other man would actually approach the scene. As you can see, I tried different positions for the head of the walking man.

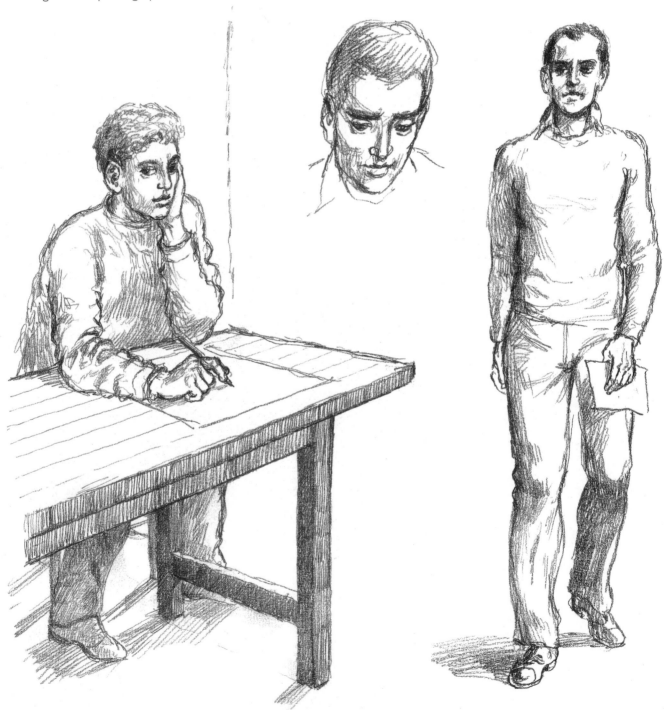

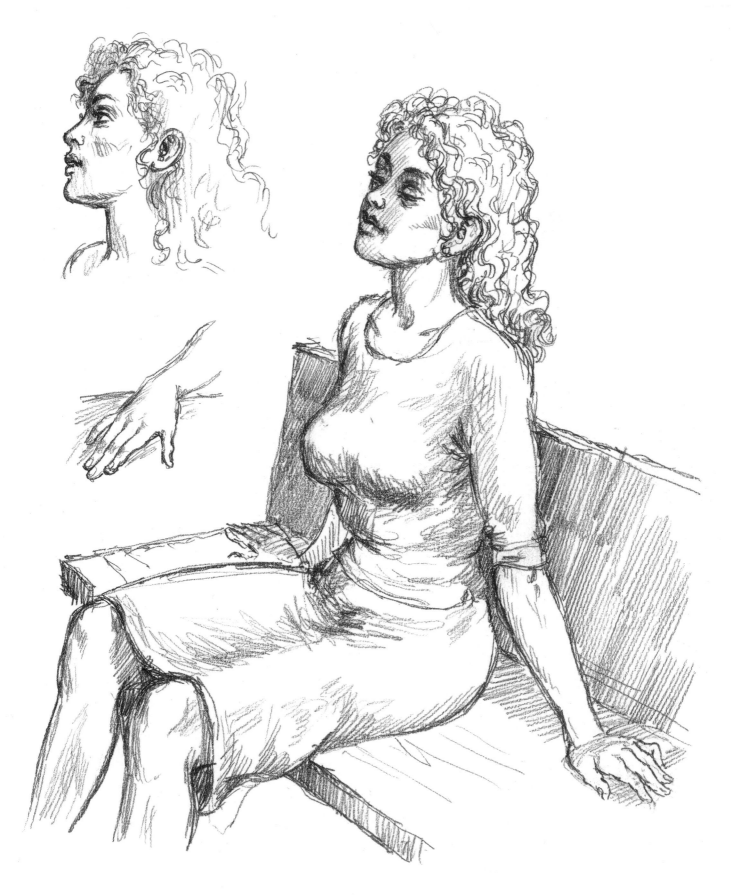

Step 4

Having researched the figures I now put them all into context by drawing up what is known as a cartoon, which is an outline of the complete picture. This was the last stage where I could alter the scene if required. Keep a version of this cartoon to enable you to correct any details when you have put in the tone.

Having got the full picture drawn up in line, I could now put in the main areas of tone or shadow in one light tone (opposite). At this stage don't overdo the weight of tone, because you will find it harder to get rid of it than to add more if you need to. It shows you where the light is coming from and gives you an idea as to how solid your figures may look.

Step 5

Now comes the final stage, where everything is put in with great detail. Using your copy of the cartoon to ensure that all the shapes remain correct, begin to build up the heaviest tones so that you can see how the depth of space works in your composition. Take your time, because the quality of your work depends on the care and attention that you give to this finishing stage.

So now you have your completed composition with all the preliminary drawings that you made. Keep these for a while, because they might be useful in later drawings. In the ateliers of old, the drawings made for pictures were always kept for quite a time to be used over and over again in other compositions.

LESSON 10

STUDYING STILL LIFE

From the exercises in this lesson you will learn about the ways in which you can build up a pleasing still-life composition and gain some practice in the genre. Traditionally the still-life picture was considered the most basic form of composition and one that every artist should know about. It still is the easiest way that an artist can work on his or her skills in any medium, and it's always easily available. Indeed, in your own house you will find numerous still-life arrangements that have occurred without any effort on your part.

As a genre it remains the most accessible way to practise and you should continue to draw still-life subjects throughout your artistic endeavours. No matter how much you draw people, animals or landscapes, the basic drawing of objects remains the simplest way to hone your techniques.

■ SIMPLE STILL LIFES

It isn't difficult to put together a still-life arrangement, but it does require some thought and aesthetic appreciation. If you are a beginner, it's a good idea to accumulate your still-life objects gradually, with some feeling of how the final shape of the arrangement will look. So I began the exercise by simply choosing things that make interesting drawing problems for an artist to solve.

Starting with what happened to be on the top of the plan chest in my studio, I gave myself the problem of drawing a number of pencils bunched together in a glass jar. I had to find a way of showing the transparency of the pot and the variety of pencil tops poking up out of it – slightly difficult, but not so much so it would become laborious.

Next I took a bowl of oranges that was on my dresser. Fruit in a bowl is a traditional prop for still-life arrangements and presents the problem of drawing spherical objects that are pushed together by the sides of the bowl. Both of these subjects are the kind of thing that make a simple still life without any other objects being necessary; of course you might want a bit more background space to show off the quality of your drawing, but nothing else is particularly needed.

I then drew a glass vase with one stalk of flowers in it. This is both simple and complex, because while there is only one flower and one vase, the latter is glass, which can be difficult to draw convincingly, and the flower is a composite stalk of many small blossoms. There are two stages to portraying the subject – first the simple outline of the shape, which you may need to correct a bit, and then the building up of tonal values so that the finished article looks as though it exists in its own space.

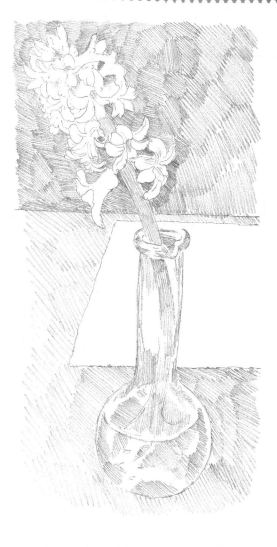

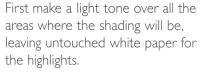

First make a light tone over all the areas where the shading will be, leaving untouched white paper for the highlights.

Following this, build up more varied depths of tone to give the objects substance. Note how I have placed the flowers against a dark background to show up their brightness, and the glass vase has a much lighter background in order to make the drawing of the glass simpler. Draw all the distortions that the water and glass produce to give a convincing impression of their quality.

ACCIDENTAL AND COMPOSED ARRANGEMENTS

Here is a vase of flowers on a windowsill, where you can see the perspective of the surface that it is standing on, the way the light from outside lights up the objects, and the background of the garden through the window pane. So far, except for the first flower drawing, which I made an attempt to arrange slightly, all these still-life subjects were just sitting there waiting for someone to notice how interesting they were. This is one of the benefits of drawing still life – you begin to see your subjects everywhere you look.

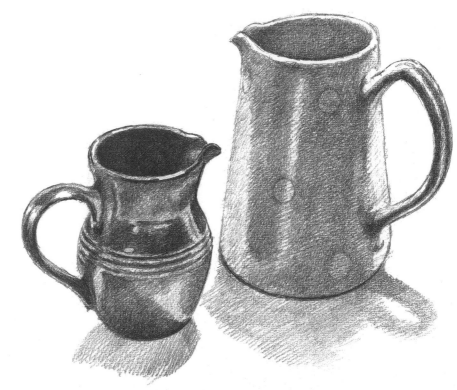

The next choice was more considered. I found two jugs of different shapes and sizes and placed them next to each other, turning them so that their spouts faced towards each other. The fact that one is short, curvy and dark in colour while the other is tall, straight and lighter figured in my reasons for choosing them, so here you can see how I have begun to make aesthetic judgements about even a very simple subject, whereas before I had just happened upon the still lifes.

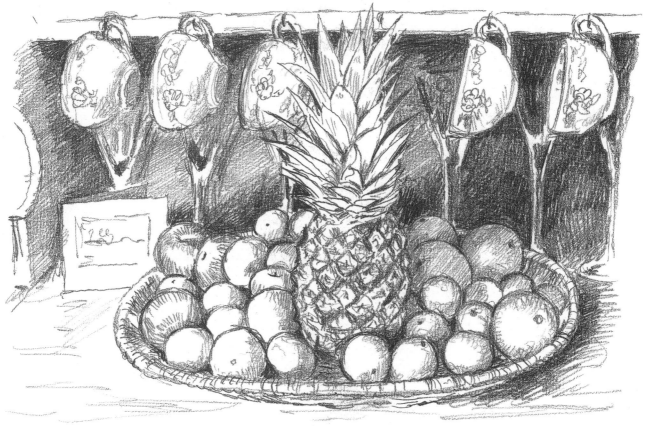

The next composition is much more complicated, with numbers of cups hanging on a sideboard, glasses under the shelf and a large basketwork tray full of fruit, arranged fairly carefully. This is much more like the traditional paintings of still lifes that artists have been making for many generations.

Now let's look at a rather less decorative still-life composition, a selection of ordinary tools that might be found in any house. The main thing here is to show the power and practicality of the objects as they lie on a surface together. I have purposely not drawn them too smartly, but left them looking a bit rough to emphasize the starkness of the hard-edged tools and the accidental nature of the composition.

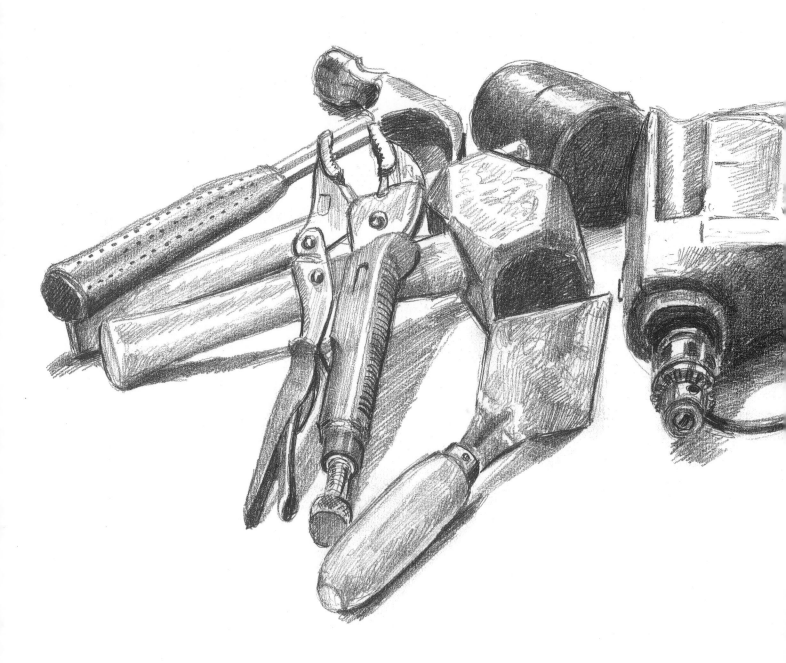

This is another homely type of still life of a loaf
on a bread-board, while in the background are
two bowls of fruit on the windowledge – a
typical corner view of part of my kitchen, again
not too carefully arranged.

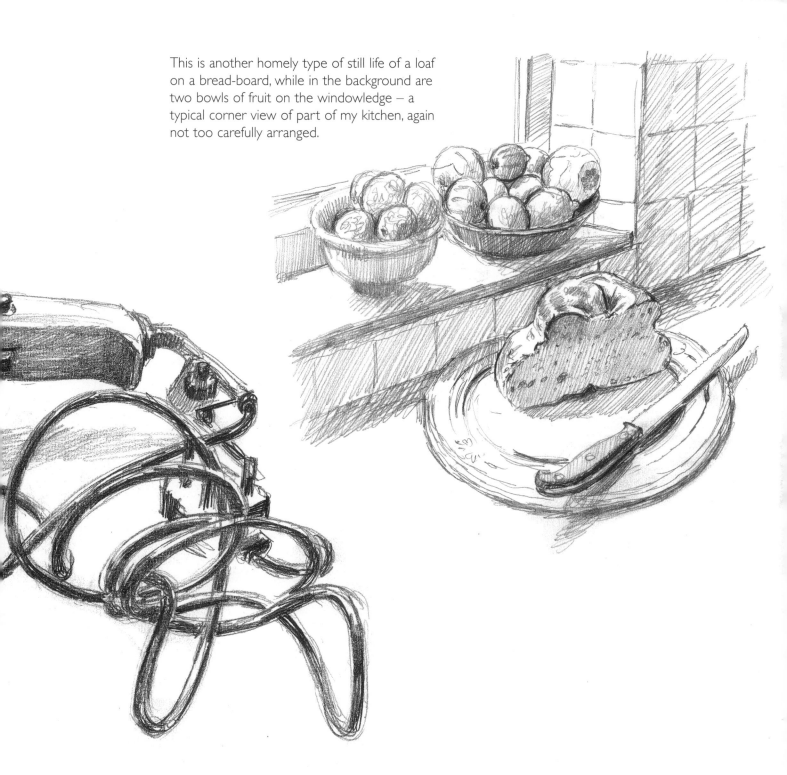

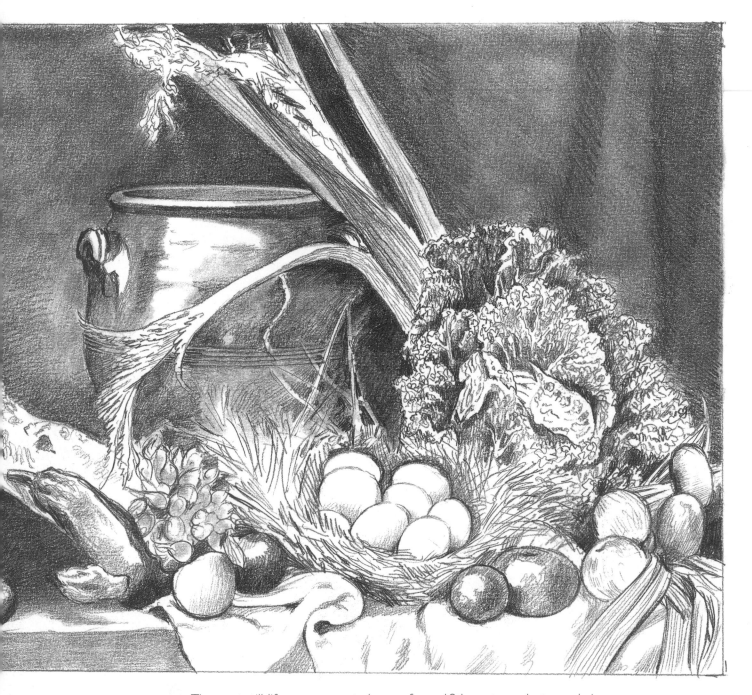

The next still-life arrangement, drawn after a 19th-century photograph, is very carefully composed to show a selection of food, probably awaiting preparation for a meal. The objects are contrasted with one another, with the smooth eggs in a rounded textured nest while the bigger vegetables are leaning against a handsome ceramic tureen – all combine to make a satisfying composition with aesthetic consideration.

This composition is a very carefully seen highly simplified arrangement of a mirror on a wall, with a decorative box and a glass cup, all on top of a polished chest of drawers.

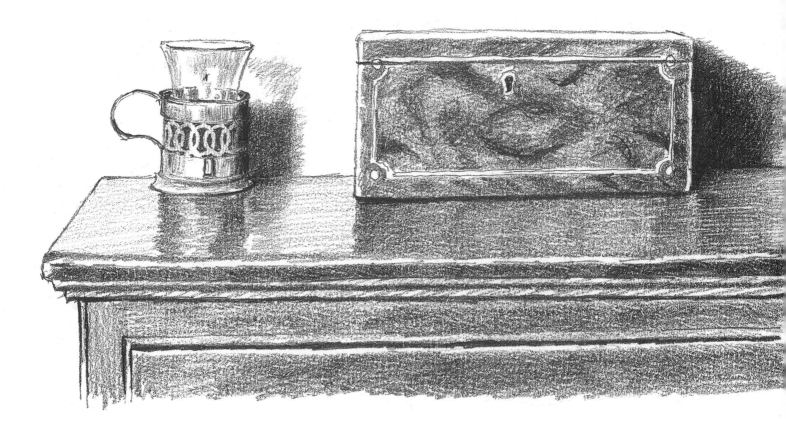

EPHEMERAL STILL LIFES

One of the attractions of still life is the simple, domestic views it often portrays: the tea-tray, a coat thrown over a chair. Even the most simple drawing can catch the feeling of a house or home.

Here is a kitchen still-life composition in a tall format, seen against the light coming from a nearby window. It is rather quickly drawn, and looks as if it is probably a temporary arrangement.

A tea setting is the next arrangement, in its simplest form of just a cup and saucer, teapot and milk jug. This is something you might see in any home at some time.

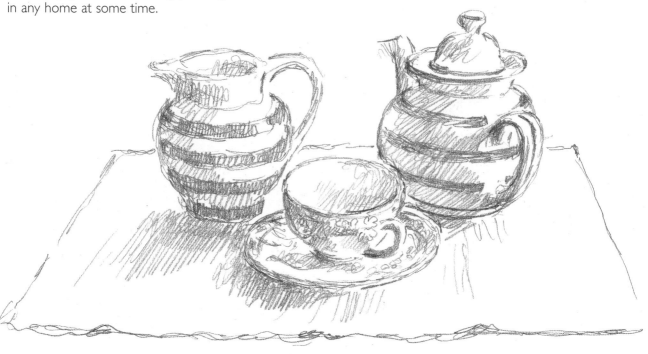

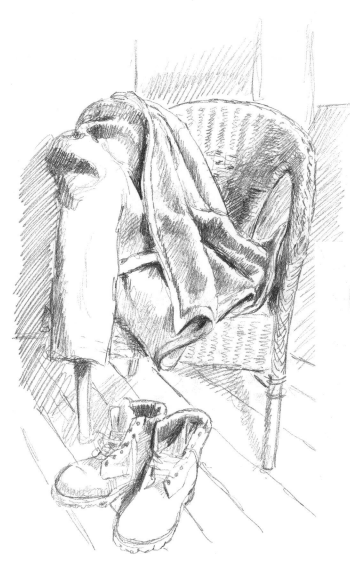

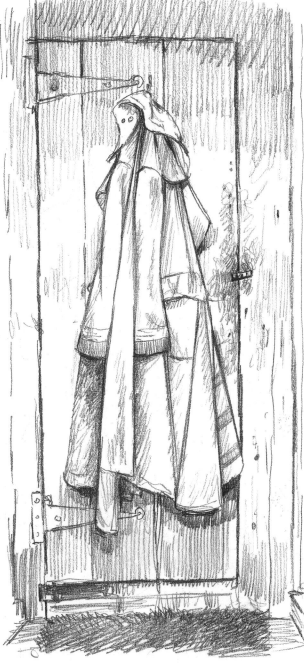

Then we see two still-life arrangements that use the effect of clothing in the scene: first a door, probably outside, with an old heavy garment like an overcoat hanging on the back of the door, then a heavy coat thrown over a basketwork chair with a pair of heavy boots on the floor nearby. They look as if they may be taken away at any moment.

This is a rather more formal composition, but still in the same vein of domestic transience: a bottle, a glass and a plate of chestnuts.

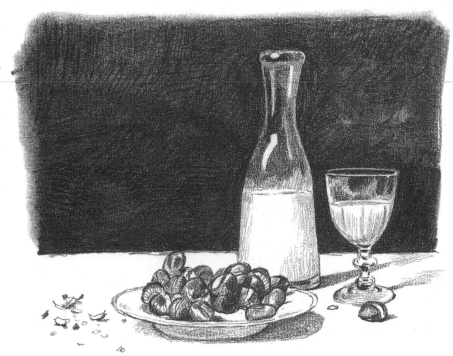

Here I simply took out the contents of my pockets and put them on the table in front of me. Art students are often given a project like this, in which small objects are drawn magnified to fill out all the space. It's a good exercise that has the effect of encouraging close observation.

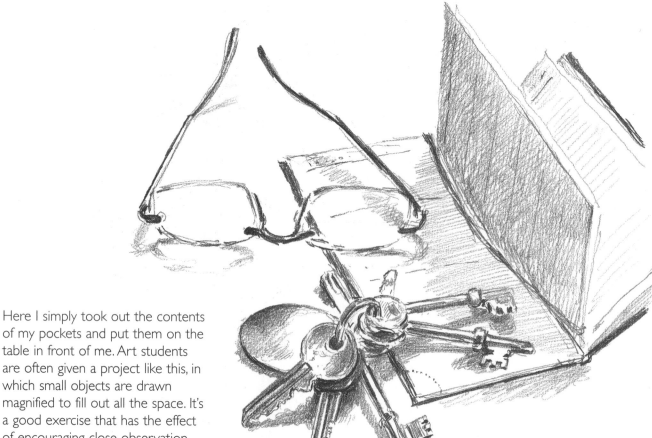

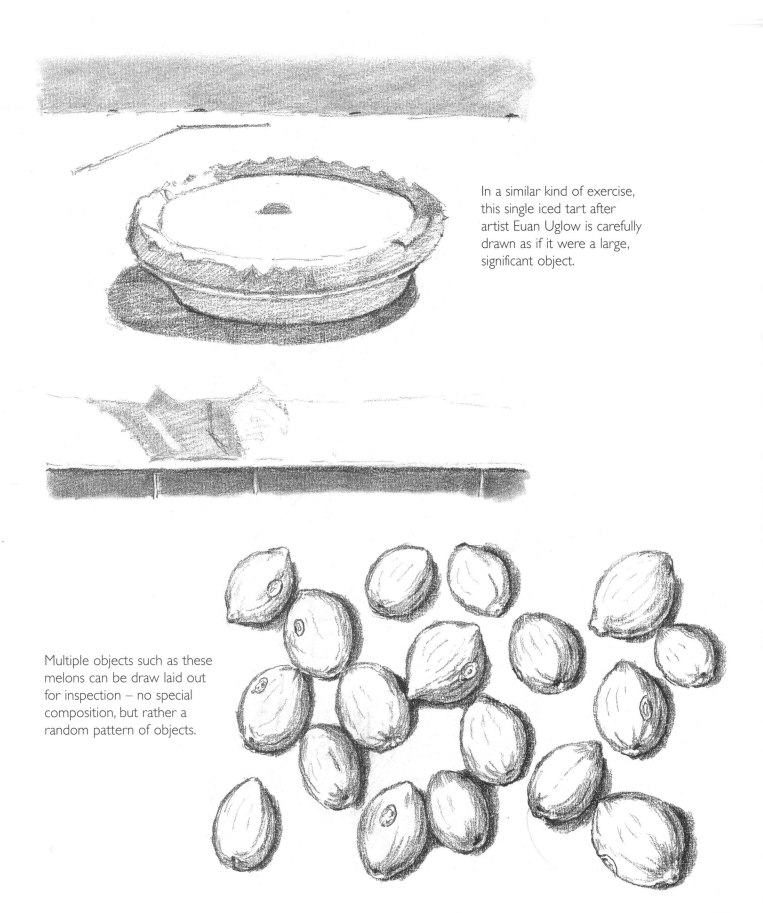

In a similar kind of exercise, this single iced tart after artist Euan Uglow is carefully drawn as if it were a large, significant object.

Multiple objects such as these melons can be draw laid out for inspection – no special composition, but rather a random pattern of objects.

A STILL-LIFE PROJECT

The drawings on these pages show how you might go about selecting a still-life subject, giving you some time to work out your ideas.

Choosing your subject

The first step is to go around your home and contemplate the different possibilities. I began by walking out into the garden near my studio and, seeing an old watering can, I just started drawing it. It didn't at this stage suggest a composition to me, but it was a good start to the search for objects for the still life.

Back inside my studio, I considered the easel in one corner with a box-easel behind it and a rucksack full of painting kit propped against it – interesting, but not quite varied enough for my taste.

When I walked into my house I noticed a group of family photographs, some pots and a candlestick on top of a bookshelf. This was a more careful arrangement but not quite what I was after.

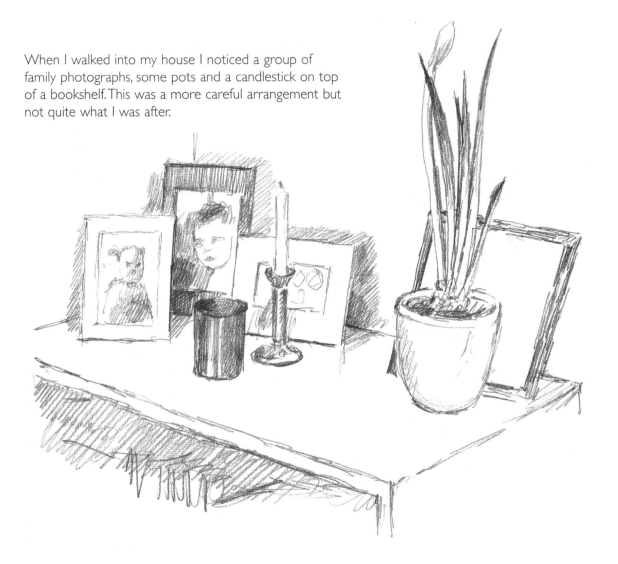

I then started collecting objects together that I thought might make a good group. From the kitchen I took a pestle and mortar, and from the top of the dresser a large jug.

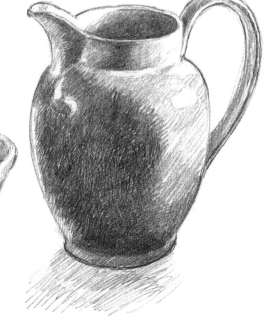

Preliminary drawings

Thinking about a kitchen theme, I got some apples and oranges and laid them out in a way that I might be able to use. The theme seemed to be developing.

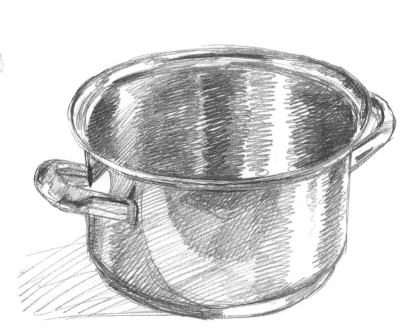

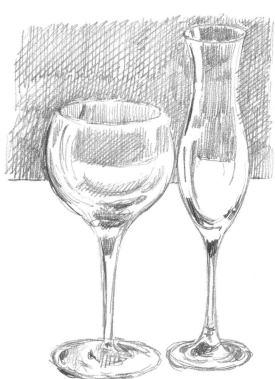

Next, to keep the idea going, I drew a large saucepan and then after that a couple of wine glasses. All this preliminary work is very useful for working up a good still-life composition. It may take you several days, but it's worth it when you are drawing a major piece of work.

After that I added a bowl and, to bring in food again, a box of eggs from the fridge. My kitchen still life seemed to be falling into place.

I then put a table napkin on the tabletop to add a different texture to the scene.

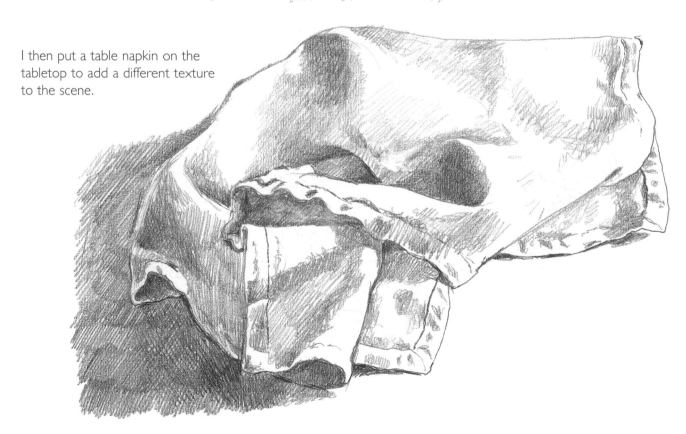

Choosing a composition

The next stage was to choose my composition pieces and try them out. I roughly scribbled out a sort of arrangement of some of the objects that I'd gathered.

Then I tried a much more simple one, but wasn't altogether convinced that it had a future.

So I tried another still but still felt it was not what I really wanted. This scribbling up of various compositions is never wasted, because it helps to clarify what you are really after.

Finally I got something that started to look like the composition that I wanted. All this preparatory work can be done long before you actually start to draw, but you do have to sit in the position that you think you will be drawing from when it comes to the real thing. Then you quickly start to see what it is that you find attractive.

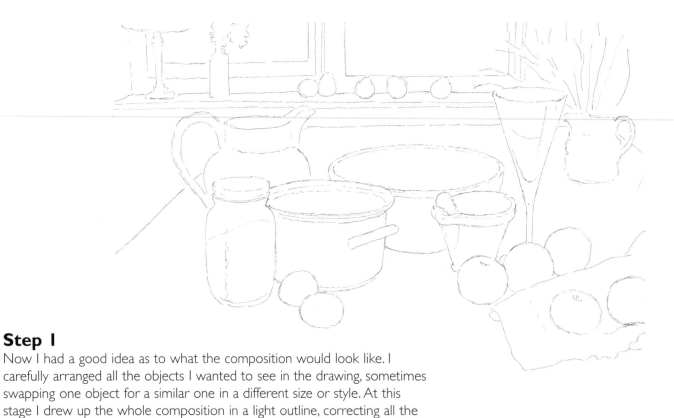

Step 1

Now I had a good idea as to what the composition would look like. I carefully arranged all the objects I wanted to see in the drawing, sometimes swapping one object for a similar one in a different size or style. At this stage I drew up the whole composition in a light outline, correcting all the time in order to arrive at a clear cartoon drawing of the whole thing.

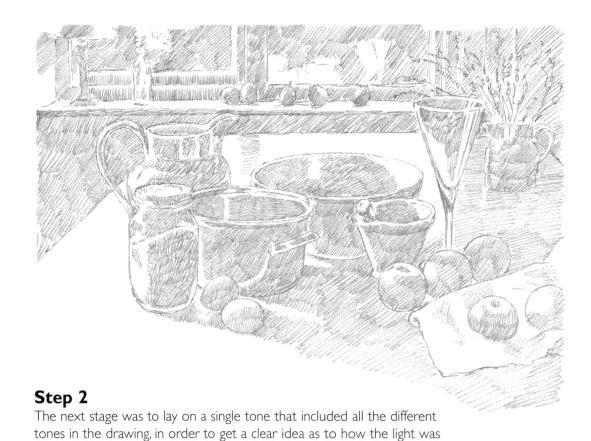

Step 2

The next stage was to lay on a single tone that included all the different tones in the drawing, in order to get a clear idea as to how the light was falling on the objects.

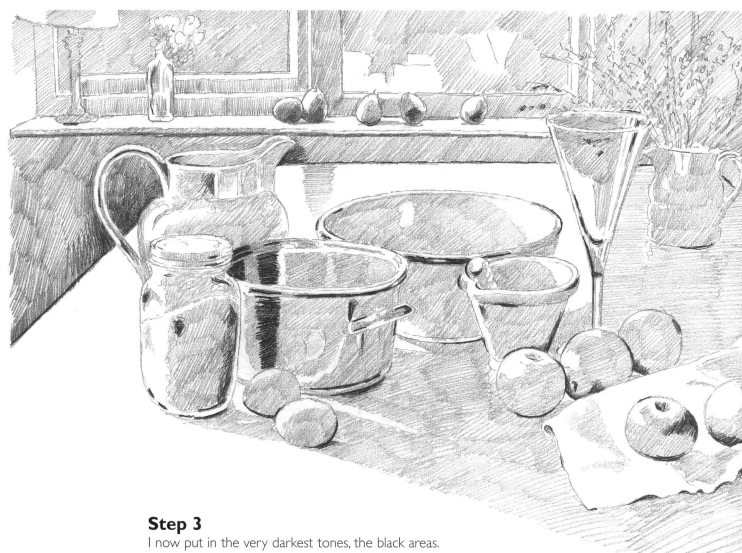

Step 3

I now put in the very darkest tones, the black areas. This gave me the contrast between the lightest and the darkest tones, and made it much easier to now put in all the mid-tones. This can take some time but if it is done attentively, it will really enhance the quality of the final picture.

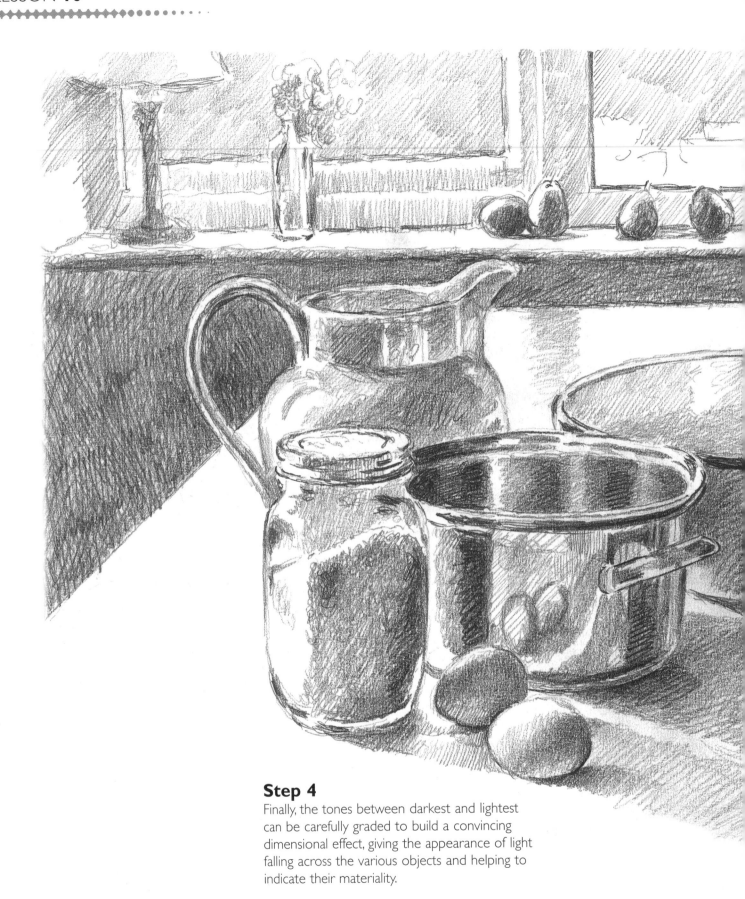

Step 4

Finally, the tones between darkest and lightest can be carefully graded to build a convincing dimensional effect, giving the appearance of light falling across the various objects and helping to indicate their materiality.

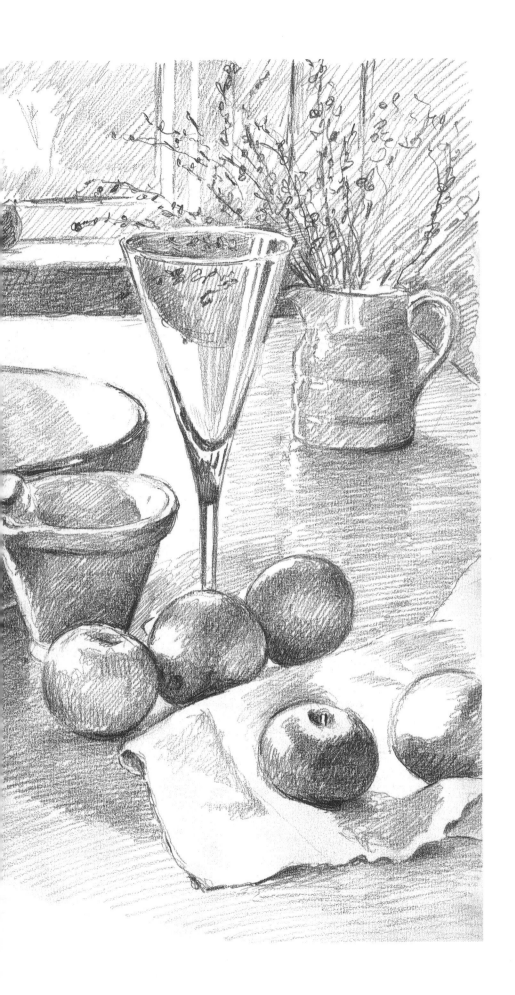

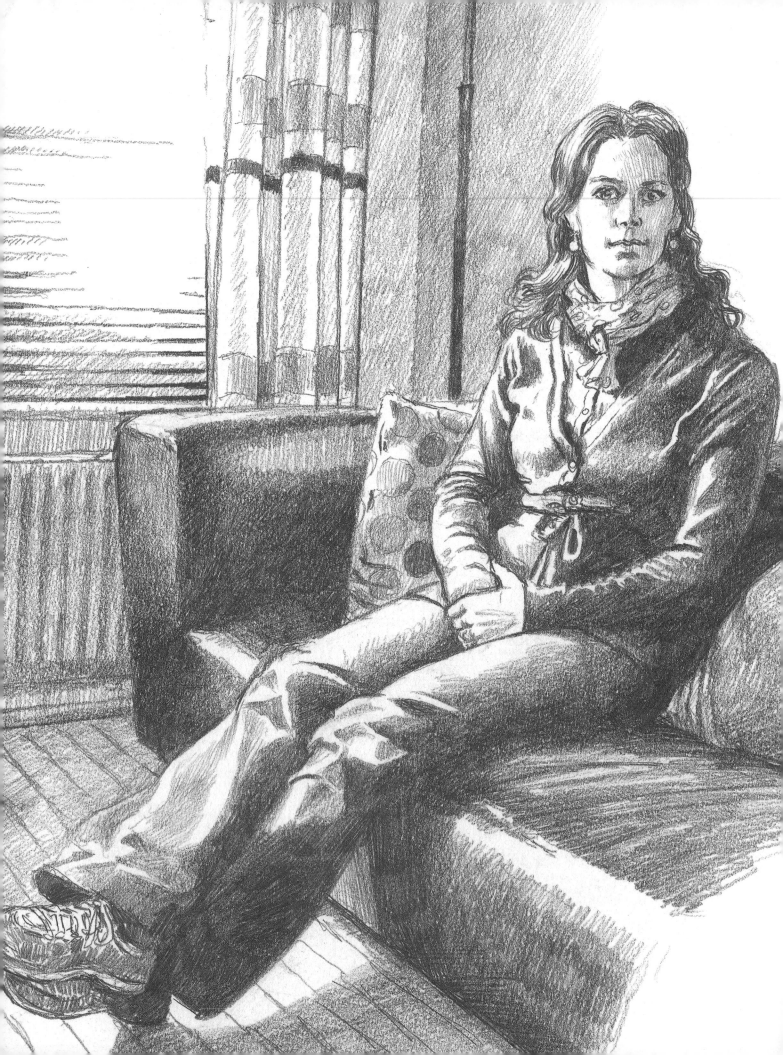

■ LESSON 11

FACES AND PORTRAITS

The human face is often the most attractive subject for an artist. In a way, producing a good portrait of another human being proves to yourself how well you are progressing; it's the hardest area in which your skills will be tested, because everyone can see at once whether you have attained a resemblance to the individual or not.

However, that isn't the be all and end all of a portrait – it's also meant to be a work of art, not just an accurate record of someone's features. In this lesson you'll learn about drawing portraits in a way that will enable you to capture likenesses of your friends and family as well as producing pictures that stand up as art in their own right.

Arranging the setting for a portrait requires some thought – you will need to consider not just the character of the sitter but also the way in which they are lit and posed. This can give vastly different effects to the style of the portrait and make it much more interesting, both for the sitter and the artist. Some portraits are of the formal and serious kind, such as an institution might commission for posterity, while others are informal and domestic, often of people that we know quite well. The sitter may be against a blank background that tells nothing of their lifestyle, or there may be details of their surroundings, perhaps with symbolic meanings. It's a field of art that has many fascinating variations.

PORTRAIT COMPOSITION

The first thing to consider in a portrait is the format to choose, which will be largely dictated by how much of the sitter and the background we wish to show. Here, we look at the choices made by various artists to convey different effects in their portraits.

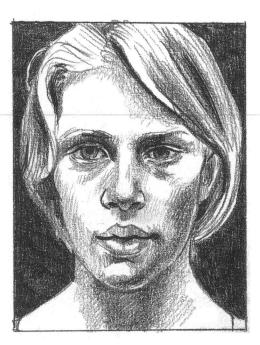

Celia Bennett's is the kind of portrait that shows only the head of the sitter, as large as possible in the frame, with a dead straight, full-face view. This style is probably what most people first think of when it comes to drawing a portrait, and it is a good way for you to start because it is a very basic version.

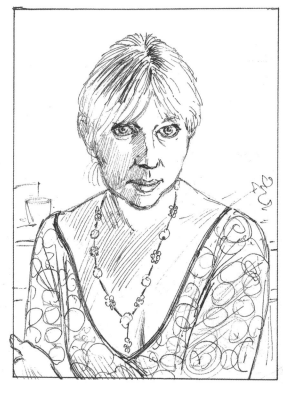

In the next picture, after Lucie Cookson, you can see the upper torso and the arms of the sitter, and the head is turned to one side with the eyes directed away from the artist. This has the effect of making the portrait a little less head on, and allows the artist to give some sense of the sitter's body language. This allows for quite a bit of interpretation to the artist. Note the rather interesting lighting as well.

In this head and shoulders portrait after Keith Robinson, the sitter's head is slightly turned and lowered. The space around the head also gives a more formal effect to the portrait, but the whole look is very gentle and attractive.

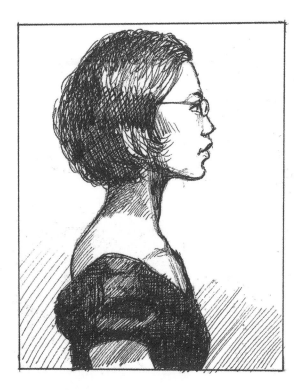

This drawing after a portrait by Geert Schless also shows the head and shoulders, but in profile, which immediately gives a more formal and less emotionally connected effect as if the artist is making a cool study of the head. People who commission portraits don't tend to ask for this view because it is not how they usually see themselves. It is very objective in style, but was quite popular during the Renaissance period in Italy.

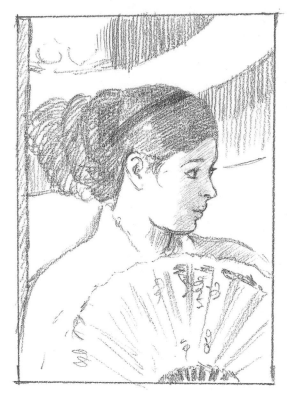

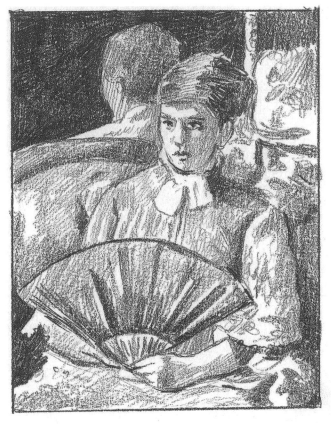

The next two drawings, after Mary Cassatt, are in a similar format, showing only the head and shoulders of the sitters, but this time they both have the additional attribute of a fan, which immediately gives a period look to the picture. The first shows the young woman seen from almost profile view with the fan coming across the top of her body, so that all you see is the face and fan below it.

The second is a bit more inclusive, showing the figure down to the waist and the sitter facing more towards the artist. The hand holding the fan is lower in the picture and the woman's head is reflected behind her in a mirror, giving an added depth to the picture.

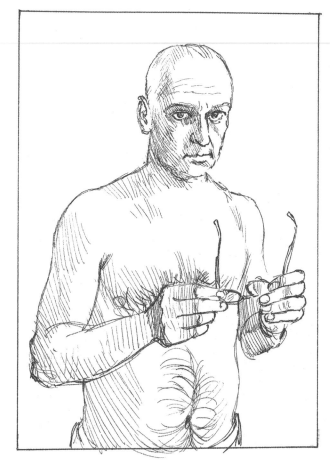

Next we have two male portraits that both have a dramatic effect. The first, after Annemarie Busschers, is of a man from the waist up, and because he is stripped to the waist, the power of the portrait is increased. Is this too much information for us, or is it a brilliant way to make the character of the sitter stand out? He also holds his glasses in a rather scholarly way, as though he is carefully considering you gazing at him.

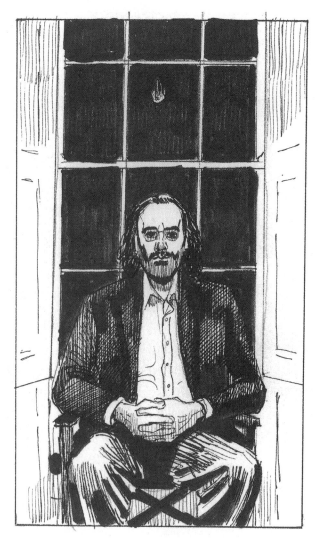

The next sitter is posed in the frame of a large window that reflects the electric light in its dark panes. He is portrayed very formally by Oisin Roche, almost like a royal portrait. He takes up only a relatively small proportion of the space, the window becoming a large part of the scene. Both of these could be considered half-figure portraits, but the forcefulness of the poses makes us somehow aware of the complete person.

Now we see two full-length portraits, one sitting and one standing. They are both very uncompromising, being face on to the viewer, one against a dark background and one in a sort of bright floodlit style. Although Toby Wiggins' sitter looks quite gentle and relaxed, because she is surrounded by space and the dark shadow of that space throws the figure forward, the effect is much more powerful and dramatic. Blaise Smith's standing figure looks very forceful, but her tough stance is made humorous by the terrier dog sitting foursquare alongside, also glaring at the artist.

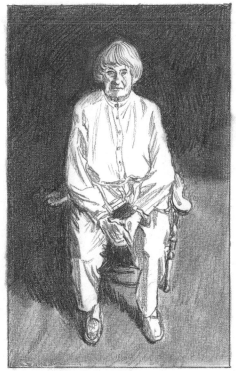

The next pair of portraits use the format of the frame to set off the figure in a different way that instantly attracts your attention. Vincent Brown's male figure is jammed sideways into a tight, narrow box of a frame that really makes you concentrate on the face and attitude of the sitter – a clever device to ensure that we look at the portrait more closely.

Sara Shamma's female figure is displayed like an exotic flower, her hand holding up a smoking cigarillo, with a jewelled pendant suspended in front of her. Her shadow cast on the background wall is complex and her hand is drawn several times as if the artist couldn't quite decide which was the best position. She also wears decorative clothing, and the whole effect is of this exquisite creature posing for our delight – an interesting statement by the artist of herself as a sort of odalisque.

GROUP PORTRAITS

In these next portraits we look at compositions where there is more than one person portrayed. Drawing two or more people introduces a new dynamic into a portrait since you have to consider how the figures interact: whether they will be in physical contact, and whether they will be looking at each other or at the viewer, as well as where they are placed in the frame.

Professors Chris and Uta Frith, after artist Emma Wesley, is of a husband and wife sitting in their own study. The scene is full of what are probably connections with their own interests and academic work. They are closely placed together, but are looking at us sideways, as though we have just come into the room. It is both formal and friendly, which is quite a difficult thing to do, and shows the artist's powers.

The next example, after Stephen Rogers, is of two young women, probably sisters, set up in a very formal side-by-side pose with an abstract background. They are both looking straight at the viewer, without any particular expression, as if they have been pinned down as objective recognition pictures, a bit like a double passport photograph – rather stark but also amusing.

The third group portrait, after Mary Cassatt, is of a mother with daughter and baby making a classic triangular composition, like a Renaissance Holy Family. The connections between the people in the picture are more important than the connection with the artist or viewer. They are all very interested in each other and appear to be oblivious of any onlooker.

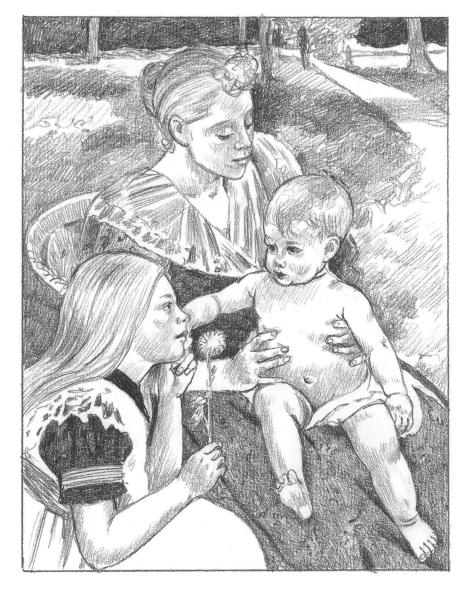

DRAWING YOUR FAMILY

Now let's look at what happens when we choose our nearest and dearest for our portrait sitters. Most of us have enough family and friends to practise our drawing skills on, and it is of great benefit to draw the people you have easiest access to and whom you know very well. This in-depth knowledge can help to give your portraits more power.

I decided to have a go at drawing most of the members of my family who were in the house one Christmas, and I started with my grandchildren. Of course young children and babies will not sit still for you much so this is probably an occasion when photography can come to your aid. It does help to have the originals around as well, though, because this helps to inform your drawings from photographs that you have taken yourself.

Here is my youngest grandson, caught in his mother's arms and laughing at the camera. As you can see, his round, open eyes and nose and mouth are all set neatly in the centre of the rounded form of his head and face.

Next my granddaughter lounging on the floor, kicking her legs and giggling. Here, I concentrated on her gleeful expression.

I drew my youngest daughter while she was talking to someone else, so almost unaware of me.

My eldest grandson, looking a bit shy but amused. He couldn't stay still for long, so I took a photograph just before I started drawing.

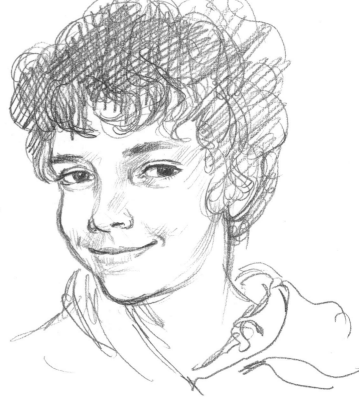

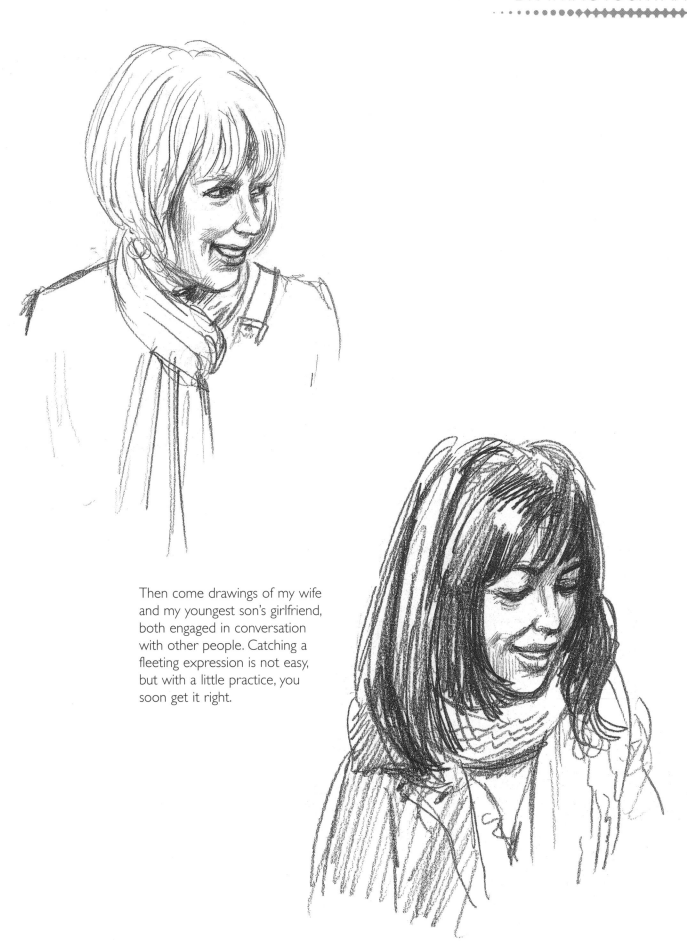

Then come drawings of my wife
and my youngest son's girlfriend,
both engaged in conversation
with other people. Catching a
fleeting expression is not easy,
but with a little practice, you
soon get it right.

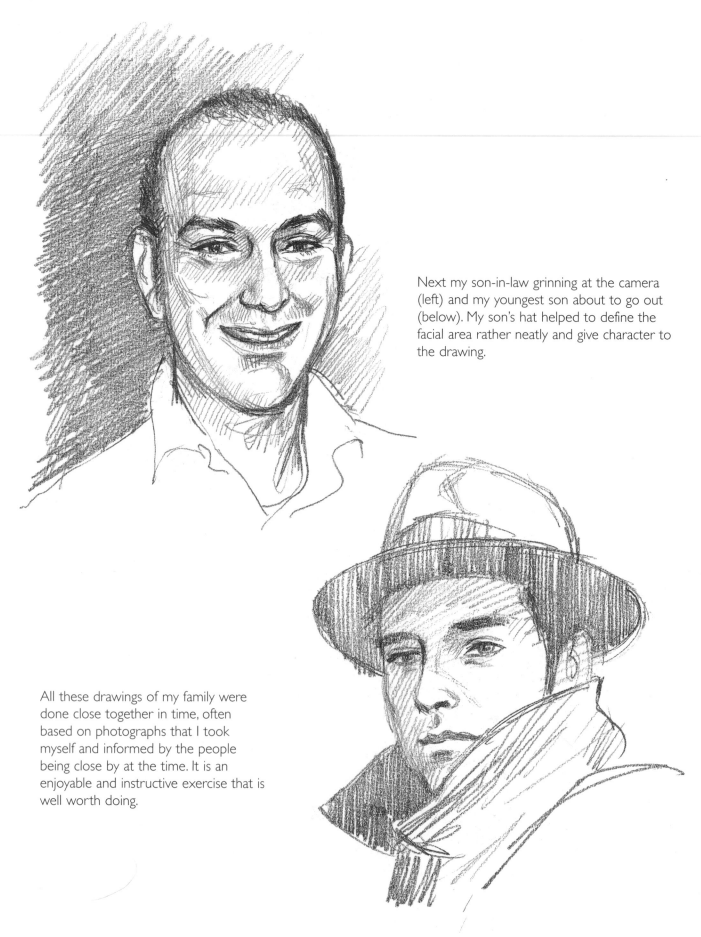

Next my son-in-law grinning at the camera (left) and my youngest son about to go out (below). My son's hat helped to define the facial area rather neatly and give character to the drawing.

All these drawings of my family were done close together in time, often based on photographs that I took myself and informed by the people being close by at the time. It is an enjoyable and instructive exercise that is well worth doing.

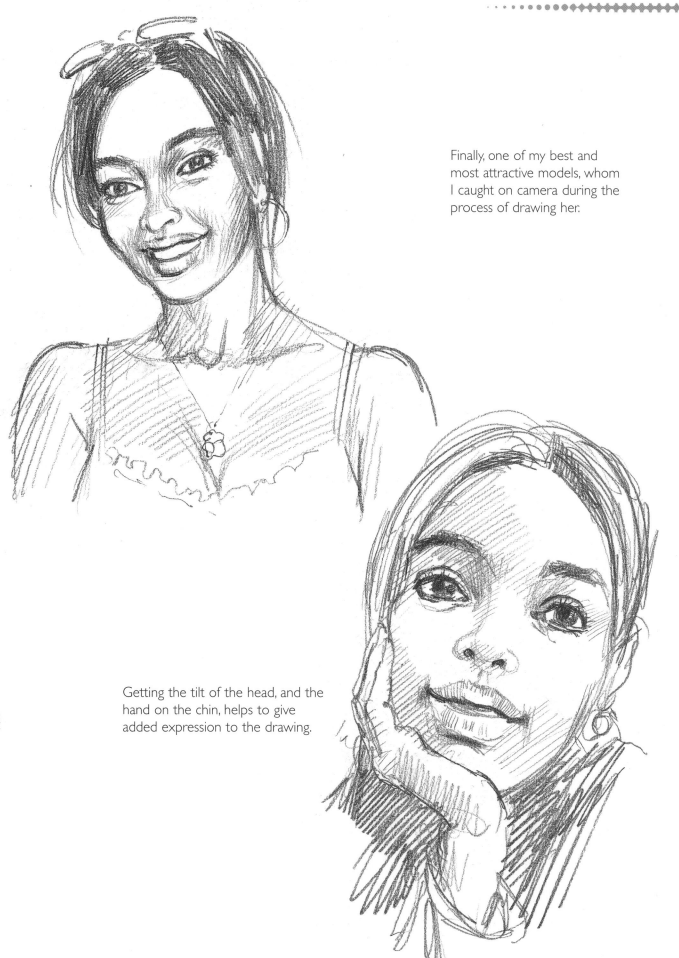

Finally, one of my best and most attractive models, whom I caught on camera during the process of drawing her.

Getting the tilt of the head, and the hand on the chin, helps to give added expression to the drawing.

■ A PORTRAIT PROJECT

This exercise entails quite a bit of drawing and you will learn a lot about your model's appearance by spending a whole session drawing and redrawing him or her from as many different angles as you think would be useful.

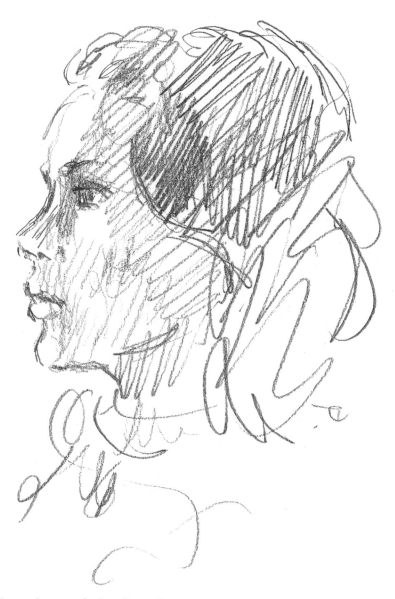

Sketches of the head

I chose as my sitter my eldest daughter, who has sat for me often, like all of my family. Not only that, she is an accomplished artist herself, so she knows the problems of drawing from life. This sympathy with your endeavours is useful, as models do get bored with sitting still for too long.

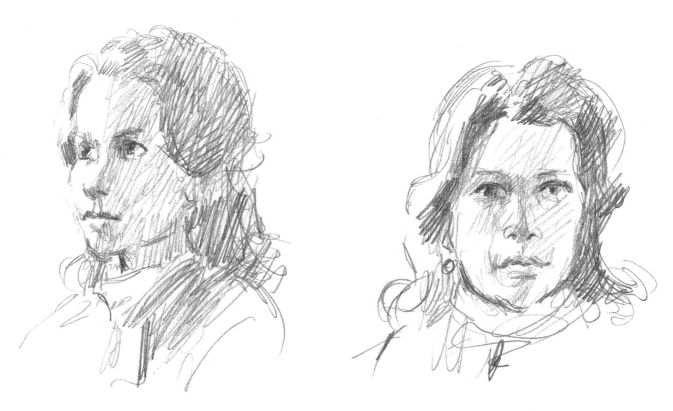

I worked my way round my sitter's head by drawing her first from the side or profile view, then from a more three-quarters view and finally full face. I now had a good idea as to the physiognomy of her face.

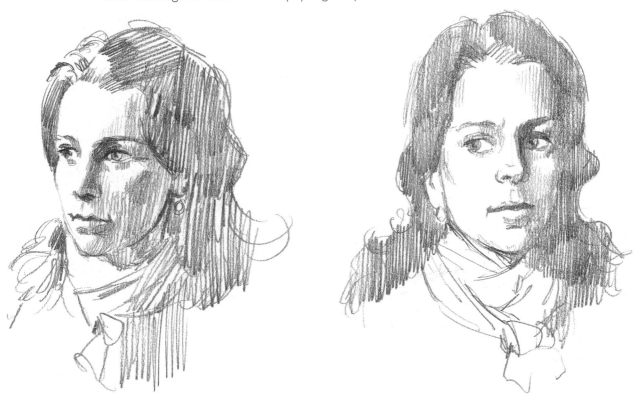

Next I took more account of the lighting, drawing her full-face and three-quarter face, both with strong light cast from the left.

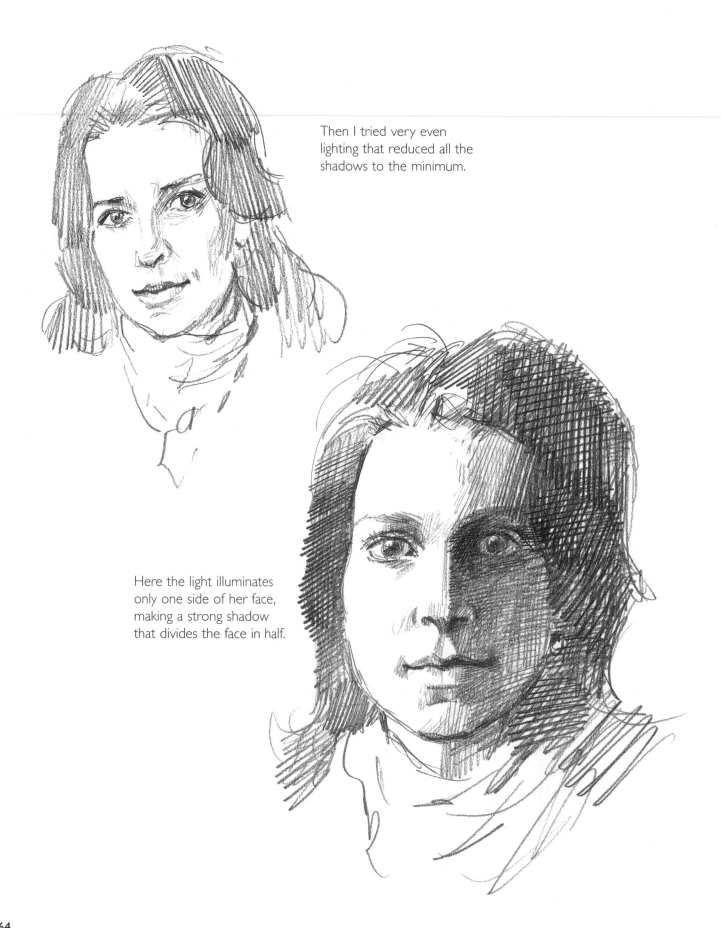

Then I tried very even lighting that reduced all the shadows to the minimum.

Here the light illuminates only one side of her face, making a strong shadow that divides the face in half.

Sketching different poses

Now you need to spend some time drawing the sitter full or three-quarter length in order to decide how much of the pose you might want to draw.

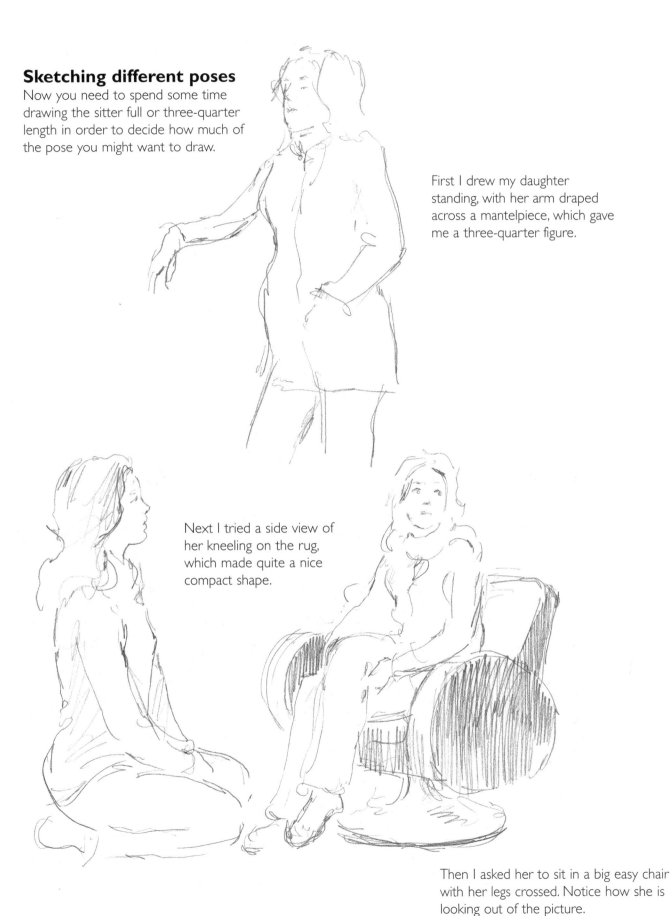

First I drew my daughter standing, with her arm draped across a mantelpiece, which gave me a three-quarter figure.

Next I tried a side view of her kneeling on the rug, which made quite a nice compact shape.

Then I asked her to sit in a big easy chair with her legs crossed. Notice how she is looking out of the picture.

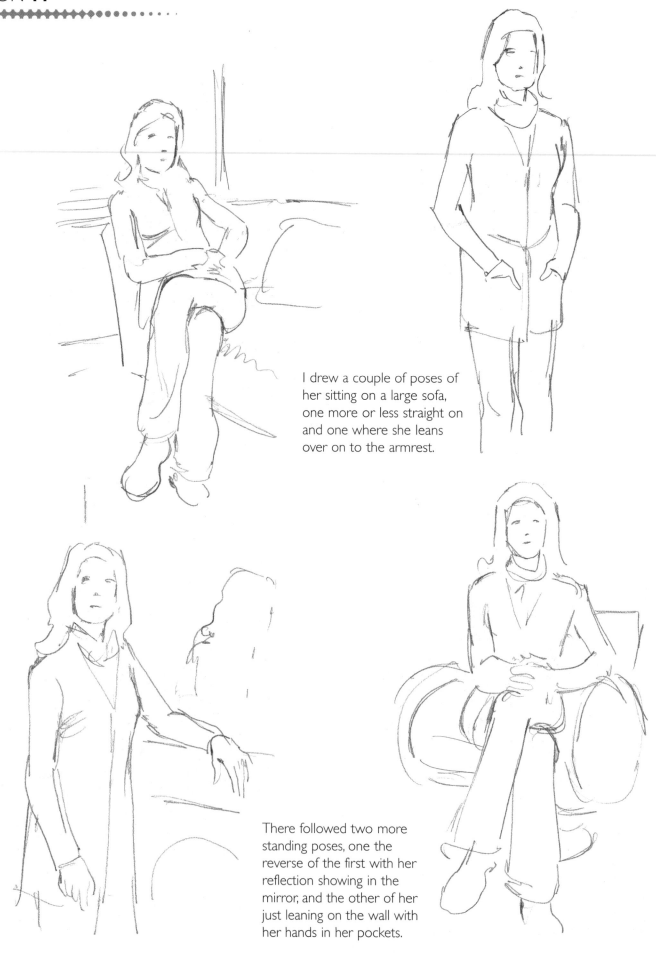

I drew a couple of poses of her sitting on a large sofa, one more or less straight on and one where she leans over on to the armrest.

There followed two more standing poses, one the reverse of the first with her reflection showing in the mirror, and the other of her just leaning on the wall with her hands in her pockets.

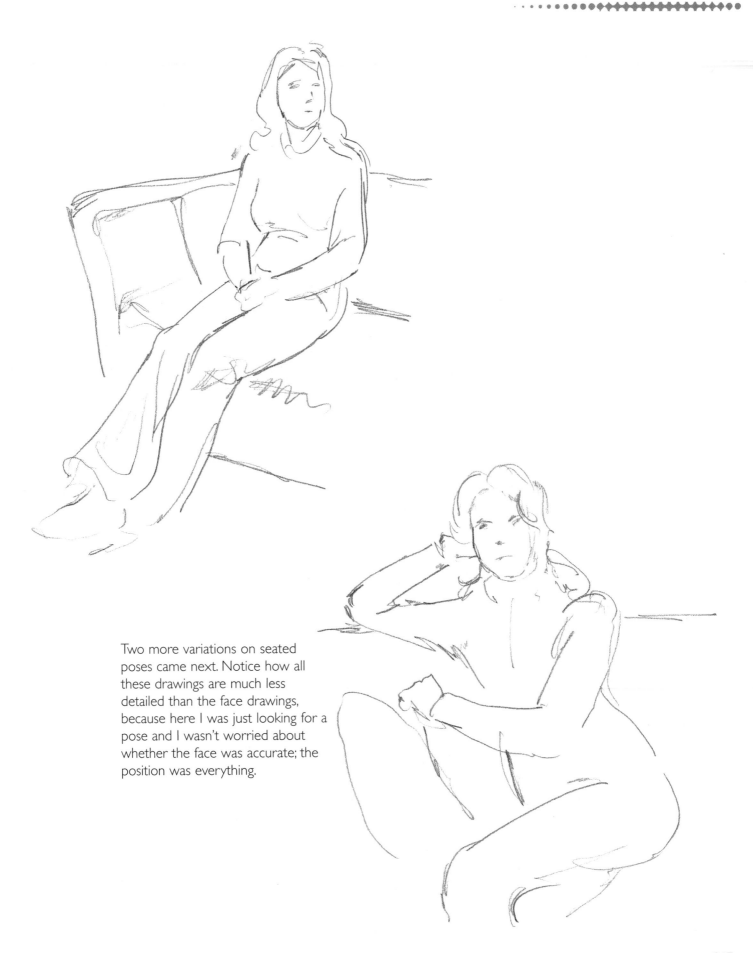

Two more variations on seated poses came next. Notice how all these drawings are much less detailed than the face drawings, because here I was just looking for a pose and I wasn't worried about whether the face was accurate; the position was everything.

Drawing the features in detail

Once you've decided upon the pose you need to turn your attention to the details of the sitter's face, taking each of the features and making detailed drawings of them.

I started by drawing just one eye. This is a difficult thing to do, as the model will find your concentrated stare a little daunting. However, it's also very revealing as to how carefully you have observed the eye. Having drawn my daughter's eye directly facing me, I then drew it from a slight angle so that I got a side view of it. I did this with both eyes, then drew them as a pair to see how they looked together, as well as the space between them.

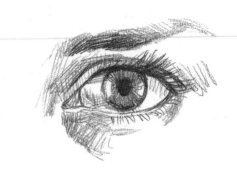

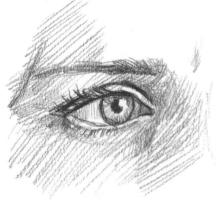

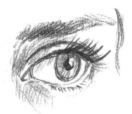

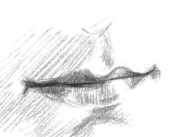

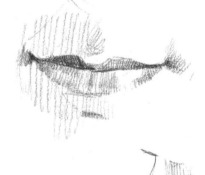

Next I moved on to the mouth and drew it two or three times, exploring the front, side and three-quarter view.

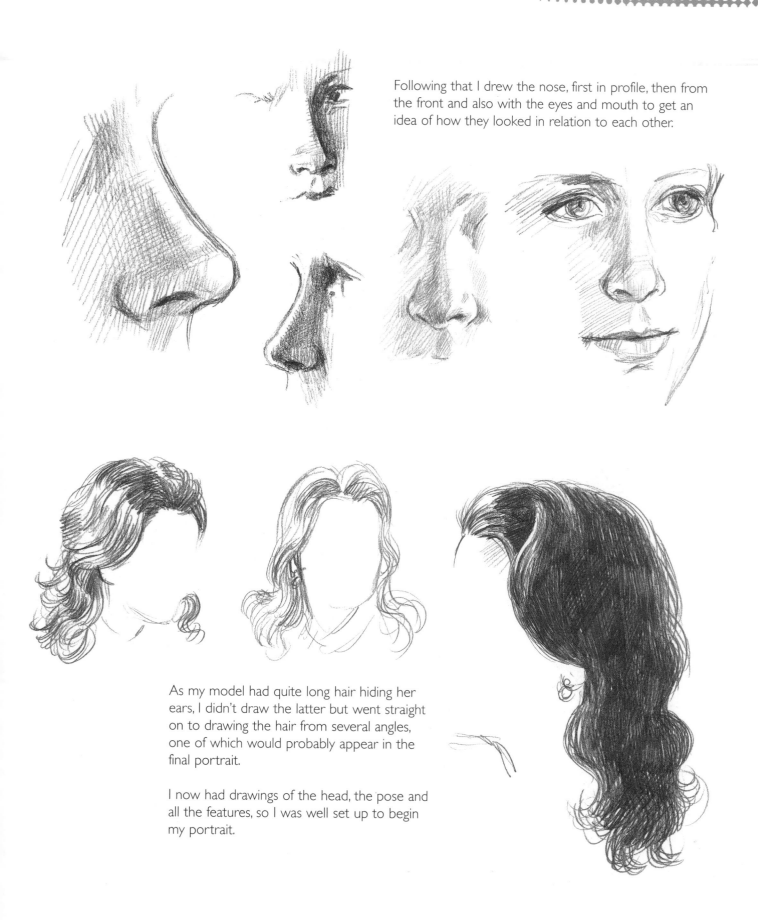

Following that I drew the nose, first in profile, then from the front and also with the eyes and mouth to get an idea of how they looked in relation to each other.

As my model had quite long hair hiding her ears, I didn't draw the latter but went straight on to drawing the hair from several angles, one of which would probably appear in the final portrait.

I now had drawings of the head, the pose and all the features, so I was well set up to begin my portrait.

Choose your composition

With my drawings gathered together and my model refreshed and ready to sit for me again, I first had to choose the pose and then draw it up in as simple a way as possible but with all the information I needed to proceed to the finished portrait. I decided to place her on a large sofa, legs stretched out and hands in her lap, with her head slightly turned to look directly at me. The light was all derived from the large window to the left and so half of her face was in soft shadow.

I then spent time drawing her in some detail, but without any shading, to create my cartoon. I tried to make it as correct as I could, but it didn't yet matter if the drawing was not quite as I wanted it because the purpose of the cartoon was to inform me as to what I needed to do to make the final piece of work the best possible portrait that I could manage. When artists in traditional ateliers were painting a large commission, they often drew up the whole thing full-size in an outline state from which to produce their final painting.

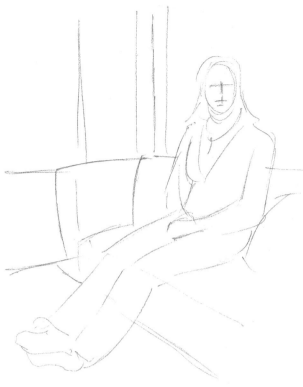

Step 1

First I drew up a quick sketch that told me where everything would be placed. This almost exactly echoed the shape of my cartoon, which I had in front of me.

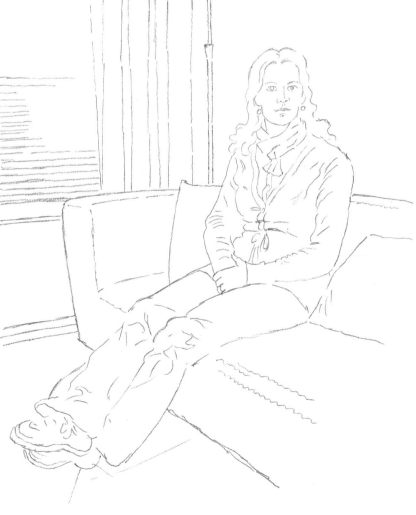

Step 2

Then, still using my cartoon as a guide, I drew up a careful outline drawing of the whole figure and the background setting in some detail. This was the last stage at which I could introduce any changes if they were necessary.

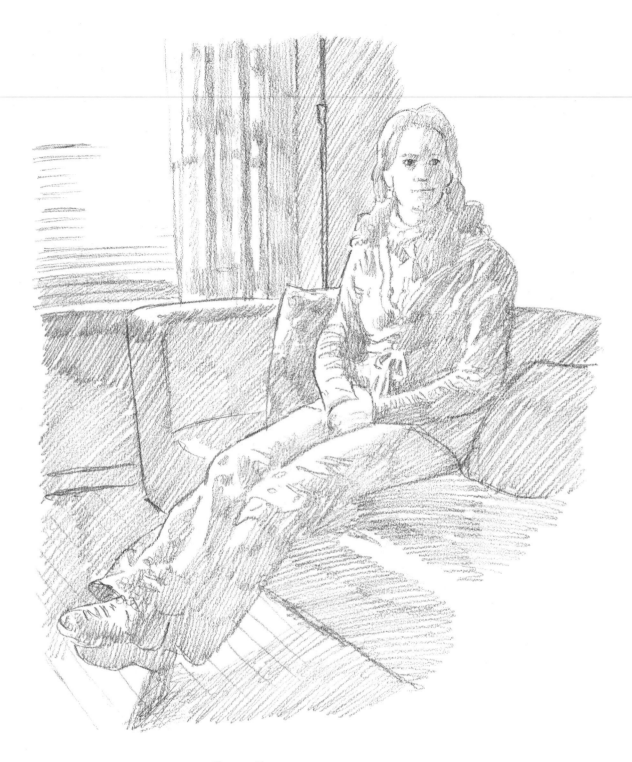

Step 3

Next I began to put in the main area of tone evenly, using the lightest tone that would appear on the finished article.

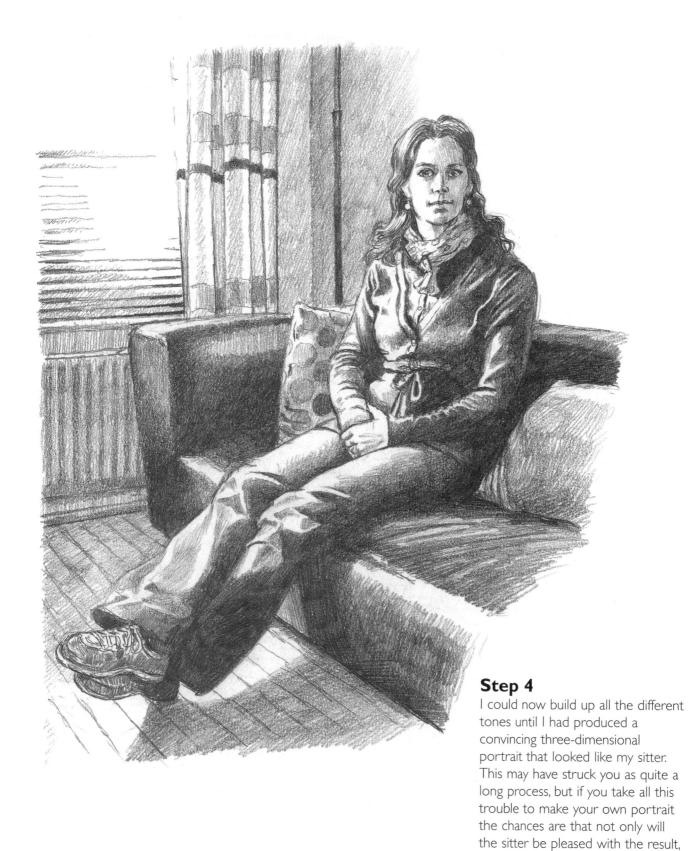

Step 4

I could now build up all the different tones until I had produced a convincing three-dimensional portrait that looked like my sitter. This may have struck you as quite a long process, but if you take all this trouble to make your own portrait the chances are that not only will the sitter be pleased with the result, so will you.

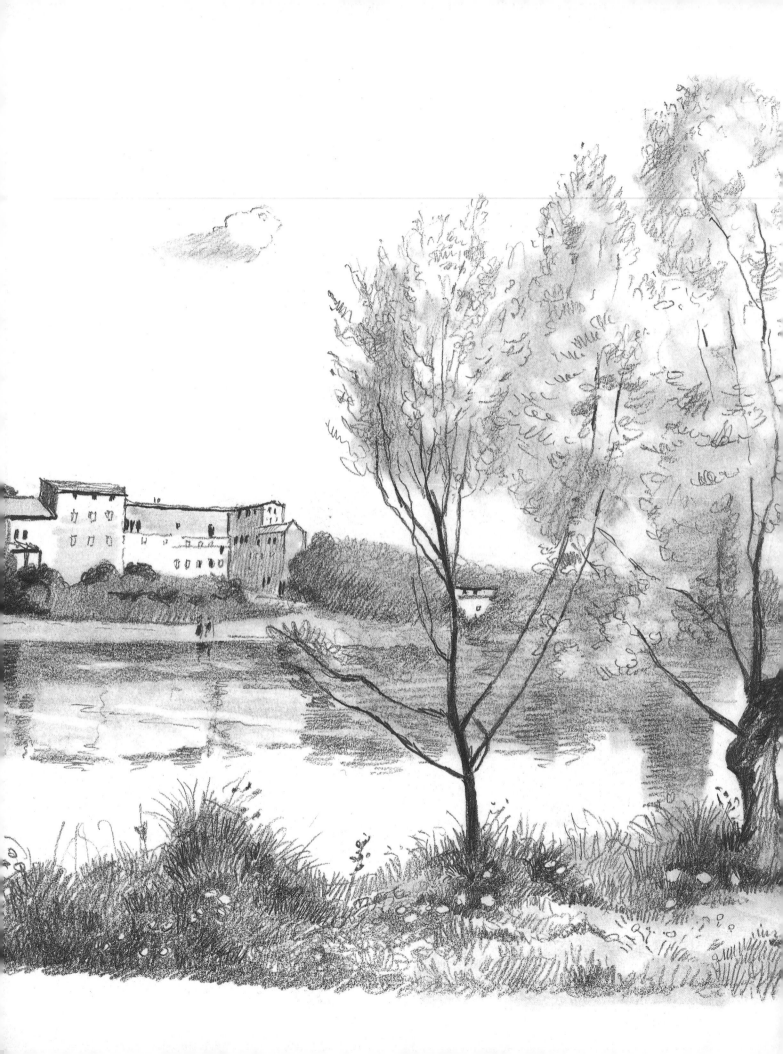

■ LESSON 12

EXPLORING LANDSCAPE

I've made landscape the last topic to explore in detail because it's probably the area for which you will need the most preparation. One habit that will help you is to always take a small sketchbook when you are out and about so that you can make a quick record of any appealing locations for later reference. Another useful tool is your camera, because when you take shots of landscape you can bear in mind how you might want to draw the scene, which has a way of sharpening your compositional skills.

Sometimes you will find you need to alter the landscape to a certain extent when you are drawing, which is a time-honoured practice of artists working in both the rural and urban landscape. However, it's best at first to concentrate on getting the landscape you are drawing as accurate as possible, and then contribute your own ideas to the scene later on when you are more confident.

You will spend more time on a landscape than on any of the other subjects in this book because the sheer scale of a location demands more work and effort. However, when you have finished one you will find it extremely rewarding to have a record of where you have been. There is also something in the human soul that responds to scenes of the natural world; it's no accident that most pictures that you see on living-room walls tend to be landscapes of some sort.

LOOKING FOR VARIETY

The idea of drawing a landscape can be a bit daunting at first because of the sheer size of the view and the amount of information therein. However, it is not quite so difficult as it looks at first glance and you'll soon gain confidence with a little practice. Trying the drawings shown here will give you a good start.

The examples in this exercise are of the sort of attractive places that you might visit for a holiday. The first is of a hilltop farmhouse in Tuscany, Italy. The scene is nicely set, with no confusing background to perplex you, and you need only draw the slope of the hill, a few trees and the shape of the farmhouse. This sort of carefully limited view is ideal for a first attempt because it doesn't create the problem of having to decide which part of the view to choose; there is only one major building that is anywhere near to the artist's viewpoint. Another advantage is that there is little or no perspective to wrestle with.

This view of Polperro in Cornwall, seen from above the harbour, is a little more difficult. Once again it is a restricted view so that you can see only a certain amount of the town, but even so there are more houses, or at least rooftops, to draw. I have concentrated attention on the main part of the harbour and the trees just above it; the only houses that I have drawn in any detail are those directly in the centre. The background and the mass of roofs on the left are just shown in a sort of inspired scribble to suggest the general shape and feel.

Next I have taken an example drawn in the 1950s by Algernon Newton. It is of an area of North London with a canal in the foreground which helps to sandwich our attention on the central area of the row of undistinguished buildings. The canal barely reflects the buildings and the sky above is lightly clouded, so the whole force of the scene is the row of houses from left to right across the centre of the picture, their darkness reinforced by the light from behind them. Here the artist has taken an ordinary, even dull, scene and turned it into an interesting and powerful picture that holds our glance.

This view of the Houses of Parliament, Big Ben and Westminster Bridge in London is famous worldwide. Drawing a familiar scene such as this is a challenge, because a certain amount of accuracy is required. The whole scene composes itself to some degree, your choice being only how much to extend the scene to the right or left of the focal point of the clock tower. The bridge is a problem in perspective, but as long as you don't try to get too much of it in the picture it's not too difficult. The hardest job here is the intricacy of the architecture of the main buildings, but keep them simple to start with as I have done here.

DRAMA, FORM AND GRANDEUR

A dramatic landscape is always a good spur to making a drawing, whether it is mountainous or watery, natural or manmade. You can emphasize the power of the scene by using strong tonal contrasts and angled viewpoints.

Here I have drawn the viaduct bridge over the River Wear in Devon, which combines awe-inspiring architecture with beautiful countryside. This sort of landscape is dramatic from many angles, but I have chosen the most obvious to show the shape of the bridge and its reflection in the river. It also helps that the sun is behind the bridge, making it into a marvellous silhouette against the bright sky and stream.

This view across the formal gardens of Hampton Court Palace just outside London is a study in gardening on a grand scale. The whole scene is a carefully composed pattern of plants and paths, with the mass of the building in the background nicely balancing the soft formality of the lawns and flowers in the foreground. Only part of the garden is shown, which stops it becoming too panoramic – what you might call a domesticated environment, but on a grand scale.

The third scene is a grand panorama of Dartmoor, in Devon, by the Victorian artist John William Inchbold. With this type of landscape you need to find a place that gives you key features to help frame the composition, which Inchbold has done well with the large rock on the left and the deep ravine on the right. The sweep of the sky is kept to about one-quarter of the whole area of the picture, so that it doesn't distract from the rugged scenery. Overall accuracy is not the most important part of a drawing such as this – capturing the atmosphere of the place comes first.

■ CHOOSING YOUR FORMAT

When it comes to drawing landscapes the usual tendency is to think in terms of a wide horizontal shape, which is indeed known as landscape format. However, a vertical shape (portrait format) can sometimes be an interesting variation that may suit your subject better. Shown here are three versions of portrait-format pictures that show how this way of selecting your scene can be useful.

The first scene is of a narrow walkway near Florence, Italy, which shows tall trees either side of a walled road. The whole interest of the picture is the perspective effect of the tunnel through the encroaching walls and trees. If you were standing in this spot it would be obvious that a portrait format is the way to draw the scene.

The next drawing is a much more selective view, because the natural way to portray an open beach scene without much in the way of foreground features is to show it in a wide horizontal format. Here, with the sides of the picture pulled in, the magnificent cloud is the main feature; the sea and beach have been reduced to the minimum so as not to distract from the view of the sky. This sort of landscape could correctly be described as a skyscape instead.

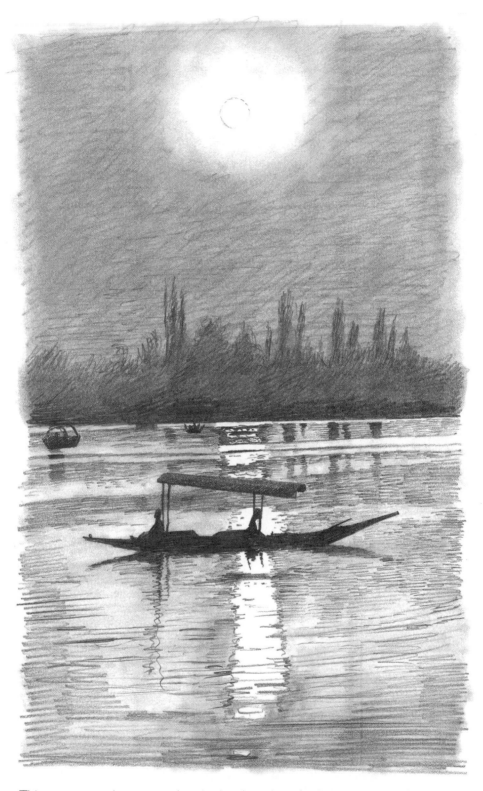

This scene was drawn very late in the day when the low sun was making silhouettes of the boats and trees. It's more a picture of the sun and its effect on the misty sky and the water rather than of the lake itself, so the portrait format was used to act as a window that selects the sun and its reflection. The passing boat in the centre of the scene is a bonus, only made possible by using photographs for information; a moment such as this doesn't allow time for detailed sketching.

A PANORAMIC VIEW

This picture of downland scenery to the south of London was drawn in the 18th century by George Lambert. He chose a wide format to include as much of the panorama as possible, positioning himself well back from the hill – he even shows another artist in front of him drawing the scene. It is clear he wanted to place the hill dead centre in the drawing, framing it with trees to either side of the picture. Many artists of the time would paint large panoramic views like this and then charge the public a small fee to see them.

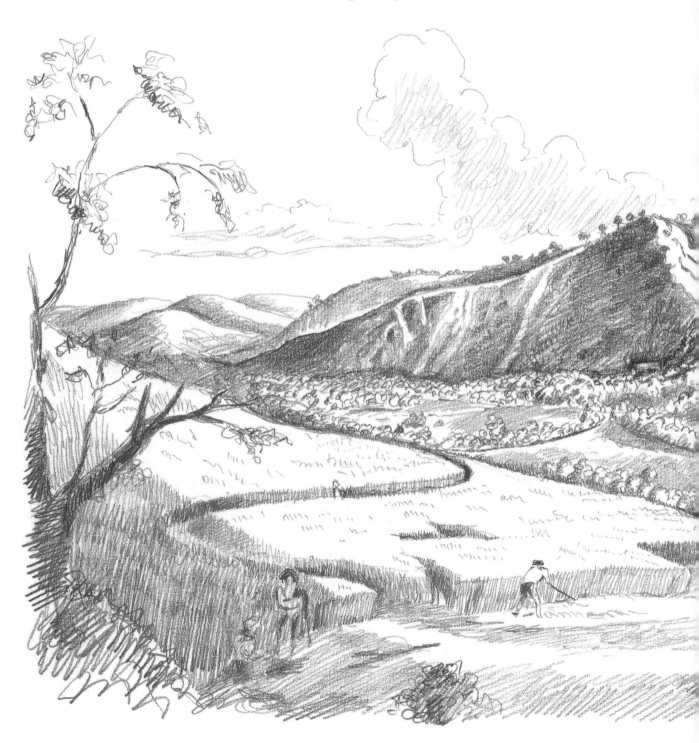

Tackling a panorama

When you feel ready to have a go at a complex large-scale picture such as this you will need to set it up carefully. You will obviously have to choose a day when the weather is going to be in your favour, and then you will have to find a spot to draw from that makes it easier for you to encompass the whole scene. It's a time-consuming subject, too, so you'll have to allot a good part of the day to your drawing, or else return several times in order to complete the picture. Again a good series of photographs will help to add extra information for completing the piece when you get it home.

Working on a piece this large is always a challenge, but if you have the courage to try it out you will probably learn a good deal about landscape drawing in quite a short time. If the view is local to you, visiting it repeatedly beforehand will tell you a lot about the times of day the light is most attractive and the best spots to place yourself. It will also help you to regard the scene as a familiar one, making the moment you arrive with your paper and pencils less daunting.

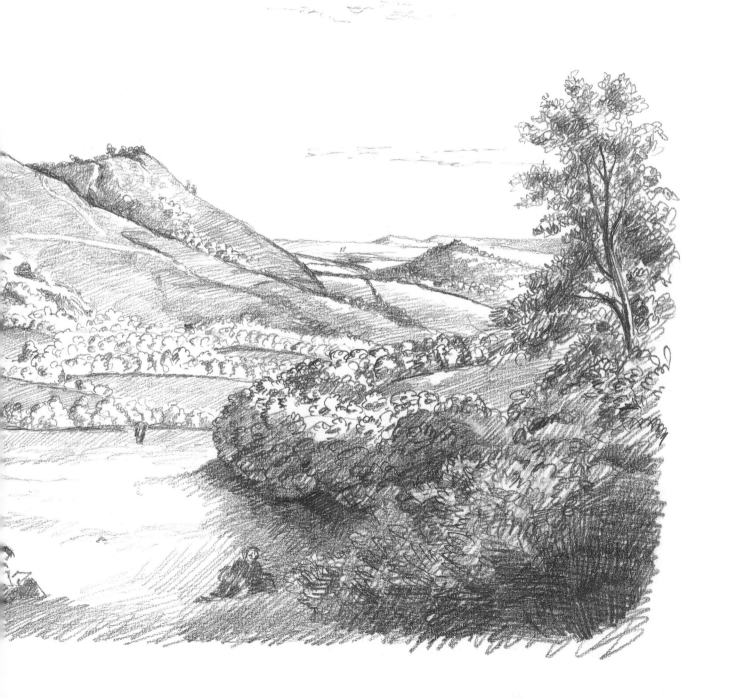

■ ELEMENTS OF LANDSCAPE

WATER

Water in a landscape always adds an extra dimension to a drawing, reflecting the sky and the scenery and bringing light into your work. You may be lucky enough to live near the sea, but a river or lake will be just as interesting for studies of water.

In this scene the water is in rapid movement and so does not reflect the landscape and sky as much as just the light. The surrounding scenery is the side of a rocky hill and the stream flows down to a pool at the base of the picture. There is not much sky as the depth of the hillside needs to be shown, and there is little vegetation except for grass. It is in effect a portrait of a waterfall. Most of the water is the white of the paper, and to make it work the rest of the picture needs some pencil work to provide contrast.

The next picture is of the Suffolk coast, along a creek where fishing boats are moored. In the forefront of the scene are a couple of boats tied to a jetty, with the water behind and in the distance the other shore, also with moored boats. The sky is clear and the water reflects that light, with only small ripples of reflection shown where the boats are. The weather is calm and still, so there is almost nothing to see in the sky and the water.

The bridge over the River Thames at Cookham is a scene made famous by the painter Stanley Spencer. The view here is from the riverbank below the bridge, showing it reflected in the water. In the foreground are a few punts, and across the river we can glimpse a few buildings and trees. Hanging over the right upper corner of the scene are willow branches, which create a fuzzy edge to the thrust of the bridge across the river. The large expanse of sky helps to make the bridge look more dramatic.

This picture is also of the River Thames, this time at Hammersmith. Here, the main feature is a row of houses curving away from the viewer, with dark reflections in the water below.

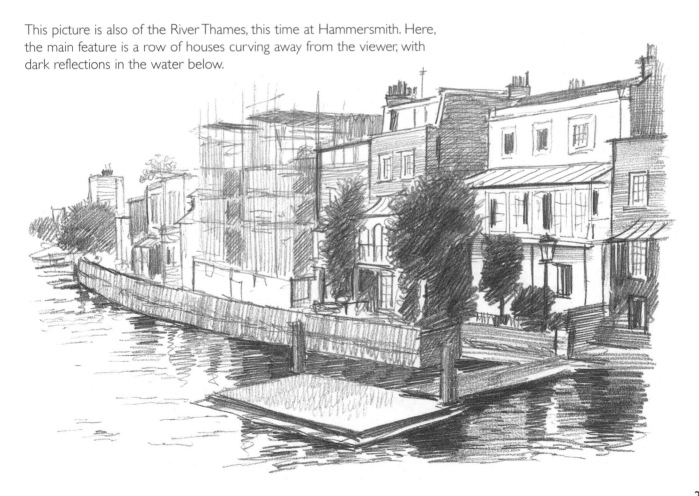

TREES

The next exercise is to make a study of trees, because they are present in most landscapes. Your earlier go at trees in Lesson 3 will have given you the basics, but now the task is to concentrate in more detail on two or three species – choose ones that grow close to where you live so that you can easily revisit them. Shown here are the works of three artists from the 19th century to give you some idea of the power and strength of skilfully drawn trees.

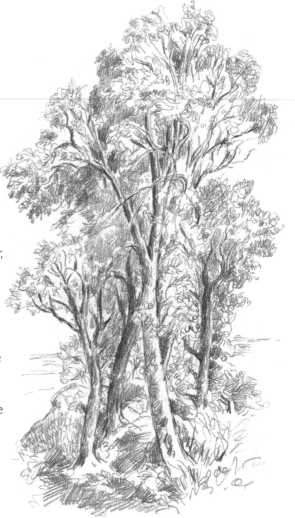

The first artist is Samuel Palmer, who portrayed the landscapes of southeast England. His drawing here of oak and beech trees in the woods is a magnificent example of the stature that the trunk of a large tree can give to a picture, if drawn expressively. This is an exercise that you could emulate and learn a lot about drawing in the process.

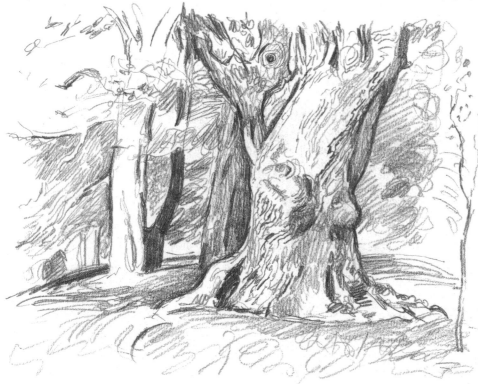

The second artist is John Constable, drawing in the Vale of Dedham in Suffolk. His beautifully realized clump of trees, with their intertwining branches and masses of leafy texture contrasting the hardness of the wood, is a lesson in itself. Copy a Constable drawing of a tree to discover some of his methods, then have a go at drawing leaves in a similar fashion.

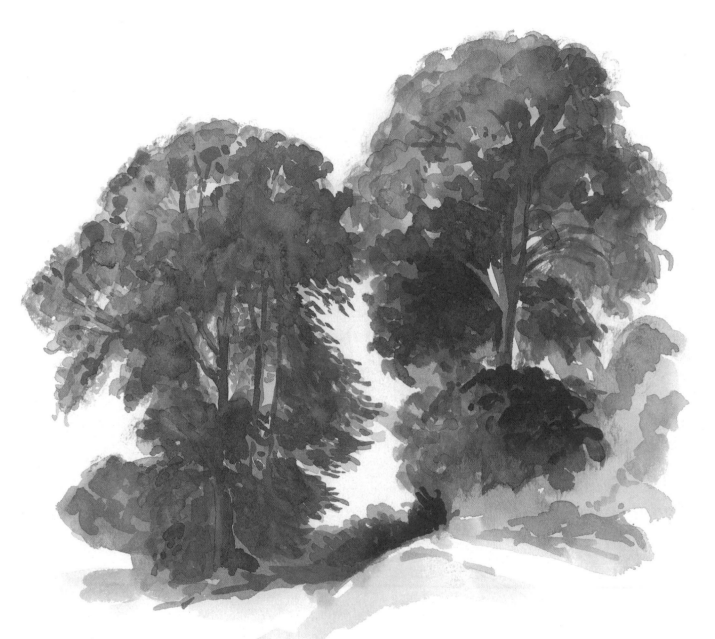

Now look at this Peter de Wint watercolour drawing of trees near Oxford. He has built up a grey mass of tone in rounded forms, then added darker and darker tones to give some depth to the scene. Again the best way to emulate this is to try copying him first, then draw some real trees in a similar style.

PLANTS

While plants can be loosely indicated in the larger landscape
you will sometimes want to draw them in more detail, perhaps
in the foreground to add a sense of depth to a panoramic
picture or in a more intimate, small-scale study.

This corner of an overgrown garden is a good example of a study of plant life, which is essential
for a landscape painter to practise. The whole landscape might not concentrate on these details,
but if you don't get them right the overall picture will suffer. One exercise you should engage in
is to make several attempts at just drawing plants in all their profusion – the more common and
tangled, the better.

This view of a valley with a tower and other buildings is seen past the profusion of wild plants on the side of the hillside nearest to our viewpoint. The nearer plants are drawn more heavily in outline than the buildings in the background, which helps to bring the foreground plants forward and push the buildings back.

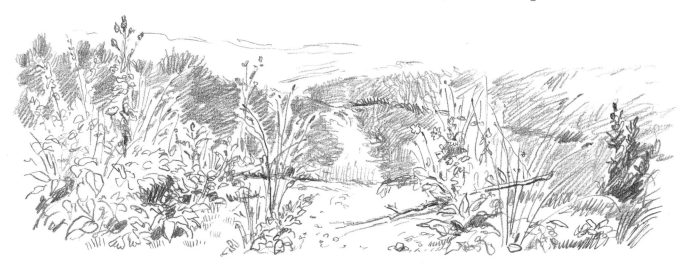

This edge of a countryside path has the usual mix of wild plants growing along it – a good test of your drawing ability, even if they never end up in a complete landscape.

■ LEADING THE EYE INTO THE PICTURE

The next three pictures show examples of scenes where a path or waterway draws the eye into the scene by leading away from the foreground into the distance. This very effective device is often used by artists to add interest to the picture.

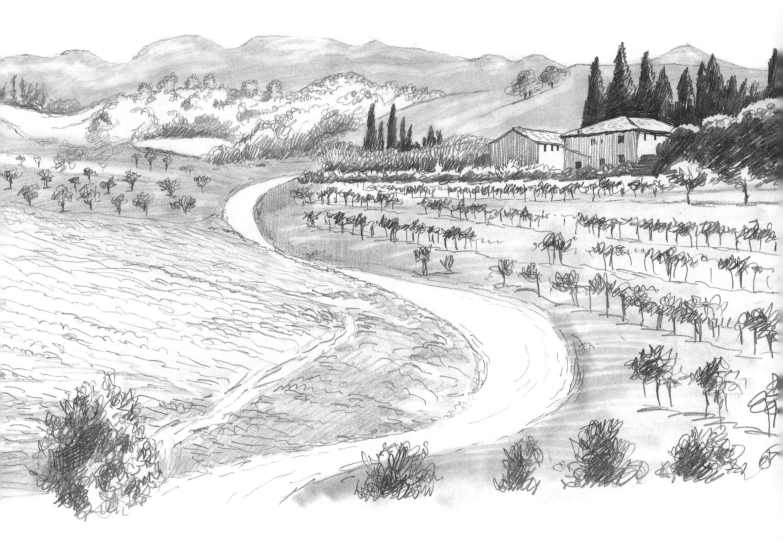

In this view of the Chianti countryside in Italy a path winds across the scene past the open vineyards and a farm, disappearing into the hills. Nearly all the main features are on the right side of the picture, but they create a horizontal thrust across the scene, counter to the direction of the path.

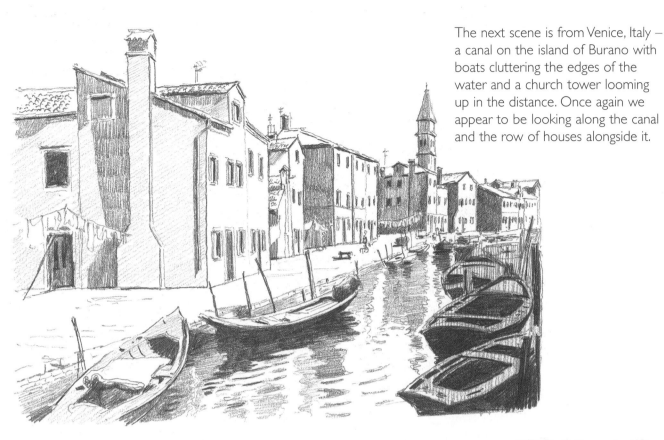

The next scene is from Venice, Italy – a canal on the island of Burano with boats cluttering the edges of the water and a church tower looming up in the distance. Once again we appear to be looking along the canal and the row of houses alongside it.

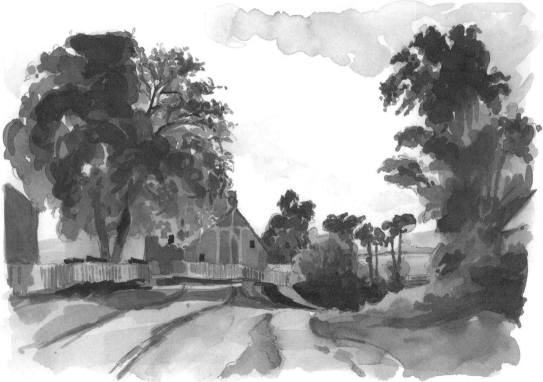

This watercolour by de Wint shows a lane dipping past a farmhouse in the Warwickshire countryside in England, where we appear to be on top of a slope. The large clumps of trees frame the whole picture in a satisfying way.

■ **PICTURESQUE VIEWS**

Certain views can have particular attraction for landscape artists, with a pleasing arrangement of trees, hills, water or buildings that will come across well on paper. Learning to spot these features is an important part of landscape drawing.

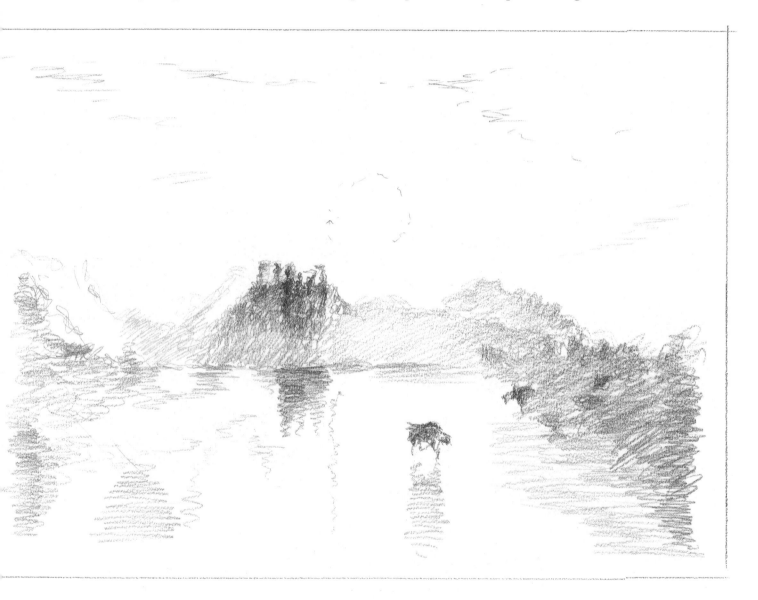

These two pictures are of examples of scenes that seem to cry out to be drawn. The first was seen by Turner, and he takes a landscape that appears to have dissolved into the sunlight. He has looked at what is actually a solid enough building, with hills around, but because of the strength of the sunlight it seems to have been diffused into the air itself. The reflected light on the water in front of the castle also seems mostly light and so the actual marks that he has made are quite flimsy. Of course he was a master of this sort of work and you will not find it easy, but it is worth trying it out some time if you can get the right circumstances. The trick is not to put too much information in the picture.

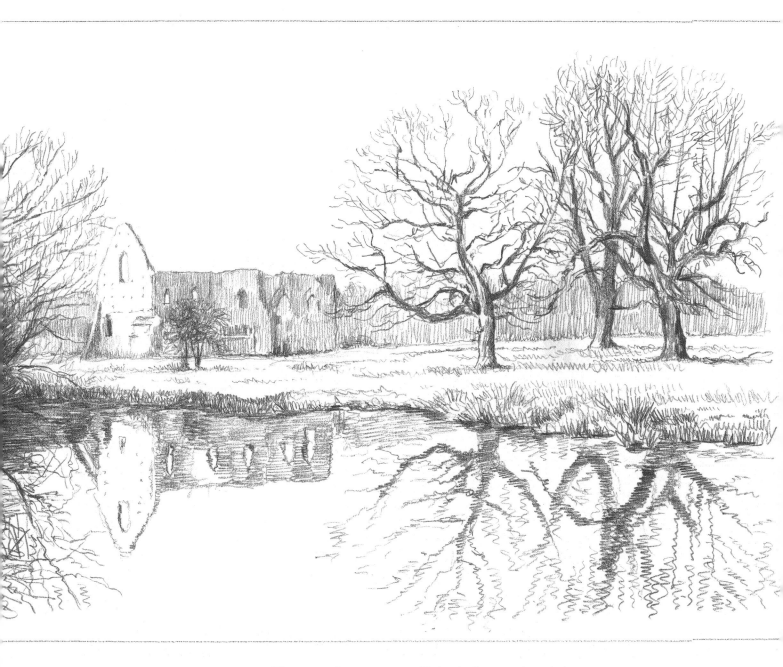

The second scene is near Ripley in Surrey, where I drew an old ruined priory, reflected across a stream, on a still day in winter. The large trees either side of the building are the main part of the reflection, and frame the ruin nicely. The search for picturesque and romantic sights is often what drives landscape artists.

◾ ENCLOSED SPACES

The next two scenes show urban landscapes, which are very circumscribed by the setting. The first is a view across the centre of London's Leicester Square by Charles Ginner (1912), and the second is after a William Ratcliffe painting of Clarence Gardens in north London, also dated 1912. Both painters were associated with the Camden Town group.

Townscapes like these are useful for the artist because the enclosed space seems to make it simpler to choose your viewing point and how much to draw. The angle of the daylight will also tend to decide your viewpoint, either with the light from the side as in Leicester Square, or against you as in the Clarence Gardens painting.

■ **A LANDSCAPE PROJECT**

Choose a location

The first step towards drawing a landscape is deciding on a location. Sometimes this is easy, because you happen to be in a place of great natural beauty and you have your sketchbook – the decision is made for you. However, often the reverse is true; you feel like drawing a landscape but don't have a particular one in mind. So how do you go about setting up a scene?

For this exercise, my first intention was to see how I could work up various sketches that I had done in France and Italy into a more considered composition. I began by drawing up a view of Claude Monet's famous garden at Giverny, in northern France, but finally decided that I wanted something a little less tamed.

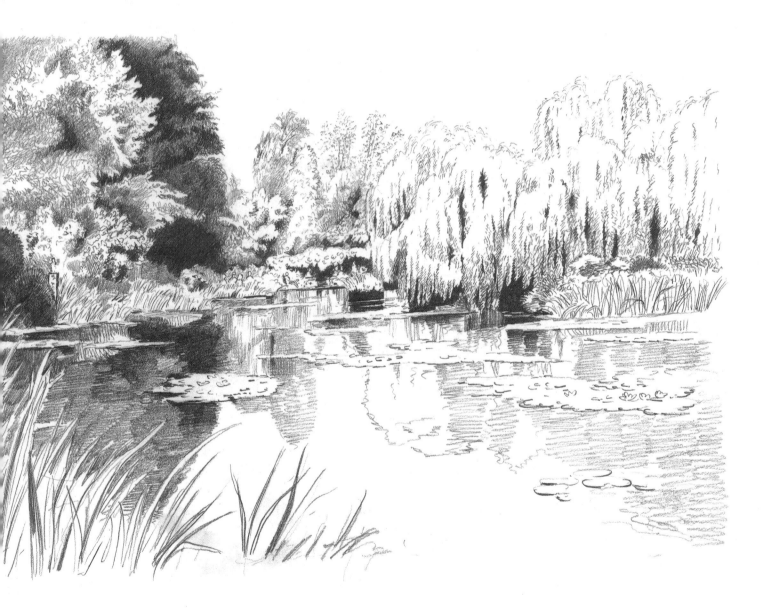

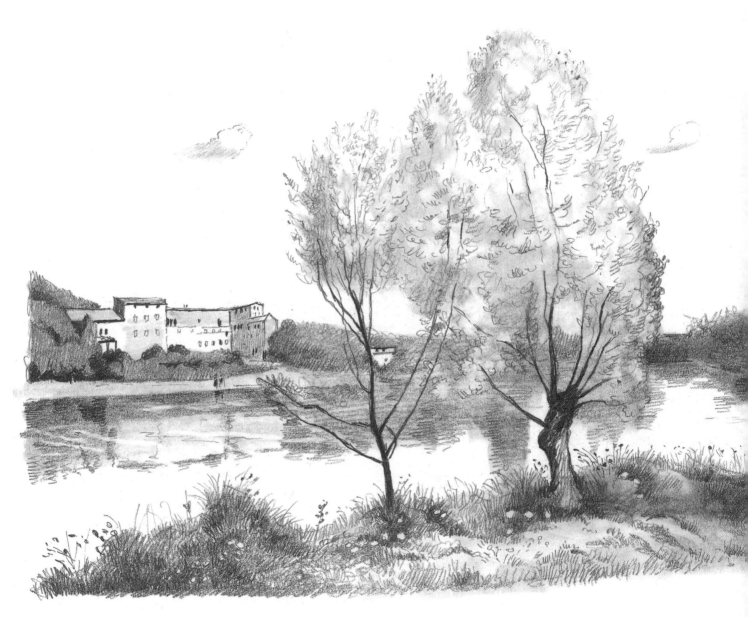

So then I looked at some sketches from Italy and worked up a view across a river, with trees in the foreground. However, I eventually felt that I wanted to start afresh with a landscape to draw from real life, so I put away my previous sketches and went out to beautiful Richmond Park, near my home.

This area is of great interest to me because of the variety in its landscape, with lakes, streams, hills and, most notably, magnificent trees. Although it's not wild countryside, it does have a breadth and range that lends itself to exploitation by the landscape artist.

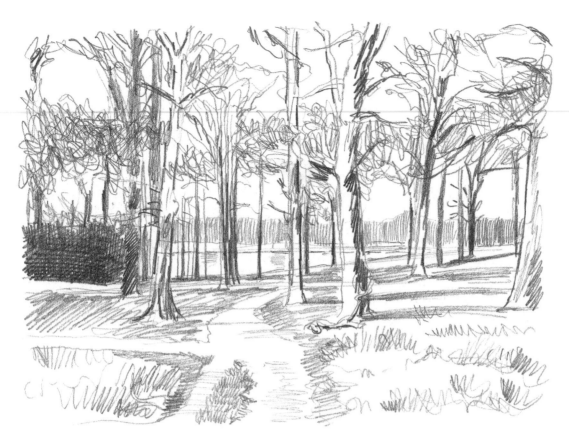

Sketching on location

I went on a long walk with my sketchbook, stopping every now and then to draw what I saw in front of me. The first pause was to draw this view of one of the lakes seen through some large trees. As it was winter there wasn't much foliage, but the bare branches of the taller trees were very attractive things to draw.

Then I moved on to a more open area where a hillside swept up to some woods in the distance. I quickly made a sketch of this and then noticed a large tree that had fallen and was gently rotting away. I made a drawing of this from one side and then moved nearer and around to the other side to make a more detailed drawing – a great thing to use in the foreground of any landscape.

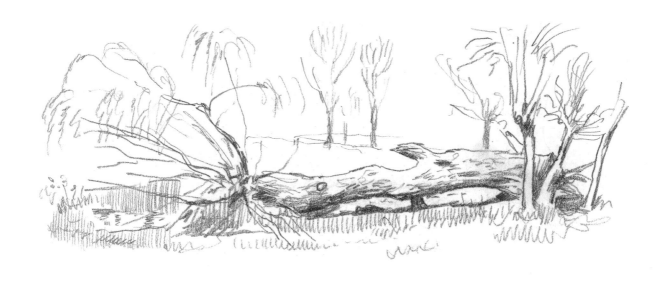

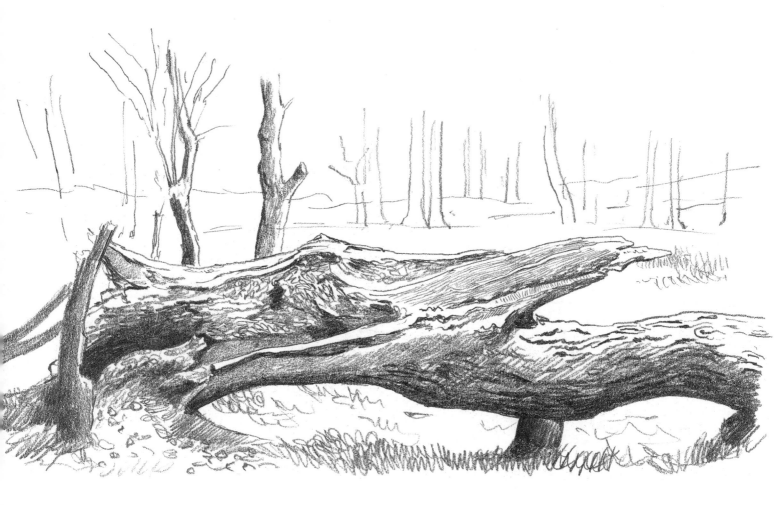

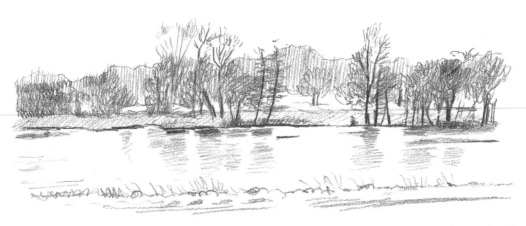

I then drew another glimpse of the lake from a distance, without any trees in front of it. This might come in handy for a background feature. So as you can see, I was beginning to compose a possible landscape picture already, without finalizing my decision yet.

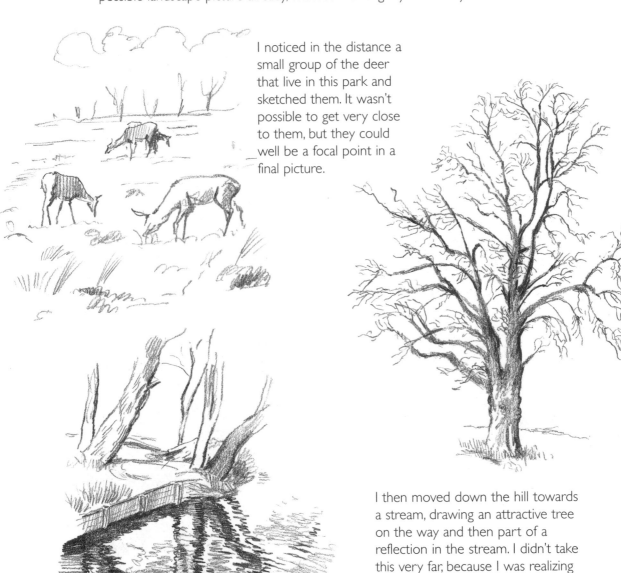

I noticed in the distance a small group of the deer that live in this park and sketched them. It wasn't possible to get very close to them, but they could well be a focal point in a final picture.

I then moved down the hill towards a stream, drawing an attractive tree on the way and then part of a reflection in the stream. I didn't take this very far, because I was realizing that I had now decided what and where I was going to draw.

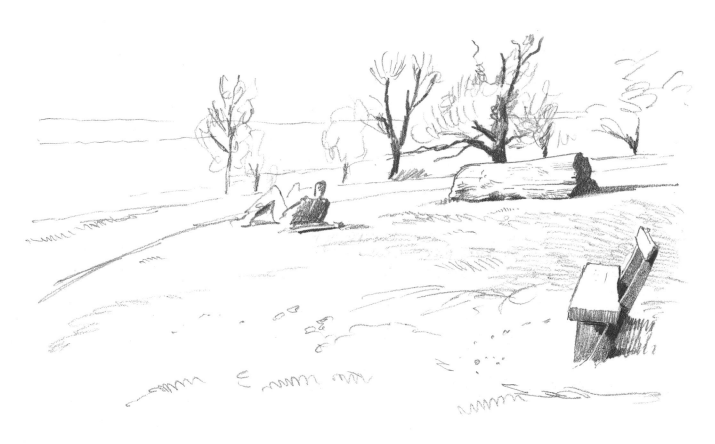

On top of a hill I drew another log, a man resting on the ground, and a wooden bench.
Nearby was a marvellous old dead tree-trunk, split and twisted, making a beautiful sculptural
shape, that might be a feature for a foreground.

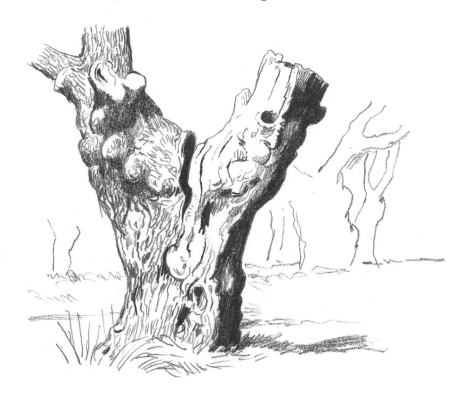

Step 1

My proposed landscape was to be a view up a hillside, with the large dying tree trunk lying across the path in the foreground. I also thought a couple of deer could appear somewhere in the picture – that is to say, my landscape would be a composite of several views. I made a rough sketch to see how it might look.

Step 2

Feeling that it would work well, I proceeded to draw it up in line only, at which point I could sort out any difficulties of composition and drawing.

Step 3

Once I had made all the corrections I needed to I could now begin to put in the texture and tone to give the picture more body. At this stage I kept the tone even and at its lightest, just in case I needed to change anything.

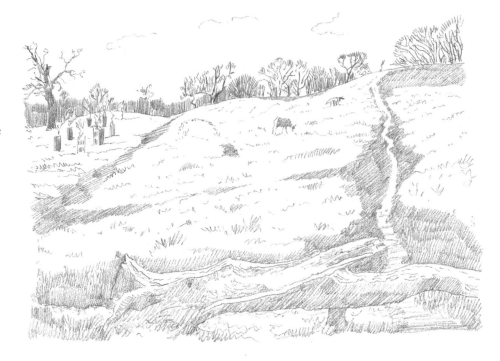

Step 4

Then came the final push to build up the depth and feeling of space that I wanted to see in the drawing. The deer almost disappear on the hillside, but they do work as a muted focal point in the composition. The path going up the hill helps to draw the eye into the picture and the undulating horizon of the hillside draws the eye around the picture to the dead tree standing on the left.

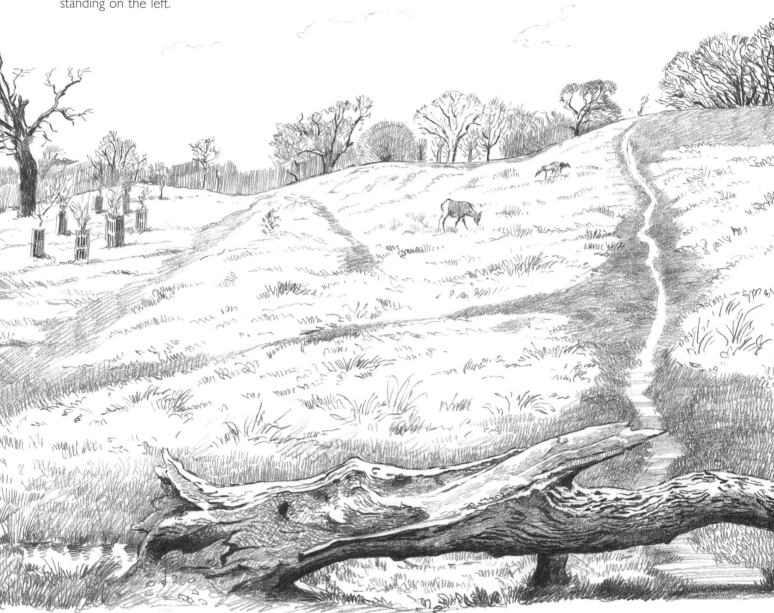

The whole project does require a certain amount of patience and determination, since drawing landscapes can be very time-consuming; when I go out to embark upon a landscape I always allow at least the best part of a day to it. But of course once you become absorbed in drawing you will find yourself spending longer and longer drawing the subjects you like. You should by all means go along with this until you feel you have achieved at least some expertise. However, do make an effort then to try something that has not inspired you so far, and you may discover that honing your skill in one area has suddenly made another more appealing.

Indeed, an artist can find interest in everything, which is why I find drawing such a rewarding subject to master. So good luck in all your efforts, and I hope this book goes some way towards helping you achieve what you want to in the world of art.

INDEX